CLASSICAL STORYTELLING AND CONTEMPORARY SCREENWRITING

Since we first arrived on the planet, we've been telling each other stories, whether of that morning's great saber-toothed tiger hunt or the latest installment of the *Star Wars* saga. And throughout our history, despite differences of geography or culture, we've been telling those stories in essentially the same way. Why?

Because there is a RIGHT way to tell a story, one built into our very DNA.

In his seminal work *Poetics*, Aristotle identified the patterns and recurring elements that existed in the successful dramas of his time as he explored precisely why we tell stories, what makes a good one, and how to best tell them.

In *Classical Storytelling and Contemporary Screenwriting*, Brian Price examines Aristotle's conclusions in an entertaining and accessible way and then applies those guiding principles to the most modern of storytelling mediums, going from idea to story to structure to outline to final pages and beyond, covering every relevant screenwriting topic along the way.

The result is a fresh new approach to the craft of screenwriting—one that's only been around a scant 2,500 years or so—ideal for students and aspiring screenwriters who want a comprehensive step-by-step guide to writing a successful screenplay the way the pros do it.

Brian Price is an award-winning screenwriter who has worked with major studios, television networks, and independent film producers from around the world. As an instructor, he has taught screenwriting at Yale University, Johns Hopkins University, and the Brooks Institute, among others, and is a proud member of the prestigious UCLA School of Theater, Film and Television screenwriting faculty.

"The insights in this volume could be provided only by an author like Brian Price, himself an experienced creator of narratives and a respected writing educator. In accessible language he explains why, millennia after his death, for contemporary dramatic writers Aristotle is more relevant than ever. Here is no pie-in-the-sky philosophical preaching but a hands-on guide to buttress storytelling craft for writers both new and experienced."

—Professor Richard Walter, Associate Dean;
Screenwriting Area Head, UCLA School
of Theater, Film and Television

"Brian Price delivers a masterful book on the essential precepts of classical storytelling, and their importance in crafting a successful screenplay—a wonderfully fresh take on the craft that both aspiring screenwriters and professionals alike will prosper from."

—Cornelius Uliano, Writer/Producer,
The Peanuts Movie (2015)

"When inspiration, craft, and chocolate have done all they can, one returns to first principles as Brian Price masterfully lays them out. I've watched Brian guide new voices for decades, and there's nobody better at identifying the heart of your story and what it needs from you next."

—Brian Nelson, Screenwriter, *Hard Candy* (2005),
30 Days of Night (2007), *Devil* (2010)

CLASSICAL STORYTELLING AND CONTEMPORARY SCREENWRITING

Aristotle and the Modern Scriptwriter

Brian Price

Routledge
Taylor & Francis Group

LONDON AND NEW YORK

First published 2018
by Routledge
2 Park Square, Milton Park, Abingdon, Oxon OX14 4RN

and by Routledge
711 Third Avenue, New York, NY 10017

Routledge is an imprint of the Taylor & Francis Group, an informa business

British Library Cataloguing-in-Publication Data
A catalogue record for this book is available from the British Library

Library of Congress Cataloging-in-Publication Data
Names: Price, Brian, 1970– author.
Title: Classical storytelling and contemporary screenwriting : Aristotle and the modern scriptwriter / Brian Price.
Description: New York : Routledge, 2018. | Includes index.
Identifiers: LCCN 2017036300 (print) | LCCN 2017043762 (ebook) | ISBN 9781315148526 (E-book) | ISBN 9781138553330 (hardback) | ISBN 9781138553408 (pbk.)
Subjects: LCSH: Motion picture authorship.
Classification: LCC PN1996 (ebook) | LCC PN1996 .P83 2018 (print) | DDC 808.2/3—dc23
LC record available at https://lccn.loc.gov/2017036300

ISBN: 978-1-138-55333-0 (hbk)
ISBN: 978-1-138-55340-8 (pbk)
ISBN: 978-1-315-14852-6 (ebk)

Typeset in Sabon
by Apex CoVantage, LLC

For Celia, Maddox, and Levi,
co-authors of my favorite story

"Screenwriting is the art of telling lies skillfully."

—Aristotle
Poetics, Part XXIV

"Okay, Aristotle never actually wrote anything about screenwriting, per se. But if he had, it might look something like the book you're reading."

—Brian Price
Classical Storytelling and Contemporary Screenwriting, this page

Contents

Acknowledgments

This book is based upon a college seminar I teach at Yale University entitled *Classical Storytelling and Modern Screenwriting*. So I am indebted to the students, faculty, and administrators there who keep filling the seats and inviting me back.

Thanks also to screenwriter extraordinaire Brian Nelson who, upon hearing the subject of my class, exclaimed "Duh, THAT'S your book!"

And special thanks to my instructors and colleagues at UCLA, still the best screenwriting program in the world. I must single out Richard Walter, Hal Ackerman, Lew Hunter, and Howard Suber, who along with Aristotle taught me everything I know about screenwriting.

And of course, thanks to Mom and Dad who taught me everything else, including the importance of following one's dreams regardless of where they might lead.

And MOST special thanks to my beautiful wife Celia and two amazing boys Maddox and Levi for their steadfast love, support, and patience while I wrestled my thoughts into words.

And finally, I want to acknowledge and thank all my students over the years. I've had the pleasure of teaching at a wide range of schools and gotten to meet and work with a huge collection of wonderfully talented students from around the world, all with unique and compelling backgrounds, experiences, and stories to tell. I've learned more from them than I have ever been able to teach. This book is a result of the education that they have given me.

So you all have my endless gratitude (in lieu of a sales percentage).

Preface

Some Obligatory Backstory

Several years ago, while developing a new MFA screenwriting program for a film school at which I was teaching, I was approached by a publisher asking if I had any desire to write a book about filmmaking. Sure, I thought. After all, I'd been making a living writing for film and television for years and teaching the craft for almost as long. So I pitched her a book on screenwriting that was based on the graduate level courses I was currently teaching.

Her reply: *Screenwriting? Good God, no. Anything but screenwriting. We're swamped with them already. Really, is there anything left to say?*

Not surprisingly, I didn't get the gig.

But the experience *did* inspire me to try to devise some new and unique way to discuss the process of crafting a successful screenplay, one that maybe hadn't been attempted before—an approach *worthy* of publication, for both its utility and novelty.

Then I discovered, much to my surprise, that my screenwriter colleagues all around me were doing the same thing—trying to create a new paradigm, a fresh way to look at structure or character to inspire a new generation of writers, or at least fill the time between writing gigs.

The Story-Generating Trapezoid™. The Seven Neon Hues of Character™. The Inverted Double Helix of Successful Cinema Structure™. And the race was on to uncover MY new approach as well, my neat, nifty way of reducing screenwriting to a simple shape or color swatch.

But on my journey to discover this spanking new paradigm, something quite unexpected happened. I rediscovered an old one. Something downright spanking ancient.

For it turns out the secret to writing a good screenplay is not held within some pithy new diagram or metaphor, but within the teachings of one of the greatest thinkers of all time, the man who, for all intents and purposes, wrote the very first book on screenwriting, and whose observations and instructions on the craft have remained relevant for the thousands of years since he first set them down on papyrus.

Of course, one might argue that Aristotle wasn't actually writing about SCREENWRITING in his *Poetics*, simply about the tragic plays of his time.

But then one would be very wrong. He was writing about "imaginative narrative fiction." And within that broader category, screenplays not only apply, but are arguably the current dominant form. His treatise is really an investigation into *why* we tell stories, and from that function, an analysis of what makes a good one and how to tell it the best way possible.

Truth is, Aristotle's observations and insights are timeless, just as valid today for the writers of the next *Star Wars* movie as they were in his time for the writers of the next *Oedipus Rex*.

So what follows is not a shiny new paradigm for how to write a successful screenplay, but rather, a shiny *old* paradigm. The right paradigm. For all those dodecagons and rainbows will come and go, just to be replaced by the next new-fangled diagram or terminology, but the classics survive for a reason.

They are classic.

SECTION I
A PROLOGUE

*(Wherein we discuss what this book is
and how to get the most out of it)*

ONE

Introduction

What You Hold in Your Hand

"Following, then, the order of nature, let us begin with the principles which come first."

(Poetics, Part I)

First, let's get straight what this book is *not*. It is not a new translation of Aristotle's *Poetics*. Instead, it treats that indispensible treatise as a jumping off point, utilizing its enduring insights into classical storytelling to help contemporary writers turn their ideas into successful screenplays.

For that reason, while it certainly wouldn't kill you to take a gander at *Poetics*, as I always advise my students to do as their first assignment, it is not necessary in order to get the most out of this book. When appropriate, I will be quoting pertinent passages and citing Aristotle's relevant observations in order to make my own points, so reading the original source is not essential to understanding and making use of its invaluable wisdom.

Furthermore, this book is not merely intended to be about how to write a successful screenplay the way the pros do it, though that is certainly one of its primary purposes. Rather, it is about placing screenwriting within the broader context of storytelling, going all the way back to when our ancestors sat around the fire to tell the tale of that morning's Great Saber-Toothed Tiger Hunt, and seeing how the principles that apply to telling a good story well have remained consistent since we first began telling them.

For the truth is that telling stories has been part of every culture, throughout the world, throughout history. It is in fact one of the things, if not the primary thing, that separates us from every other animal on the planet. Despite what you may have learned in grade school, it's not opposable thumbs, or having language, or using tools, that sets us apart. It's that we, as a species, tell each other stories.

So the question arises: WHY?

Does it fulfill some kind of function, perhaps a biological imperative or evolutionary need for us as a species, beyond simple entertainment? And if so, what might that function be?

Perhaps the answer lies somewhere in the fact that if you survey all the stories we tell, in every medium—the epic poems, the oral histories, plays, movies, novels, short stories, commercials, jokes—you discover, as Aristotle did, that the same observable patterns emerge. That in all successful stories, the ones that have stood the test of time, we see the same key elements and principles—what I'll be referring to as ARISTOTLE'S GUIDING PRE-CEPTS (AGPs)—of structure, theme, character, plot, etc., recurring over and over, and yes, over again, regardless of culture or history or geography.

And what these patterns reveal is that there must indeed be something built into our very DNA that requires us as a species not just to tell stories, but to tell them in a *very particular way*, with those same key principles and components.

So in the chapters that follow, we will explore the function of storytelling and identify those AGPs of story, structure, character, plot, theme, etc., that are essential to make a story work. And once we understand those principles, we can then utilize them in our own creative endeavors, specifically in our screenplays, to help make them deeper, more universal, and ultimately, more successful.

Therefore, in lieu of discussing Aristotle's observations and concepts in the order in which they appear in his *Poetics*, I've organized them according to their order in the actual professional screenwriting process. So each section of this book is structured in the following manner: Aristotelian concept, its contemporary significance to screenwriting, and finally, its practical application for the reader's own work.

For that reason, most chapters begin with a relevant quote from Aristotle (I'll be utilizing the S.H. Butcher translation of *Poetics*, first published in 1895 and now in the public domain), and many will end, when appropriate, with an actual ASSIGNMENT that will take the reader through the steps of writing their own original screenplay, using Aristotle's principles as a guide.

So before we start to break down how to craft a screenplay, and how we can utilize Aristotle's teachings to do so, let's first take a quick look at that essential source material.

Shall we?

TWO

Aristotle's *Poetics*

It's All Greek to Me

"I propose to treat of Poetry in itself and of its various kinds, noting the essential quality of each, to inquire into the structure of the plot as requisite a good poem; into the number and nature of the parts of which a poem is composed; and similarly into whatever else falls within the same inquiry."

(*Poetics, Part I*)

Aristotle's *Poetics* may be a short read, but it's also often quite dense and complex, as the above quote handily illustrates. The truth is, it's not really a unified work itself, but has been compiled over the centuries from various extant works, with many explanations missing, and even some things downright contradictory. Don't worry about it; we'll get through all the important parts together.

But first some background.

Aristotle was a Greek philosopher, actually Macedonian if we're splitting hairs, who lived from 384–322 BCE. He was a pupil of Plato and a teacher of Alexander the Great, and he wrote treatises on just about every subject under the sun, from physics to ethics to linguistics.

In his *Poetics*, he wrote what is essentially the earliest surviving work of dramatic or literary theory. The title comes from the Greek word *poiesis*, literally translated as "creation" or "the making," and he uses the term *poetry* to encompass every form of imaginative fiction—drama, comedy, tragedy, lyric poetry, epics, satyr plays, and dithyrambs (don't ask, but I'm sure they're due for a comeback any day).

And what he does is examine the narrative works that were popular in his time and prior and ask what the successful ones have in common. What are the recurring elements that can be observed from one to the next, as dramatic forms have changed and evolved, that have contributed to their success?

So if we acknowledge the reality that screenwriting is simply the most contemporary and ubiquitous medium of that narrative evolution, then we must accept that not only are his observations and discoveries valuable, they are INDISPENSIBLE to our understanding of what makes a good screenplay story, and even more importantly, to how to tell a good screenplay story well.

In other words, the elements that *Oedipus Rex*, *Iphigenia*, *The Odyssey*, and every other classical narrative that's stood the test of time have in common—and which are absent in the countless more dramas that have since vanished from our collective history—are the SAME elements that exist in *Star Wars*, *Some Like It Hot*, *The Shawshank Redemption*, *Wonder Woman*, and every other drama of OUR time that we deem worthwhile, artistically or commercially.

Truth is, if you were to read *Poetics*, and simply substitute the word SCREEN-PLAY every time Aristotle mentions drama, narrative, tragedy, comedy, or poetry, you would have the first and finest book on screenwriting.

And for all intents and purposes, that's what we will be doing within these pages, taking Aristotle's observations and wisdom about the dominant narrative forms of his time and applying them to our own. So while Aristotle never got to enjoy hot buttered popcorn sprinkled with melting Goobers at his local multiplex nor have the chance to apply his guiding precepts to the latest cinematic blockbuster or art house darling, if he had, it might look something like the book you hold in your hands.

As Emerson said, "All my best thoughts were stolen by the ancients."

So given that Aristotle never actually said anything about screenwriting, let's have a look at what he has to say about it.

Motivating Factors

Why We Tell Stories

"The instinct of imitation is implanted in man from childhood, one difference between him and other animals being that he is the most imitative of living creatures, and through imitation learns his earliest lessons . . . [and] to learn gives the liveliest pleasure. . . . Thus the reason why men enjoy seeing a likeness is, that in contemplating it they find themselves learning or inferring, and saying perhaps, 'Ah, that is he.'"

(Poetics, Part IV)

As I said, when Aristotle wrote *Poetics*, he surveyed the canon of dramatic works written up to that time, particularly the tragedies (many of which have since been lost to antiquity, so we have to take his word for what they were about), and set out to discern the common elements among them, to draw conclusions about how we tell stories, and, just as significantly, the reasons for doing so.

It's worth noting, just to give the work some historical context, that Aristotle was also responding to his teacher Plato's critical attacks on tragedy, and was actually trying to defend the relevance of the art form. This was not merely to rationalize elevating the subject to a level worthy of discourse, but also to make a case for the importance of storytelling from a societal perspective.

So he starts by acknowledging that telling stories is something that has existed among human societies since we first showed up on the planet. And like any good philosopher he asks:

Why?

What *need*, of the individual, of society, of the SPECIES, is being satisfied by this shared desire to sit around the campfire or Theatre of Dionysus or Cinerama Dome and listen to a tale, whether of the aforementioned Great Saber-Toothed Tiger Hunt, the downfall of King Oedipus, the madness of Lear, the death of Willy Loman, or the talking butt cheeks of Ace Ventura?

He comes up with two explanations that, together, form the basis of his understanding of our need to tell stories, and thus, of everything that is subsequently required to do so.

In Greek, they are *MIMESIS* and *CATHARSIS.*

Let's take these two vital concepts in order.

First *mimesis,* defined, depending upon your translation, as "imitation" or "representation."

As the quote that begins this chapter indicates, Aristotle believed that the fundamental quality that separates us from the other animals on the planet is that we want to learn. We have questions. *Who are we? Why are we here? What is our place in the universe?* And we derive PLEASURE from seeking answers.

And the primary way we get those answers is to experience ourselves and our world reflected back to us, imitated, represented.

So *mimesis* concerns the pleasure of LEARNING, of looking at something and saying, "Ah, I recognize that," or "I get that," which occurs whenever we experience a representation, whether gazing at a painting or watching a play.

Consider the fact that even in English, that word "play" has a dual meaning. As adults we go see *plays,* the plays that Aristotle is deconstructing, imitations of life represented on stage. Similarly, when we are kids, we *play* cops and robbers, *play* house, *play* Elsa and Ironman. Our PLAY as kids is all about representation too.

As Aristotle observes, our earliest lessons are through imitation, and that continues throughout our entire lives. Why? Because it's through imitation that we best learn about the world and our place in it. And exploring those universal, existential questions gives us pleasure, scratches that desire for answers that is built into our DNA, that allows us to recognize not just "Ah, that is he," but "Ah, that is *me.*"

So we have an instinctual desire to learn. Still, the question remains, *why* must that pleasure from learning come through representation and not simply through direct experience?

Perhaps it's because the distance between the observer and what is being represented allows us to be *objective* in our analysis, something that would be more difficult if the experience were actually happening directly to us. Maybe we learn most effectively by adopting a more circumspect vantage point.

Additionally, maybe the answer has something to do with Aristotle's assertion that we get the same pleasure from watching something joyous and beautiful as we do from watching something terrible and horrifying, that perhaps the distance afforded by imitation allows the experience to be *safer.*

And finally, maybe it has something to do with the *communal* nature of the experience of observing a representation. When something is happening to us alone, we might imagine the experience is unique to us. But when we are looking at that painting or sitting in the theatre, surrounded by a group of people experiencing the same representation, we can remark not only "Ah, that is me," but also take pleasure and comfort in knowing "Ah, that is US."

Which isn't a bad segue into the second reason we tell stories.

Catharsis, defined as "a purge, specifically of emotions."

This concept is a bit more problematic to nail down, mainly owing to the fact that Aristotle mentions it only once and never elaborates on it. As a result, it has engendered a lot of debate over the centuries.

So what exactly does he mean by a "purging" of emotions?

The most common idea is that the phrase refers to an emotional cleansing of the audience. This idea is based upon the observation that while we may have entered into a civilized society, we are still basically animals, with the same primal urges and emotions of our fellow creatures.

Experiencing a drama then is a chance to purge those emotions, to laugh or cry or scream, to have an appropriate outlet for our strong but bottled-up feelings, that would then allow us to continue living in that civilized society. In other words, *catharsis* is a way to have a safe, communal forum for expressing and releasing otherwise troublesome and detrimental emotions.

Though a fairly common explanation for *catharsis*, the problem with this interpretation is that there is no evidence whatsoever that Aristotle found emotions the least bit troubling. It is Plato who thought that emotions were bad. As a result, Plato thought that TRAGEDIES were bad because they caused those emotions to be felt.

Aristotle, on the other hand, thought emotions were good, vital even. But he believed in moderation. Not too much, not too little emotion. His idea was that you NEED fear. Not so much fear that you shrink away from the slightest challenge. But not too little that you stupidly plow right into any dangerous situation. It was all a matter of balance.

So the second reading of *catharsis* is that it is a way to RECALIBRATE one's emotions. This school of thought says that Aristotle's sense of *catharsis* is all about telling stories in order to let off some excess emotional steam, to be able to restore a healthy and proper harmony of emotion. So there is something therapeutic about seeing a play or going to a movie since the emotional experience they provide resets us to an emotional equilibrium.

A problem with this interpretation is that it implies those with a greater imbalance of emotion would derive a greater benefit from the experience. Yet that doesn't seem to be the case in reality. Having a disproportionate amount of emotion is hardly a prerequisite for enjoying a drama, and unstable people don't necessarily get more out of a play than the rest of us.

So still a third approach to this question is that Aristotle is talking about the purging of emotions in a way that is similar to his more defined description of *mimesis*—that *catharsis* is also rooted in the pleasure we feel at representation, not simply in the way things *appear*, but in the way we *respond* to them.

In other words, the emotion we experience while watching a movie is an IMITATION of that emotion in real life.

Think about it. When we watch *Alien*, we are terrified as Ripley walks through that long, dark tunnel. Something is lurking in the shadows. Something is going to jump out. We are going to scream. And then we are going to laugh with relief that such an emotion was provoked, yet we are in fact still safe and sound.

Now imagine feeling that *same* fear in real life. You walk down a dark alley, knowing that someone is following behind you, knowing that something horrible is in the shadows up ahead. Are you feeling that same chill? That same giddy dread? Not at all. Because it's *real*. Because that alley has the potential for actual danger and pain.

And if those feelings provide you pleasure or any positive benefit at all, then put this book down immediately and call your therapist, you've got bigger concerns than how to write a screenplay.

The threat of actual peril does not exist in the movie theatre, so the emotion cannot possibly be the same. Instead, we experience a facsimile, an approximation of fear. The same holds true with sorrow. With joy. With the whole gamut of emotions.

But why would we want to experience an *imitation* of an emotion?

For the same reason Aristotle says we desire to experience an imitation of an object.

We derive pleasure from learning—and we accomplish that through FEELING just as much as, if not more than, by OBSERVING. But, as with *mimesis*, that experience requires a safe environment, with that same objective distance only afforded by experiencing the *representation* of those powerful emotions.

Make sense? I hope so, since this is where our understanding of the purpose of storytelling starts.

According to Aristotle, we have an innate, instinctual desire to better understand ourselves and our world. And we most effectively do that by both SEEING and FEELING representations of ourselves and our experiences reflected back to us. So *mimesis* and *catharsis*, imitations of objects and emotions, together, allow us to experience the world, and life in general, while maintaining a safe, objective, and *communal* vantage point.

And because STORIES provide that experience, we find them not only pleasurable, but *necessary*.

Aristotle may have not known the term, but he is in fact describing an evolutionary imperative. We need to learn about ourselves in order to grow and develop, as individuals, as a society, and as a species. Therefore Nature, in her infinite wisdom, has blessed us with pleasure in learning, along with a built-in mechanism to accomplish that end, the desire to tell stories.

So storytelling has a purpose, an important one. And that purpose provides us with **Aristotle's Guiding Precept #1:**

> **TO TELL A GOOD STORY EFFECTIVELY, WE MUST a) SHOW OUR AUDIENCE SOMETHING UNIVERSAL OF THEMSELVES AND THEIR WORLD REFLECTED BACK TO THEM, AND b) THROUGH THAT IDENTIFICATION, GIVE THEM AN EMOTIONAL EXPERIENCE.**

We might not all have owned a bar in a war-torn way station like Rick Blaine, risen to the top of an underworld empire like Michael Corleone, or rescued a space princess like Luke Skywalker, but we certainly know what

it's like to be jilted, to deal with family conflict, to dream of a more excit-ing and fulfilling future. These movies, like all good ones, make us cry and cringe and curse and laugh and scream as we see aspects of our own experi-ence reflected back to us, allowing us to recognize important truths about ourselves through the experience of another.

So everything about the craft of screenwriting, from idea to story to struc-ture to character to theme to the choice of the very words on the page, must help provide that experience.

In other words, we must fulfill the dual purpose of storytelling—*mimesis* and *catharsis*—to provide the joy of LEARNING through the experience of FEELING.

And now that we know a little more about *why* we tell stories, let's begin exploring *how* we tell them. And for that, we should start by defining just what makes a good one.

FOUR

Starting the Journey

Defining the Road Ahead

"Tragedy is an imitation of an action that is serious, complete, and of a certain magnitude; in language embellished with each kind of artistic ornament, the several kinds being found in separate parts of the play; in the form of action, not of narrative; through pity and fear affecting the proper purgation of these emotions."
(*Poetics, Part VI*)

And there you have it. How to write a screenplay in one simple sentence. Goodnight and don't forget to tip your server.

But wait, you say. What does Aristotle's definition of dramatic narrative, as stodgy and archaic as it sounds, have to do with contemporary screenwriting?

Glad you asked.

Believe it or not, within that definition exists just about everything a modern screenwriter needs to know to write a successful screenplay.

So let's break it down, shall we?

AN IMITATION OF AN ACTION . . .

As we shall see when we discuss STORY in the next section, and I shall be repeating almost as often as Aristotle does, the subject of a successful screenplay, the central idea, the premise, is not a person. It is not a location. It is not an era or historical event. Not a theme or arena of thought. Rather, it is an ACTION. A *doing*. A thing that is *done*.

So *The Odyssey* is *not* a story about Odysseus. It is a story about Odysseus trying *to get home*. Likewise, *Annie Hall* is not a movie about Annie Hall. It is a movie about Alvy Singer trying *to win the heart* of Annie Hall. Those are actions. To return. To woo.

Jake Gittes is trying to solve the case. Sheriff Brody is trying to kill that shark. Jeffrey Lebowski is trying to get his dang rug back. After all, it really tied the room together.

These are all ACTIONS. Good dramas are based upon an action, something specific that our hero is trying desperately to accomplish. Knowing and accepting this simple truth is critical to crafting a successful screenplay.

And of course, Aristotle refers to it as an "imitation" of an action, in keeping with our earlier discussion of *mimesis*, reminding us that this is a construct, a fiction, a REPRESENTATION of that action and not the action itself.

. . . THAT IS SERIOUS . . .

Some might suggest that Aristotle is distinguishing here between subject matter that is appropriate for a tragedy versus what is fit for a comedy, that the former must be serious while the latter may be frivolous.

But a better understanding of this part of his definition is that in Aristotle's time as in ours, what is *serious*, often translated as "admirable," is simply that which is worthy of being written about. Once upon a time, that referred to the actions of the gods, of noble people, of characters of a higher station than the audience. *Their* actions were worthy of representation, for their plight, their successes and failures could be seen as a lesson for the common man, the ones for whom the narrative was intended.

But Aristotle understood that the dramatic arts are an evolving medium, that in addition to such elements as the use of a chorus and the number of actors on stage, the dramatic subjects and manners of representation of *his* time were further along, more complex, than those of his forebearers.

And as Aristotle predicted, that evolution has not ceased. Nowadays, what is worth writing about includes just about anything that gets at the heart of the human experience. Not just gods and nobility, but WE are worthy subjects. OUR actions and desires are serious and admirable.

In fact, you can trace the evolution of narrative subject matter from the time of the Greeks to today and see that it is really a history of the broadening of that sense of serious, from Oedipus Rex to Willy Loman to Jeffrey Lebowski. Our stories today still remain about an action that is admirable; only our sense of what constitutes admirable has been democratized along with most every other aspect of our society.

. . . COMPLETE . . .

The narrative has closure. It starts at the beginning of the story, a bunch of stuff happens, and then it ends at the story's conclusion. Seems basic enough, though this simple clause will form the basis of our entire approach to structure. Much *much* more on this to come.

. . . AND OF A CERTAIN MAGNITUDE . . .

The drama is an appropriate size. Not too small, not too big, as Goldilocks might say, in terms of subject matter, scope, and duration. It is composed of just the right number of events in order to tell the story of this action, to get from the beginning to the end, with nothing extraneous or tangential in between. This will also be a vital concept when it comes to determining a story's proper structure.

... IN LANGUAGE EMBELLISHED WITH EACH KIND OF ARTISTIC ORNAMENT ... FOUND IN SEPARATE PARTS OF THE PLAY ...

Aristotle goes on to explain that this passage refers specifically to the use of song and verse in a drama, literary devices very much in vogue in the tragedies of his time. Not so much today. But as we've noted, Aristotle acknowledges the art of dramatic writing continues to evolve, so some specific elements (like those awesome dithyrambs) may have changed or fallen by the wayside.

Still, song and verse continue to play a role in movies, whether we're discussing an outright musical like *Singin' in the Rain* or *La La Land*, or a more conventional story embellished with a musical score or soundtrack to help convey the narrative and enhance the emotional impact.

But beyond literal music, the concept of "language embellished with artistic ornament," sometimes translated as "language made pleasurable," will become more relevant when we discuss the crafting of actual script pages. As we'll see, the choice of specific words and phrasing is never incidental, but always intended to create the most pleasurable experience for both the film's audience hearing those words, and the screenplay's readers reading them.

... IN THE FORM OF ACTION, NOT NARRATIVE ...

Pretty straightforward. The story is told through actors, not a narrator. This is what separates drama from all other writing mediums, epic poetry, novels, short stories, etc. No one is *telling* the story. It is being *acted out* by the characters within it as it transpires. As we shall see, this creates something unique from all those other forms, the fact that the audience is never TOLD what is going on. Rather, they are SHOWN.

And finally—

... THROUGH PITY AND FEAR AFFECTING THE PROPER PURGATION OF THESE EMOTIONS.

And now we circle back to our original discussion of *why* we tell stories, that drama creates an emotional experience, allowing for an expunging or purification of those emotions. But why *pity* and *fear*? Is he talking specifically here about tragedy, the genre we might expect to elicit those powerful emotions? Or can we take away something broader here?

Let's start by examining the difference between these two very specific emotions. We *pity* someone because we feel sorry for what is happening to them. In dramatic terms, we pity them because they don't deserve their fate. The key here is that we see them as separate and distinct from us. Pity comes from a place of superiority. *We* aren't having their bad luck, so we can stand in judgment of it.

On the other hand, *fear* comes about when we *ourselves* feel affected, when *we* are in danger. When experiencing a drama, we feel fear because we realize that the same fate might befall us.

So by choosing these two distinct emotions, *pity* and *fear*, Aristotle demonstrates that an effective drama creates an emotional experience by having us objectively OBSERVE the actions and the characters experiencing them

(pity), while at the same time having us directly IDENTIFY with what they are going through (fear).

As a result, when we experience these two emotions, we are simultaneously WATCHING and PARTICIPATING in the action.

Hmm, are you having a bit of déjà vu all over again? Watching and participating may enable us to experience both pity and fear, but if you've been paying attention, you'll recall they are also the dual activities that allow us to both LEARN and FEEL. *Mimesis* and *catharsis*.

So our definition of WHAT constitutes a dramatic narrative has come full circle back to the WHY of it. AGP #1! A good drama must compel us to both watch and participate in the action in order to allow us to learn about ourselves through an emotional experience.

Simple enough, right?

Yeah, right.

Truth is, even after we embrace the ramifications of Aristotle's definition of drama—and we'd be foolish not to, it's pretty solid, with little to add or argue—the question remains: How do we, as modern screenwriters, make use of these admittedly abstract truths to help us write effective screenplays?

We may now have a sense of what we need to end up with, but how do we *get* there?

Well, every journey begins with a single step. And our first step is simply to acknowledge the most important element of any dramatic narrative. The alpha and the omega of every good screenplay.

So let's do that . . . and begin our journey.

A BEGINNING

(Wherein we discuss the important characteristics of a good movie STORY and how to go about crafting one)

FIVE

Story

And I'm Sticking to It

"If you string together a set of speeches expressive of character, and well finished in point of diction and thought, you will not produce the essential tragic effect nearly so well as with a play which, however deficient in these respects, yet has a plot and artistically constructed incidents. . . . The STORY, then, is the first principle, and as it were, the soul of a tragedy."
(Poetics, Part VI)

Let's go ahead and put too fine a point on it. Whether we're discussing tragedy, comedy, movies, jokes, commercials, any form of narrative, **Aristotle's Guiding Precept #2** is simply:

> **THE MOST IMPORTANT ELEMENT OF A SCREENPLAY IS THE STORY.**

If you have to go to sleep every night chanting to yourself "story, story, story," so be it. But the sooner you accept this fact and absorb it into the core of your being, the sooner you'll be writing successful screenplays.

As Aristotle explains, one can be proficient in every other aspect of writing, whether in shaping character, choreographing action, crafting the dialogue, or arguing the themes, but if you have no STORY, your play will *suck*, roughly translated, of course.

On the other hand, if you have a great story, it makes up for many other lapses and deficiencies. And boy is that the truth. Disregard this crucial principle at your own eternal peril.

Still, while STORY is far and away the most important element, it is only one of several that Aristotle deems essential to every dramatic narrative. And the bulk of his *Poetics* is then devoted to defining, analyzing, and understanding these six key elements:

STORY/PLOT
CHARACTER
THOUGHT/REASONING/IDEAS
DICTION
SPECTACLE and
SONG/LYRIC POETRY

We, too, will examine each at greater length as they become relevant to our screenwriting process. But for now, just as we did with Aristotle's definition of drama, let's break these essential dramatic elements down so we can start our process with a basic understanding of each, as Aristotle defines them.

Story/Plot

I should note that many translations of *Poetics* tend to use the terms STORY and PLOT somewhat interchangeably. But Aristotle makes a distinction. He says that the *story* is the ACTION that is being imitated, while the *plot* is the arrangement of the episodes.

For *our* purposes moving forward, STORY is simply what your screenplay is about, what you might find described in your cable guide. PLOT refers to the choice of specific events that convey that story. And STRUCTURE, as we'll see, is the actual ordering of those events.

What is important is that STORY comes first and every other element on Aristotle's list is in service to it.

Character

First, it's important to understand that Aristotle's term CHARACTER does *not* refer to what we think of as character today, Hannibal Lecter, Indiana Jones, Belle, etc. Rather, these personages are what he refers to as the "Agents of the Action."

CHARACTER, on the other hand, refers to the MORAL character of those individuals, where Lecter or Jones lie on the spectrum of good and evil. It also refers to the *moral character* of the story as a whole. So think of CHARACTER as the *moral dimension* of the story and as the *moral disposition* of the individuals within it.

Thought

As the term implies, THOUGHT refers to an actual cognitive process. Alternatively translated as REASONING or IDEAS, it represents a character's judgments about a circumstance or situation. What is Lecter *thinking* when he's visited by a census taker? Or Jones when he's selecting a grail? A useful

way to think of THOUGHT, as Aristotle describes it, is as the *inner life* of an individual, what is going on inside their head at any given moment.

And as we'll later see, just as with CHARACTER, Aristotle's term THOUGHT applies to more than just the personages within the narrative. It also refers to the *thoughts* and *ideas* conveyed by the story as a whole. More on that when we discuss THEME (an element that we'll reserve, just as Aristotle does, for the very end of our discussion).

But crucially, these two elements, CHARACTER and THOUGHT, *moral disposition* and *reasoning*, taken together, form the principle aspects of what we think of today as "character." They define WHO someone is and HOW they behave. Jones will choose wisely. Lecter will eat that hapless census taker's liver with some fava beans and a nice Chianti.

Understanding these two elements and their interaction will become crucial for how we develop our movie characters and use them in service to the story. Much, *much* more on that when we get to the chapter on CHARACTER.

Diction

Now if we think of *thought* as the character's inner life motivating their words and deeds, then Aristotle's term DICTION refers to any actual words expressed. The former refers to WHAT is communicated, the latter to HOW it is communicated. DICTION then relates to the speeches, what Lecter and Jones say in order to express their thoughts, put forth an argument, or achieve some other effect, whether to frighten Clarice or win Marion's heart.

However, since a screenplay is also meant to be READ before it is ever meant to be performed (as we'll discuss in Section Four), DICTION refers not just to the words that a character *says* but also to the words that the script reader *reads*, the actual description of everything that happens in the story.

Spectacle

SPECTACLE simply refers to the stagecraft or physical presentation of the action. It could be as big as Lecter's violent escape from police custody or as subtle as Jones' smiling rakishly. And while Aristotle may have downplayed this element due primarily to the physical limitations of his time to produce much spectacle, film's tools are veritably infinite for doing so. Hence, spectacle has become a much more significant component, just one more example of the evolution of narrative.

Together, these two elements, DICTION and SPECTACLE, constitute everything the audience can *hear* and *see*. As such, they make up the totality of what a screenwriter may present on a screenplay page. We'll discuss these elements, the practical tools in the screenwriter's arsenal, in the chapters on DIALOGUE and DESCRIPTION.

Song

Okay, so I lied. Not EVERY one of these six elements is essential to crafting a screenplay. SONG, which Aristotle refers to as an "embellishment," a manner in which certain *thoughts* can be expressed, is an element of drama much more requisite in his time when some speeches were spoken and others, particularly from the chorus, were sung. So as with that once ubiquitous chorus, unless you are writing the next *Chicago*, this element has since fallen out of use. Hence we won't be dwelling on it.

Still, if you want to insert some lyric poetry into your non-musical script, knock yourself out.

So in our more modern parlance, Aristotle's list of the important narrative elements becomes: STORY, CHARACTERS, THEME, DIALOGUE, and DESCRIPTION, all the fundamental ingredients in the craft of screenwriting. And we'll discuss them one by one in the order of their inclusion in the screenwriting process.

But of all these elements, in case you missed it the first hundred times I mentioned it, STORY COMES FIRST.

I am dwelling on this point, just as Aristotle does, because there is frequently an argument that character, in the modern sense, matters more than story. But any screenwriter worth his salt (or born of the UCLA MFA screenwriting program) agrees with Aristotle. As he says in the quote at the top of this chapter, you can have drama without other elements, but never without story.

Stubbornly disagree? Then play this game in your mind where you swap out one character for another in a popular movie. Does it remain the same movie, more or less?

You replace Dorothy with Scarlett O'Hara in *The Wizard of Oz*, keeping the story the same, and it's still essentially *The Wizard of Oz*, maybe with a few more histrionics here and there.

But now do the same with swapping out the story. If you take Dorothy and put her in the events of *Gone With the Wind*, it is certainly no longer *The Wizard of Oz*, even though you've kept the protagonist the same.

See the difference? If you can change the protagonist without altering the movie all that much, yet you can't change the story without eradicating it completely, obviously the story is what is defining the movie.

Story comes first. AGP #2.

So now that we know story is king, the first steps in creating a good screenplay the Aristotelian way is to construct and develop that story. And lucky for us, Aristotle tells us just how to go about doing that.

Ideas

Liar, Liar, Pants on Fire

"The poet and the historian differ not by writing in verse or in prose. . . . The true difference is that one relates what HAS happened, the other what MAY happen . . . what is POSSIBLE, according to the law of probability and necessity. Poetry, therefore, is a more philosophical and a higher thing than history."

(*Poetics, Part IX*)

The very first step of writing a good screenplay is to come up with a good movie PREMISE.

From that premise, you will develop a story, expand it to the specific incidents needed to tell that story, determine the proper order of those events, and finally, transform those events into words on a page. We will be getting into *all* those steps and what Aristotle has to say about them when appropriate, but for now, let's start with that simple, basic element that starts the whole ball rolling.

Think of the PREMISE as the central *idea* of the story, the answer to the question, "hey, what's this movie about anyway?" distilled down to its essence.

That idea might spring from something that's happened to you, something that's happened to someone you know. Something you've read or seen or overheard or dreamt about. But once that inspiration has struck, how do you know if it is an idea worth telling, if it can go the distance? If it is a good idea for a *story*?

Fortunately, Aristotle has some very keen insights into what makes for a good premise, starting with the quotation that begins this chapter.

Again, he uses the term poetry here to stand in for drama, for narrative, and for our purposes, screenwriting. But what's more important than him asserting that dramatic writing is of a higher order than historical writing, is his acknowledgement that the writing of a drama is *different* than the chronicling of history.

Because movies are NOT LIFE.

Sounds obvious enough. But you'd be surprised by how many of my students think that if they can simply retell some interesting event that actually occurred in their real lives, exactly as it happened, more or less, that it will make for an equally compelling movie.

It won't.

Because in case you missed it two paragraphs above, movies are NOT LIFE. Though through *mimesis*, the best ones illuminate something interesting and universal *about* life.

My first instructor at UCLA, the esteemed screenwriting guru Lew Hunter, used to start each new quarter telling the story of the Golden Buddha (a tale he credited to Hollywood studio chief Sid Sheinberg). I'd be remiss not to pay homage to it here, though I'll paraphrase:

> *Once upon a time, a Wanderer came upon a copse of trees at the foot of a mountain. He thought to himself, "Hmm, this would be a lovely spot to build a shrine to the Buddha so that other wanderers might stop and contemplate and meditate and find their inner peace." So he set about building his shrine. Unfortunately, he had no materials to work with, just a can of gold spray paint. (Yeah, I know. Bear with me, it's been years since I heard the story, so I might not remember all the details correctly.)*
>
> *Anyway, he looked around and saw in a nearby field a herd of cattle. So he walked over to the field and gathered up as much cow "leavings" as he could carry in his arms. He brought it to the copse, molded it into a rough shape, and then proceeded to spray paint it all gold. Voila.*
>
> *From that moment on, wanderers would stop at this beautiful Golden Buddha and contemplate and meditate and find their inner peace—never realizing that underneath was nothing but bull crap.*

I remember staring at Professor Hunter on my first day at UCLA and wondering what the heck I was supposed to take away from this. That behind the screenplays we'd be creating, these box office behemoths that would join the pantheon of all the other award winners that emerged from this program, was nothing but crap? Really?

Well, in a word: *yes.* That's exactly what he was saying. But a very particular *kind* of crap.

It took me many years in the professional world to realize the profundity of this simple fact. That as artists, we must embrace the artifice of this medium, that underneath, no matter how well we dress it up and gild it, is the pure *leavings* of our own creation.

But don't take my word for it. In his *Poetics*, Aristotle sums up this reality quite eloquently himself when he refers to the art of dramatic writing as—

> *"The art of telling lies skillfully."*
> (*Poetics, Part XXIV*)

So there you have it. Screenplays are lies.

Since I began teaching, I've started every seminar by having my students reveal four facts that are unique and interesting about themselves. And I ask that ONE of those facts be a total lie. And I tell them that ideally, we shouldn't be able to tell which fact is the lie. It usually makes for some lively discussion, as well as a good chance to break the ice and get to know each other.

But more importantly, it allows a segue into the broader discussion of just what makes a good lie, or more precisely, what makes a lie *believable* (which is what makes it good). Usually the responses I get are the same. That the lie is reasonable within the context it's told, that it can't be readily disproved, that it is consistent within itself, that it is based upon truths, that it contains just the right amount of specifics, that the teller conveys it confidently as if he believes it himself.

What is interesting about these qualities that go into making a good lie is that they are the same qualities that go into making a good screenplay, and a good story in general.

As filmmakers we tell a whole mess of lies. But we tell them in order to ultimately tell what Aristotle terms a *general truth*, a truth about the human condition. It all comes down to a simple precept, the one that makes drama of a higher order than the mere recounting of history, **Aristotle's Guiding Precept #3**:

IN A GOOD STORY, *TRUTH* IS MORE IMPORTANT THAN *FACTS*.

For facts, read a medical journal or watch a slide show of your neighbor's summer vacation. Then pick this book up after you regain consciousness.

A good screenplay, on the other hand, is not slave to the PARTICULAR, the factual record of what actually happened. It's concerned with the UNIVERSAL, the truths of the human experience to which we can all relate. So a good story cannot simply be a depiction of another person's life. It must show *our* lives reflected back to us in the experiences of that other person.

And for Aristotle, a story cannot accomplish that when it is strictly bound to what HAS happened. Instead, it must dramatize what MIGHT have happened or what MAY happen—what is POSSIBLE according to the same universal laws of *probability* and *necessity* that govern all our actions and outcomes. Only then can we relate the events to what COULD happen to us.

So what matters isn't that a historical Oedipus actually experienced the events depicted in the play, but that a person with the qualities of Oedipus, given those circumstances, would probably or necessarily behave in a similar manner and then those same events would probably or necessarily result.

In this way, we in the audience can see *ourselves*, not just Oedipus, up on that stage. For if *we* had those qualities and encountered those circumstances, WE might behave that way, WE might have those outcomes. And it's a story's ability to put us in the shoes of its characters that makes it universal, more philosophical, and of a higher order than history. It's what allows us not only to OBSERVE, but also to PARTICIPATE in it.

Bottom line: The fact that something occurred a particular way in real life is NEVER a legitimate reason to put it in a script. I don't care what actually happened. Your audience doesn't care. The only *valid* reason for any choice you make in a story is because it makes the story BETTER, comedically, dramatically, in *any way*. In fact, in my classes I have but one rule (other than no texting while I'm saying something pithy), that the phrase "But that's the way it happened!" is barred from ever being spoken.

Moreover, not only does Aristotle say you mustn't be slave to the actual events that occurred, he also insists you aren't obligated to how things WOULD actually occur in the real world. As he puts it so elegantly:

> *"The poet should prefer probable impossibilities to improbable possibilities."*
> *(Poetics, Part XXIV)*

In other words, one must always choose what is most believable within the context of the story regardless of whether or not that's what would occur in reality.

Or to put it yet another way: MOVIES ARE NOT LIFE.

But now you have to be wondering why I (and Aristotle, for that matter) am so relentlessly beating this clearly dead horse, that screenplays are made of lies, in a chapter about PREMISE.

It's because I have NEVER taught a screenwriting class without some new writer wanting to write the equivalent of *THE HEART-BREAKING EXPERIENCE I HAD AT MY GRANDMA'S FUNERAL* or *THE ROOMMATE I HAD IN COLLEGE WHO WAS COMPLETELY NUTS*. They think that something uniquely interesting or profound has happened to them and if they can just get it down verbatim, it will make an awesome movie.

The reality is that movie will *suck* (again, loosely translating Aristotle).

No matter how well it is written or how closely the writer hews to the actual events, it will matter to no one but the writer and those who participated in that history. It will have no resonance *beyond* the particulars, since it is just concerned with recounting the facts, not getting at the universal truths that transcend those facts.

Of course, as Aristotle concedes, you may *use* history in a story, since things that *have* happened are certainly probable. You can even use proper names, by which Aristotle means historical figures. But these things don't have the same value to a screenwriter as to a historian. The historian is interested merely in the details of what happened. The screenwriter is interested in how those events are relevant, not just to the people to whom they happened, but to EVERYONE experiencing the story.

Have I hit you over the head enough with this point? Movie stories are invention. Lies. Make believe.

BUT HOLD ON THERE FOR A SECOND.

Before you go pulling some fanciful premise out of the nether regions of your psyche, be warned that the *opposite* of this maxim is just as true.

For every *wacky roommate* story, I'm faced with students who think they have a stellar script idea on the order of the next great epic fantasy sci-fi gangster kung fu shoot-em-up extravaganza.

That script will invariably *suck* too.

That's because, on the opposite end of the spectrum from *THE HEART-BREAKING EXPERIENCE I HAD AT MY GRANDMA'S FUNERAL*, the *FLYING HOBBITS OF NINJA ALLEY* has absolutely *nothing* of the writer's life in it. It is complete pretense, with no universal truths possible.

A movie premise based upon pure fiction, or worse, upon other movie premises, is just a snake swallowing its tail. A mere shadow of a reflection of a copy, to crib from Plato's Allegory of the Cave, far too removed from life to accurately reflect anything of it.

If we are looking for LIES to tell a GENERAL TRUTH then we must find a balance, a sweet spot between reality and artifice that allows truth to be spun from fiction, the universal from the particular.

I'm reminded of that movie written by that guy who grew up in Modesto, California, with dreams of becoming a racecar driver while all his friends spent their dead-end lives simply cruising around the Malt Shop. His dad, of course, wanted him to join him as an office supply salesman and never quite understood his son's wanderlust, his need to lead a more exciting and purposeful life, leading to increasing conflict between them. As a student at USC film school, this writer actually got to WRITE about that experience growing up, to get at the truth of his tumultuous adolescent experience. What do you think he called this deeply personal work?

If you answered *Star Wars*, gold star to you.

Or take the case of another young filmmaker who wanted to make a movie about HIS experience growing up. Living in the sun-drenched suburbia of Burbank, California, with its perfectly manicured lawns and soul-sapping nine-to-five jobs, his dreams of being an artist made him feel like an outsider, disconnected from the other kids in the neighborhood. He found it difficult to communicate with them, and as a result, couldn't maintain any friendships. As he later put it, he had "the feeling people just got this urge to want to leave me alone for some reason, I don't know exactly why." So what was the name of the story he wrote, and commissioned screenwriter Caroline Thompson to adapt, to dramatize THAT true-to-life experience? The story of an artificial boy, unfinished, with intimidating blades where his hands ought to be.

Yes, Tim Burton's story about the truth of his adolescence is *Edward Scissorhands*.

The point is, these filmmakers made very personal films about their experiences, their lives, their hopes and dreams and fears. And they did it by taking their *real* feelings and concerns, and placing them within a *fiction*. By doing so, they made those experiences universal, by dwelling not on the facts of their adolescence, but on the truth of it.

In short, what makes a successful screenplay idea is a proper proportion of CREATIVE INVENTION and PERSONAL TRUTH. That balance allows an audience to laugh and cry and scream, and say, ah, that is *my* experience up there on the screen. And as we've seen, *that* is our ultimate goal.

The personal truth makes it real, authentic, and believable. But the creative invention makes it universal, relatable, and accessible.

And THAT is what gives us our Golden Buddha.

So while screenplays may contain lies, the spark that creates them MUST be a truth. A truth about YOU, the storyteller.

They say, "Write what you know." And that admonition is crucial to a good starting point. But what you know isn't merely your own experiences. It's your passions and interests. Your fears and obsessions. What you dream about. What repulses or consumes you. But above all, the idea must be predicated on something that you *care* deeply about. Otherwise, why waste your time?

Base your story upon something that is personal, or else you will never have the necessary investment in it to devote the blood, sweat, tears, and *time* that will be required to see it through to the end.

That's why the question you face when first formulating your story premise is *never* "what will they want to read?" but instead, "what do I *need* to say?" The only way to remain passionate about a story through the years of rewrites and development and production is simply for it to *matter* to you, for you to actually have a personal STAKE in it (beyond the anticipation of gobs of cash).

That then is the most basic and essential quality of a solid movie premise: If a screenplay is made of lies to get to general truths, then its foundation must be a truth about YOU that has been transplanted into a fiction, allowing it, through *your* experience, to relate a *universal* one.

Still, the question remains: How do we know if that idea will make a good *movie*?

To answer that, we need to discuss the various qualities that Aristotle says are crucial for one.

So let's do that.

ASSIGNMENT #1: LIES AND THE PERSONAL TRUTH

1. Write down FOUR interesting, unique FACTS about yourself. ONE of them must be a complete and total lie, but a good lie, one that would be hard to detect from the truths.
2. Then write a short one-page story about a fictional character that incorporates both that lie and one of your true facts. Think about the differences between facts and lies, and how both can be used in service of the truth.

Conflict

People Who Write Should Throw Stones

"Let us then determine what are the circumstances which strike us as terrible or pitiful."

(*Poetics, Part XIV*)

In the last chapter, we discussed how Aristotle thought drama to be of a higher order than history because the universal truths of the human experience could best be related through fiction. Thus an essential component of a sound story premise for a screenplay is that it be based upon a personal truth that has been filtered through one's imagination.

The next vital component of a good story premise comes directly from Aristotle's definition of drama. Remember, he says a good one affects through *pity* and *fear* the "proper purgation" of these emotions.

And what creates pity and fear, or at least the *potential* for these strong emotional responses? According to Aristotle, it is the essential story element of SUFFERING.

Professor Richard Walter, a renowned screenwriting guru and colleague at UCLA, is fond of saying "No one wants to see a story about the Village of the Happy People!" And that pretty much gets to the heart of why we go to the movies.

We want to see our lives reflected back to us, and life is a STRUGGLE, one full of difficulty and pain. We want to *see* that struggle on screen, and hopefully be left with a sense that our own difficulties can either be overcome or provide us with some kind of wisdom or meaning. And if not, that at the very least, we aren't alone in dealing with them.

It is that struggle that is the lifeblood of a good story.

In fact, your primary function as a writer is to punish, test, and challenge your characters at every turn. For it is those challenges that reveal your characters and enable them to grow, that engage your audience by investing them

in the character's journey, allowing them to see their own lives reflected back to them, and ultimately, to be moved when those challenges get resolved . . . or don't.

Simply put, no distress, no success.

So that is **Aristotle's Guiding Precept #4:**

A GOOD STORY IS INFUSED FROM START TO FINISH WITH CONFLICT.

That need for conflict is vital whether you are writing a tragedy or a comedy. Michael Corleone wants nothing to do with his family business, but after a gangland war decimates their ranks, it falls upon him to take control. Phil Connors wants nothing more than to get out of Punxsutawney, PA, but finds himself stuck there, having to repeat the same day over and over again.

Oedipus wants to escape the oracle's prophecy, but his impetuous actions only serve to bring it about. Hamlet wants revenge on his uncle, but he's filled with doubt and inertia. Elliot wants to help E.T. get home, but government agents are trying to capture him. Alvy wants Annie, but his neuroses keep getting in the way. Luke wants to rescue Princess Leia, but she's a prisoner on the heavily fortified Death Star. Joe and Jerry want to escape the mob, but their band is playing at the same hotel in which the killers are staying AND their cross-dressing disguises are in danger of exposure since Joe can't control his lust for Sugar.

And on and on and on.

These are all prime examples of conflict. Sometimes it is internal, arising from qualities or deficits within the character. Sometimes it is external, coming from others, from nature, from the supernatural, from technology, from society itself.

But hopefully, in all the above examples you've started to notice a pattern. Look again, do you see it? In describing the conflict at the heart of each of these classic stories, what words keep being repeated?

WANT and BUT.

The repetition of those words is no coincidence, but is revealing of an essential pattern. Namely, that the central conflicts in these stories are of a very particular nature. In each example above, indeed in *every* example from *every* good story, movie, play, novel, etc., the conflict that infuses the premise arises from this simple truth: Someone WANTS something BUT obstacles stand in their way of getting it.

After all, is there any greater suffering than desperately desiring something that you simply cannot have?

This truth will become crucial to our process of developing a PLOT, but for now, take its central tenet to heart. Find a premise that is rife with conflict, that takes your hero out of any kind of comfort zone, that makes him a stranger in a strange land, a fish out of water, stuck in a situation in which he doesn't know the rules to *survive*, let alone *thrive*.

 The paradigm is simple: You toss him overboard, and then you lob coco-nuts at him.

 And when he's had enough, you pull him back in, soaked and bruised, but hopefully better for the experience.

 Which conveniently brings us to Aristotle's next imperative for a good story idea.

EIGHT

Wholeness

We Need Some Closure

"Tragedy is an imitation of an action that is complete, and whole, and of certain magnitude. . . . A whole is that which has a BEGINNING, a MIDDLE, and END. . . . A well constructed plot, therefore, must neither begin nor end at haphazard, but conform to these principles."
(Poetics, Part VII)

The above definition may seem so self-evident as to be verging on goofy. Seriously, does anyone *not* know that a story has a beginning, middle, and end? But stop snickering. You can begin or end a tale at any of an infinite number of points. Knowing where those points *are* is what defines your story and what often makes the difference between a good one and a bad one.

For Aristotle, a well-told story must start at a specific moment, the moment where nothing vital comes before it. This event sets the story into motion and eventually leads to some kind of resolution, after which nothing more need be said.

Aristotle's description of what makes a story whole and complete will later form the basis of our understanding of sound story structure. But for now, it is also essential to developing a movie idea since a sound premise must imply a story that begins at a clear, non-arbitrary place, and ends at a similarly specific, defined moment. And EVERYTHING that happens in between, leads from that first event to the last.

Which brings us to **Aristotle's Guiding Precept #5:**

A GOOD STORY HAS CLOSURE, WITH A CLEAR BEGINNING, MIDDLE, AND END.

The story of *E.T.* begins when Elliot finds a stranded alien. It ends when he's returned him home (hopefully, no spoilers here). *Little Miss Sunshine* begins when Olive is invited to the pageant, and ends after she's finally

33

gotten to compete. *Star Wars* begins when Luke finds the Death Star's schematics and ends when he's blown it up.

And in all these examples, everything that happens between those two events gets us from one to the other. That is what we mean by CLOSURE, that the story is bound by episodes on either end that are connected by everything in between.

This might seem ridiculously obvious, but you'd be surprised by how many students of mine present story ideas that are amorphous, intangible, and abstract. "The horrors of war" is *not* a story premise. Neither is "World War II," "camaraderie," or "a guy finds his worth through sacrifice." These may represent a kernel of an idea, a theme or avenue of thought to explore, but they won't form a basis for an actual story until they can be expressed in terms of a clear, unambiguous, and deliberate beginning, middle, and end.

A soldier is tasked with finding the one remaining son of a woman who's lost her other three sons in battle. He searches for him. He finds him or he doesn't.

Beginning, middle and end.

That's *Saving Private Ryan*. And that's the essential pattern of every solid movie premise. Remember, throw him overboard, lob coconuts at him, pull him back in.

But for Aristotle, it's not enough that a premise has closure. It's also essential to have an appropriate distance between those bounding episodes. And it is Aristotle's discussion of a story's MAGNITUDE that provides us with the final component of a good movie premise.

Magnitude

It All Boils Down to One Thing

"A very small animal organism cannot be beautiful; for the view of it is confused, the object being seen in an almost imperceptible moment of time. Nor, again, can one of vast size be beautiful; for as the eye cannot take it all in at once, the unity and sense of the whole is lost for the spectator."
(Poetics, Part VII)

So what exactly does Aristotle mean by "a certain magnitude?" We know that a good story must be bound by a clear start and finish. Now we need to figure out how to ensure it has the proper length in between, that it covers the proper ground, neither too sprawling nor too narrow in focus or duration.

As the above quote indicates, Aristotle thinks that things too small aren't beautiful because we can't really see them. Things that are too big aren't beautiful since we can't really grasp them. As usual, it's all about balance, moderation, finding a middle ground.

Are you noticing a recurring theme here?

Consider the difference in magnitude between these two story premises: THE STORY OF BOB LOOKING FOR HIS LOST PENCIL and THE STORY OF BOB'S LIFE. One is too limited; one is too expansive. Somewhere in between is a story, as Goldilocks says, that is just right. We want a beginning, middle, and end that can be expressed in a story that is of a suitable length.

So what constitutes a suitable length for a dramatic narrative?

At first, Aristotle says:

> *"It should be such as can be readily held in memory."*
> (Poetics, Part VII)

That seems pretty reasonable. The proper magnitude for a story, like the proper magnitude for an animal in nature, is one that we can wrap our

heads around. It starts somewhere, a bunch of things happen, connected by necessity and probability, and then it ends. And all the while, WE CAN FOLLOW IT.

But even more importantly, Aristotle goes on to say:

> *"The structural union of the parts must be such that, if any one of them is displaced or removed, the whole will be disjointed and disturbed."*
> (Poetics, Part VIII)

In other words, if you can remove any part of the story without the whole thing crashing down, you remove it since it doesn't belong in the first place. It is not part of the whole.

So for Aristotle, what gives a story its proper magnitude is that it is made up ONLY of those events essential to tell the story, to get from that beginning to that ending, no more and no less. Nothing tangential, nothing unnecessary, nothing that can be missing without being missed.

But how do we know if any given event is NECESSARY in a particular story?

Well, because it adheres to the most essential element of a good movie premise, the one expressed at the very beginning of Aristotle's definition of drama when he calls it AN IMITIATION OF AN ACTION.

Let's look again at that definition. We've already discussed the importance of IMITATION and of ACTION. We want *mimesis*, a representation of life. And we want the drama to center, not on a character or time or place or theme or philosophy, but on a *doing*.

So what's the other important word in that central concept? The one so significant he uses it twice.

Yes, I am talking about that little two-letter article.

AN.

And why is that significant? Because a good story isn't just based on an ACTION, it is based on AN action.

As Aristotle says, expanding his definition of the ideal premise:

> *"It should have for its subject a SINGLE action, whole and complete."*
> (Poetics, Part XXIII)

Single. One. Uno.

A good story isn't about a smorgasbord of things, no matter how delicious they all may be. It is about ONE thing.

And that *one* thing is NOT the protagonist, as we've said. On the contrary, Aristotle makes the point that a person contains infinite aspects, and their life consists of countless incidents between which there are no necessary or probable connections. So unity of plot cannot come from unity of the hero.

No, unity of plot comes only from unity of the *action*. So the question arises, just what kinds of things might that one specific, singular action be?

What the heck are we even talking about when we talk about an ACTION in the first place?

Aristotle is great with theory, but he's also a pro at backing it up with specifics from the narratives of his time. So let's take a page from his book for ours and do the same.

Take a look back at the premises described in the previous chapter on conflict. Remember what they had in common?

Oedipus wants to escape the oracle's prophecy. Hamlet wants revenge on his uncle. Elliot wants to help E.T. get home. Luke wants to rescue Princess Leia. Alvy wants Annie. Joe and Jerry want to escape the mobsters.

Recall the pattern? Duh, of course you do.

The hero WANTS something. Something specific. Something *singular*. Escape. Revenge. Home.

And *that* is what gives a story unity, what makes it about ONE action.

And it's **Aristotle's Guiding Precept #6**:

A GOOD STORY HAS A UNITY OF ACTION, ONE DEFINED BY A HERO'S OBJECTIVE.

What the hero wants to acquire or achieve or reach or prevent, is what gives a good story its *unity of action* since the story's unified action is quite simply the PURSUIT of that objective. That pursuit connects everything that happens in your story. It *defines* it.

The hero's OBJECTIVE is in fact what gives a story its beginning, middle, and end. After all, the story begins when the hero acquires that want. The middle consists of his pursuit of it. And the ending occurs when he either succeeds or fails at getting it.

Hamlet starts when the ghost of the Prince's dad urges him to vengeance against the King. Hamlet wrestles with that task throughout the middle, and at the end, he succeeds, but with tragic results.

In *Chinatown*, Jake is hired to solve a case, he works the clues, and in the end, discovers the truth.

In *Annie Hall*, Alvy Singer meets Annie, sets out to woo her, and eventually wins her heart or loses it.

Saving Private Ryan starts when Captain Miller is tasked with finding Ryan. Complications arise as he pursues that goal and meets up with a myriad of obstacles. And it ends when he either succeeds or fails at that mission.

And to bring this whole conversation back to where we started, a discussion of *magnitude*, you can see that it's the hero's OBJECTIVE that defines a story's proper magnitude since it should be made up of only the events necessary to depict the pursuit of it.

So if you're keeping score, a hero's objective gives a story a UNITY OF ACTION. A hero's objective defines the story's PROPER MAGNITUDE. And a hero's objective gives a story its BEGINNING, MIDDLE, and END. And if we throw in obstacles to prevent our hero from obtaining that objective, it also provides us with CONFLICT.

It's impossible to overstate the importance of this simple truth. Essential to *any* good story, and therefore to any good premise for that story, is the Aristotelian principle that your hero WANTS something. Something specific. Something tangible—

—a DRAMATIZABLE OBJECTIVE (or DO).

We make that distinction, adding the qualifier *dramatizable* because the objective is NOT an abstract idea. A character doesn't want *love*; she wants ROMEO. He's not pursuing *answers*; he's after the MALTESE FALCON. They're not searching for *glory*; they're searching for PRINCESS LEIA.

A more abstract goal may enter our story on a thematic level, but as we shall see, for a solid story, the hero's objective is something concrete—something that, at any given moment, we can track how close or how far they are to accomplishing it.

So at the core of any good story premise is a simple dramatic question: Will the hero fail or succeed at achieving that objective?

Therefore another way to view the wholeness, completeness, and proper magnitude that Aristotle deems essential, is that at the beginning of a good story, a dramatic question is posed. In the middle, it is discussed and debated. And at the end, it gets answered.

In the case of *Saving Private Ryan*, that dramatic question is "Will Captain Miller find Private Ryan before it's too late?" In E.T., it's "Will E.T. get home?" Will Luke rescue the princess? Will Joe and Jerry escape the mob? Will Andy Dufresne gain his freedom? Will they find the treasure, win the battle, make partner, commit the crime, thwart the crime, *solve* the crime?

By thinking of a solid movie premise in terms of that specific, singular dramatic question, you define the central, unified action being imitated.

All well and good, you say. But if Aristotle says a story should only be about *one* thing, the dramatic question that's posed by the hero's dramatizable objective, that doesn't leave a lot of room for anything else. What about SUBPLOTS or stories with multiple storylines? Is Aristotle saying we have to avoid them?

You raise a good point. And thankfully, Aristotle addresses this very issue while reaffirming the imperative of the Unity of Action.

He describes how Homer, in composing his masterpiece *The Odyssey*, did not include each and every adventure related to Odysseus—

> *"such as the wound on Parnassus, or his feigned madness at the mustering of the host—incidents between which there was no necessary or probable connection."*
> (Poetics, Part VIII)

Homer didn't leave out these events due to lack of space, but because they had no bearing on the central dramatic question that defines his story. Remember, that story isn't about Odysseus, but about his specific, singular dramatizable objective—TO GET HOME.

Even so, Homer does *not* spend the entire story simply chronicling that voyage. On the contrary, he sets a sizeable chunk of it back in Ithaca, where

Odysseus' wife and son are dealing with villainous interlopers hell-bent on stealing their riches.

Those incidents could constitute a completely different story, one in which our hero isn't even present, let alone involved. So doesn't their inclusion violate the principle of Unity of Action?

Of course not. The subplot of Penelope, Telemachus, and those dastardly suitors is not tangential to Odysseus' quest, but an integral part of it, providing motivation, urgency, and ultimately, the requisite climactic showdown.

Similarly, the central dramatic question of *King Lear* may revolve around Lear and the tragic results of trusting the wrong progeny. But equally compelling is the subplot of the Duke of Gloucester and his two sons, incidents that may be separate from the central storyline, but that provide vital commentary on it, and ultimately intersect with it in dramatic ways.

And finally, look at the primary subplot of *Silence of the Lambs*, Hannibal Lecter and his objective to escape custody. To some, his *is* the central storyline, as in many ways it is the most memorable. But no, the dramatic question at the heart of the film concerns Clarice Starling and whether she can stop Buffalo Bill before he kills again. *Her* story provides the movie's Unity of Action, but Hannibal's story remains an integral part of it, as his actions directly impact her progress, whether hindering or supporting her pursuit.

The point is, for Aristotle, elements of the story may indeed chronicle actions distinct from that of the central character, as long as those actions maintain some *probable* or *necessary* connection to the hero's pursuit of their dramatizable objective, either running parallel and thus serving as commentary, or intersecting with it and thereby directly affecting it.

In that way, far from violating Aristotle's principle, these secondary storylines reinforce it, remaining part and parcel of that essential singular dramatic question that defines the unified action being imitated, and which in turn provides the story its necessary wholeness, completeness, and proper magnitude.

And in the next chapter, we'll put ALL these vital story principles together and see just what a solid movie premise should look like.

TEN

Loglines

Putting It All Together (Part 1)

"This is the essence of the story; the rest is episode."
(Poetics, Part XVII)

So what have we learned so far, from Aristotle, with regards to what makes an effective story idea, one that will help lead us to a solid screenplay?

We've learned that a solid idea must strike a balance between personal truth and imagination, must be based upon an action that has a clear beginning, middle, and end. Must be rife with conflict. And must have at its heart, a unity of action, a dramatic question that is based upon a hero's dramatizable objective, one posed at the beginning and resolved at the end.

Distilling all of these vital qualities down to their essence, in a way that befits our modern screenwriting purposes, is what we call a LOGLINE.

And a LOGLINE is where every good screenplay starts.

To be clear, a logline is not a tag for a poster. It's not about a thematic or abstract idea. It's not a marketing tool, as in "In space, no one can hear you scream." That was a great TAGLINE for *Alien* that may have gotten us excited about buying a ticket, but it doesn't tell us anything about the story.

Rather, since story is what matters most, and story is based on an imitation of an action, we must think of a logline as a way to focus a story down to its barest essentials, down to that singular action that defines the complete, whole, unified story.

> The crew of the spaceship Nostromo accidentally brings on board a deadly alien life form that begins to pick off the crew one by one, until only one, science officer Ripley, remains, and the fate of humanity rests on who makes it back to Earth first.

What is the dramatic question here? Will the humans defeat the alien in time? What is the beginning, middle, and end? An alien comes aboard. A

bunch of people die. The alien is defeated (or isn't. No spoilers.). Is there conflict? Hell yes. A unity of action? Yep. And does it deal with universal truths though fiction? I'll say, not because we've all been stranded in space with an acid-bleeding monster, but because we all know what it is to be afraid, to be helpless, to find inner reserves of strength and determination we didn't know existed.

So, it makes a good idea for a story. And a great movie by the way.

Try these other loglines/ideas on for size. While you do, think about how they demonstrate the critical elements of universality, conflict, wholeness, and unity.

> While attempting to thwart a tragic prophecy, the King of Thebes tries to discover who's responsible for the plague upon his land, unaware he's brought it on himself.
>
> After being visited by the ghost of his dead father, the Prince of Denmark sets out to get revenge on his murderous uncle, now the king, but is beset by doubt and hesitancy.
>
> Michael Dorsey, an unemployed actor with a reputation for being difficult, disguises himself as a woman, Dorothy Michaels, in order to land a role on a soap opera, but complications arise when he falls for his leading lady and her father falls for him.
>
> Allen Bauer falls in love with the woman of his dreams, unaware that she is in actuality, a mermaid.
>
> Private Eye Jack Gittes is tasked with a simple case of adultery, but stumbles onto a vast criminal conspiracy to control the Los Angeles water supply.
>
> A young boy, Elliot, discovers a stranded alien in his backyard, and enlists the help of his friends and family to help the creature return home before government forces capture him.
>
> Rick Blaine, an apolitical nightclub owner in Morocco, has his world turned upside down when his lost love, Ilsa, returns and asks him to help her husband escape the Nazis.
>
> Marion Crane, having just embezzled a small fortune from her employer, hides out at the Bates Motel, unaware that its proprietor is a psychopathic serial killer.
>
> Father Karras, a priest who has lost his faith, is tasked with determining if a 12-year-old girl is actually possessed by the devil.
>
> Dorothy, forever wishing for adventure "somewhere over the rainbow," rides a twister all the way to the magical land of Oz, where her only hope of returning home to Kansas is to steal a Wicked Witch's broomstick with the help of some unlikely allies.

Did you notice any patterns here?

First, these loglines are not dissimilar from what you might find in your cable guide, simple descriptions of the STORY IDEA.

They include a protagonist, a dramatic premise, and any other relevant dramatic circumstances that are essential to understanding the basic story.

And they all answer, implicitly or explicitly, the following three questions:

WHOSE STORY IS IT?
WHAT DO THEY WANT?
WHAT IS STANDING IN THEIR WAY?

The answers to these essential questions provide the premise of any good movie since they describe the elements necessary for a story that's based upon an imitation of an action, that has a unity arising from a singular objective, that is told through conflict, and that contains a clear beginning, middle, and end.

And as we can see, these answers can be encapsulated into one or two sentences.

That is a logline. And crafting one is the first step in developing a screenplay.

ASSIGNMENT #2: PREMISE

Write TEN loglines. Five from movies you've seen. Five from ideas you make up yourself. The trick is to be specific without too much detail. Give a sense of a dramatic question; of a beginning, middle, and end; and of whose story it is, what they want, and what's keeping them from getting it.

Congratulations, you are now on your way to writing a successful screenplay, the Aristotelian way. Now let's begin turning that premise into an actual story.

A MIDDLE

(Wherein we discuss PLOT, STRUCTURE, and CHARACTER, and flesh out the shape of our STORY)

ELEVEN

Plot

Let's Stay Connected

"Of all plots and actions, the episodic are the worst. I call a plot 'episodic' in which the episodes or acts succeed one another without probable or necessary sequence."

(Poetics, Part IX)

I'm often faced with students who are terrified of discussing their story ideas in class. They've heard horror stories about writers being ripped off, brilliant ideas getting stolen.

To them, I tell the same story that was told to me by screenwriting guru Professor Richard Walter to put my own mind at ease. Paraphrased and adjusted for inflation.

The painting *The Card Players* by Paul Cezanne recently sold to the nation of Qatar for close to 300 million dollars. Pretty impressive. But just imagine that back in the 19th century, when Cezanne was toiling away, some kibitzer had come up to him and said, "*Hey, Paulie, I got a great idea for a painting. Poker!*"

Now, just imagine that same gentleman showing up today and demanding his cut of those millions since it had, after all, been his idea.

Such a thing would be ludicrous, of course. Why? Because the idea was relatively insignificant. It may have started the endeavor, may have sparked the artist's imagination, but what truly mattered was the *execution* of that idea, the choices of color and brushstroke, the actual labor that went into making that idea a reality.

And just as with Cezanne, the screenwriter gives value to that initial idea by crafting it into something tangible. The idea may be the genesis for all that follows, but ultimately, it's a trivial part of the process. What matters is how that idea is expanded into a PLOT, the choice and arrangement of events necessary to execute that idea.

So in our analogy, think of the episodes of the story as the painting's colors and brushstrokes, and their order, its shape and form.

Still another concern that often arises in class is when a student responds to another's premise by saying, "Aw, I've seen that idea already." To that I always respond, *of course you have.* I'm beginning to doubt there even IS such a thing as an original idea that hasn't been done countless times before.

Thankfully, it doesn't matter in the slightest.

There may be thousands of paintings of roses, but only one that looks like Salvador Dali's.

Similarly, no matter how many times a particular premise has been executed before, yours will be distinct because it comes from your unique passion and experience and voice. It's not ultimately about *what* you write, but *how* you write it. Because again, it is the PLOT that you spin from that initial idea, the choices and details of the actual labor of writing, that matter.

And if you still don't believe me, take the case of that movie that I love—yikes, what is the title of it—about the farmer who becomes a warrior. Damn, it's on the tip of my tongue. Oh yeah, *Braveheart*!

No, wait, not *Braveheart*, but . . . come on, you know the one. He's working on the farm at the beginning, living with his family. And then they are all cruelly wiped out, and he has to take up arms against the government for a greater cause. Oh yeah, *Gladiator*!

No, wait, *The Patriot*.

No, no, I'm thinking of *The Outlaw Josie Wales*.

No, I got it. It's *Star Wars*.

My point? All those movies have the same basic premise: A simple farmer loses his family to violence, seeks revenge, then ultimately emerges as a leader, hero of a rebellion, warrior for a greater cause.

Yet no one is going to mistake one of these movies for the other. They are all completely different, despite the similarities in premise, since again, what matters is the *execution* of the idea, not the idea itself.

Because when you really think about it, all stories are built upon the same basic premise. As we shall see shortly, ALL STORIES ARE ABOUT IDENTITY. Or more specifically, they are all about a character who starts off one way, then ends up another. The King who becomes a blind exile. The moisture farmer who becomes a Jedi. The construction worker who becomes the savior of his Lego brethren.

It is *how* we tell that story that makes our screenplay unique.

And the how of our story is its PLOT.

So what does Aristotle have to say about plot?

Well, he starts off by distinguishing between three different types of plot. The EPISODIC, the SIMPLE, and the COMPLEX.

Let's deal with, then hopefully banish forever, the first type.

As the quote at the top of the chapter indicates, a plot is EPISODIC if its events are not connected, but simply consecutive. *This* happens and then *this* happens and then *this* happens. One event does not cause or affect the next; they merely follow a chronology with no other connective thread.

It's a horrible plot since it really is no plot at all, just a collection of individual episodes, a slideshow of your neighbor's summer vacation. Here's where he went parasailing. Here's where a jellyfish stung him. Here's where he met a cute girl at the bar. Each episode might be entertaining in and of itself, but without a dramatic through-line connecting them, they don't add up to a coherent story.

Recall how we made the point earlier that movies are *not* life, that there is a difference between drama and history. Aristotle says that the former deals with the universal, the latter with the particular. But there is a fundamental *structural* difference between life and movies as well.

For Aristotle, history is made up of events that FOLLOW one another. Dramatic narrative, on the other hand, is made up of events that CAUSE one another.

This is because life is episodic, a timeline of unconnected experiences. But in a story, something of a higher order than a mere history, there must exist a cause-and-effect between all actions, and it is that connection that is essential for a good plot.

And which makes for **Aristotle's Guiding Precept #7:**

> **IN A WELL-CONSTRUCTED PLOT, EVERY EVENT IS CAUSED OR AFFECTED BY WHAT PRECEDES IT AND CAUSES OR AFFECTS WHAT FOLLOWS, ACCORDING TO THE LAWS OF NECESSITY AND PROBABILITY.**

That final clause is so vital to this precept that Aristotle stresses it repeatedly. The causal connection between incidents may be surprising, but it must always be believable and reasonable, based upon our understanding of the way the universe operates, how it functions for all of us.

So in a good plot, a non-episodic plot, something happens, and it is then followed by something that PROBABLY or NECESSARILY would ensue as a natural result. In this way, the story remains relatable, because even if the characters and events are far outside our actual lives, they still abide by the patterns, expectations, and observations of our own experience.

Remember that slideshow of your neighbor's vacation? With a few adjustments, it could become this: Trying to get over the heartache of a breakup, my neighbor went parasailing. Preoccupied with grief, he wasn't paying attention so his line got tangled and he fell into the ocean where he was stung by a jellyfish. When he went to the infirmary for his wounds, he met a cute nurse and, for the first time in months, completely forgot his ex.

In this example, each event either *causes* or *affects* the next in some way, connecting them all through CONSEQUENCE. Doesn't that make for a better, more cohesive story than the mere slideshow of disjointed events? Without that cause-and-effect, a plot is episodic. And that, according to Aristotle should be avoided at all costs.

I should note that an episodic structure is one of the most common problems I encounter with beginning writers. For their stories, they hope to merely string along a series of interesting events, often because (GULP) *that's the way it happened.*

They soon discover, as Aristotle warns, that an episodic plot is the absence of plot, just a compilation of isolated vignettes. And no matter how solid those individual moments may be, the story invariably fails to hold together because it lacks that required connectivity that pulls us through, the dramatic thread that keeps the story whole, complete, and unified.

So don't make your plot episodic. Okay? Good.

And now that we've agreed to connect the events of our story by the laws of probability and necessity, a logical question arises.

What exactly *are* these events we're connecting?

Good question. And lucky for us, Aristotle has some things to say about them and about the two flavors in which those story events most often come.

Reversals and Recognitions

Pieces of the Action

"The most powerful elements of emotional interest in Tragedy—Reversal of the Situation, and Recognition scenes—are parts of the plot."
(*Poetics*, *Part VI*)

In his discussion of the importance of PLOT over other elements of drama, Aristotle observes that what makes a plot emotionally resonant, the ultimate outcome we are always seeking, is that it is made up of two powerful ingredients, *REVERSALS* and *RECOGNITIONS*.

Let's take them one at a time, though they often come hand in hand. Aristotle says:

> *"A reversal is a change by which the action veers round to its opposite, subject always to our rules of probability or necessity."*
> (*Poetics*, *Part XI*)

In other words, a character is traveling down a certain path, something *happens*, and suddenly they find themselves on a very different path. The *something* that happened was the *REVERSAL*.

He uses Sophocles' *Oedipus Rex*, what he considers a perfect plot, as an example. Oedipus is the King of Thebes, much loved, powerful, and happy, having escaped the Oracle's dire prophecy that he would kill his father and marry his mother by fleeing his native Corinth years before.

Then in one moment, when the Shepherd arrives and confesses to having once spared the life of a Theban baby and giving it to a Corinthian to raise, the trajectory of Oedipus' life changes drastically. He becomes an outcast, shunned, exiled, bereft, and blind, a victim of the very fate he had tried to avoid.

The action "veered round to its opposite" as a result of the Shepherd's arrival. So that event constituted a reversal.

RECOGNITION, sometimes translated as *revelation*, Aristotle defines as:

> *"A change from ignorance to knowledge."*
> (*Poetics, Part XI*)

He relates this concept specifically to the recognition of a person, as in the moment when one character learns something crucial about another, or even about themselves.

In *Oedipus Rex*, after the Shepherd reveals his own actions, Oedipus RECOGNIZES the truth of King Laeus' and his wife Jocasta's identities, and once he recognizes who *they* are, he goes from ignorance to knowledge about who *he* is.

And upon the recognition that he is the cause of the plague that curses his country, the plot veers around from Oedipus trying to find Laeus' murderer to Oedipus desperately trying to punish himself, a *reversal*. In the end, a respected king has been reduced to a blind exile.

In *The Empire Strikes Back*, Luke discovers the truth of his parentage, leading him from having the upper hand to losing one, and leaving him dangling in space, the clarity of his identity, mission, and destiny now in doubt.

Marion Crane thinks she's gotten away with the perfect crime when she holes up at the Bates Motel. But one memorable shower later, she learns the truth of the hotel's owner, goes from criminal to victim, and subsequently, the plot takes a sharp and dramatic turn in a new and surprising direction.

Spats Colombo learns the truth about those hot broads Daphne and Josephine, and our story reverses from what it's become, a romantic comedy about wooing the comely Sugar Cane, back to the action comedy of two desperate men trying to avoid getting whacked.

Recognition. Reversal.

In the best stories, something new and unexpected is going to be learned by a character *or* by the audience about a character. And that revelation, in turn, will lead to a change in the direction of the plot.

But there is more to it. As Aristotle continues:

> *"Reversals and recognitions should arise from the internal structure of the plot, so that what follows should be the necessary or probable result of the preceding action."*
> (*Poetics, Part X*)

In other words, something unexpected will happen and alter the story's trajectory. But crucially, that *something* will not arise out of the blue, randomly, conveniently, but will have been built into the story from the get-go.

As Aristotle points out with Oedipus, it was HIS ACTIONS that caused this reversal, not divine intervention, not a sudden case of bad luck. It was choices the character made from the outset of the story that set into motion the chain of events that ultimately result in this dramatic turn.

Put simply, the reversal is a *surprise* for the characters and for the audience, which in retrospect, seems completely inevitable because of the laws

of probability and necessity. The plot is going along one path, something happens, and the plot takes an unexpected, but motivated, turn in another direction.

And this doesn't just occur once in a good story, but many times. Some reversals may be larger than others, often with the biggest coming at the end (which we'll discuss in the next chapter), but big or small, what is critical about these plot elements is what leads us to **Aristotle's Guiding Precept #8**:

A SOUND PLOT IS BUILT UPON MOTIVATED MOMENTS OF REVERSAL AND RECOGNITION.

Case in point: *Witness*, screenplay by Earl W. Wallace and William Kelley. If you haven't seen it, pop it in quickly, I'm about to spoil it.

An Amish boy, Samuel, witnesses a murder, leading to our hero, policeman John Book, getting the case. Looking through mug shots, the boy doesn't find the killer in the book, he sees him in a photo in a trophy case. BOOM, a moment of recognition. Samuel recognizes the killer. And going from ignorance to knowledge, WE recognize that the killer is in fact a decorated cop.

What does this recognition affect? A reversal of the plot. Prior to that moment, we had a whodunit, a mystery. The dramatic question was "Will the crime be solved?" Suddenly, the mystery is gone and the question becomes "Will the dirty cop meet justice," and Book has a whole new set of issues to deal with.

So he informs his Captain who comes up with a plan. He'll investigate, but in the meantime, Book should keep quiet about this discovery. As soon as Book leaves, the Captain picks up the phone and says essentially, "Damn, he's on to us, we have to take care of him."

BOOM. Another moment of recognition, this time just for us. The Captain is crooked too. That causes another reversal. It's no longer a police procedural but a conspiracy thriller. Will our hero expose it before they silence him forever?

This leads to a shoot-out where John is wounded. He manages to escape, but passes out as he drives. He wakes up on a farm, being tended to by members of a pastoral Amish sect, knowing he's now a hunted man and can never go back home.

So his only choice becomes to try and create a new life for himself here in this strange, beautiful, and completely alien community.

BOOM. Another reversal. We've gone from a crime story to a conspiracy story to a fugitive story to a clash of cultures story. The dramatic question now is "Can this big city cop make a whole new life for himself here on the farm?" And now THAT becomes the focus of the plot.

Note that this all began at the moment the boy witnessed a murder in the train station. That is the event that set all the rest into motion, leading surprisingly but inevitably, by the laws of probability and necessity, from a whodunit to a fish out of water story. That's a big *reversal* . . .

. . . and we are barely thirty minutes into the movie.

The point is, according to Aristotle, a sound plot is made up of causally connected events, big and small, that alter our understanding of the characters and that change the direction of the story, in addition to the connective tissue that leads from one of those events to the next.

And ultimately, all these reversals and revelations result in the same thing, the next essential ingredient of a sound plot. But to best appreciate what that is, we must first discuss the two remaining types of plot and what they share in common.

So let's do that, shall we?

THIRTEEN

Change of Fortune

Covenant of the Arc

"An action which is one and continuous in the sense above defined, I call SIMPLE, when the change of fortune takes place without Reversal of the Situation and without Recognition. A COMPLEX action is one in which the change is accompanied by such Reversal, or by Recognition, or by both."

(Poetics, Part X)

Having dispensed with the episodic, Aristotle goes on to describe the difference between the *SIMPLE* and the *COMPLEX* plot.

As his above definition indicates, they have similar characteristics, both being complete, whole, unified, and made up of causally connected events. In fact, they differ only in that the complex plot has a reversal that leads to a change of fortune, while the simple plot has a change of fortune without a reversal.

In the previous chapter we discussed the concept of reversal and how, along with revelation, it is a fundamental building block of a solid plot. So we can now devote an entire chapter to discussing why Aristotle distinguishes between plots that have a change of fortune *because* of a reversal and those that have a change of fortune *without* one.

Or we can make like Oedipus and stab out our eyes with Mommy's brooch.

Or instead, we can get right to the meat of the matter and acknowledge what is most significant in the above definition—that for Aristotle, all good plots, whether characterized as simple or complex, share this same vital component: The hero undergoes a *CHANGE OF FORTUNE*.

Hmm, where have we heard this concept before? If you've been paying attention, you'll recall I began our whole discussion of plot with the bold statement that all good stories are built upon the same basic premise of *identity*; that all heroes start out one way and end up another.

In our example of *Witness*, John Book goes from tough, loner, big city cop, solving problems with a gun to a gentle, loving man, embracing and embraced by a pacifist community, able to resolve problems peacefully. And critically, that transformation doesn't happen all at once, but gradually through the events of the story.

And that is precisely what Aristotle means by a change of fortune. Our hero, at the conclusion, is different in some fundamental way from who they were at the beginning.

Aristotle says that it could be the hero's actual fortune that changes, for good or for ill, OR it could be their *understanding* of who they are that changes. And all the connected events that occur from the beginning to the end of the story help to facilitate that transformation.

So for all the finer points of Aristotle's discussion of the various types of plot, it really all comes down to a basic truth: Simple or complex, in a good plot, our hero CHANGES.

That means, if you're keeping score, we now have two different ways to describe the progression of our story. Up until now, we've defined it by the hero's objective, posed at the beginning and resolved at the end.

Now we find that another way to track that story is that it starts with our hero being one thing and ends with him being another.

So which is it? What actually shapes and defines the plot? The hero's objective or the hero's transformation?

Some writers I know refer to these two dramatic threads, the pursuit of a dramatizable goal and the character's transformation, as the HEAD STORY and the HEART STORY. Others call them the PRIMARY STORY and the SECONDARY STORY, or even the A STORY and the B STORY.

Aristotle does not assign relative value to them in his discussion, for they are both equally *essential*. And far from being two separate approaches to plot, they are in fact, intricately connected.

For what accounts for the character's change of fortune, from good to bad or bad to good, IS the pursuit of their objective. The events of the story that the hero encounters in that pursuit are what cause him to *become* someone new or to *realize* he was someone else all along. And as befits the principle of proper magnitude, the plot is made up ONLY of the events necessary to affect that change or realization.

Which brings us to **Aristotle's Guiding Precept #9**:

THROUGH PURSUING AN OBJECTIVE, THE HERO IN A SOUND PLOT UNDERGOES A TRANSFOR-MATION.

This is what we refer to as the character's ARC. It doesn't just happen all at once. The hero doesn't wake up one day and suddenly realize he is other than he thought initially. Rather, as he is dealing with the many obstacles standing in the way of his objective, our hero is changing THROUGHOUT the story.

So Oedipus goes from king to outcast. Luke Skywalker goes from callow moisture farmer to brave Jedi Knight. Michael Corleone goes from upright college boy to the head of a criminal empire.

And as we'll soon see, tracking the specific moments that contribute to the hero's transformation, making sure they are happening in the proper order and with the proper emphasis, is what gives a story a sound *structure*.

But we'll have to wait for another chapter, one conveniently called STRUCTURE, to deal with those concerns.

In the meantime, Aristotle raises the question as to what actually makes for the *best* change, the most satisfying transformation?

And the answer to that will lead us, through some admittedly labyrinthine twists and turns, to Aristotle's general framework for the ideal plot.

So let's roll up our sleeves and get to it, shall we?

Fatal Flaw

And the Plot Thickens

"The change of fortune should be not from bad to good, but, reversely, from good to bad. It should come about as the result not of vice, but of some great error or frailty, in a character either such as we have described, or better rather than worse."

(Poetics, Part XIII)

Aristotle's discussion of plot, and the various choices a writer must make when constructing one, can seem dauntingly complex, circuitous, and downright contradictory. But trust me, once we follow his train of thought to its logical conclusion, we will discover a paradigm for plot that will prove indispensable.

So stick with me.

We'll start where we left off. In a sound plot, our hero undergoes a transformation while pursuing an objective.

But what, specifically, should be the nature of that transformation?

Aristotle says that a character can either go from good fortune to bad fortune or from bad fortune to good fortune. And characters themselves can be either good or bad.

So keeping in mind that the function of a good story is to create an emotional experience, to evoke pity and fear, pity that the character doesn't deserve their fate and fear that that fate could befall us, Aristotle weighs the merits of the various combinations.

A bad man meets good fortune? No, not fair.

A bad man meets bad fortune? There's no pity; he deserved it.

A good man meets good fortune? Nope. No pity or fear.

So that leaves the ideal outcome as: *A good person meets with bad fortune.*

But Aristotle stresses that for this to work, the hero must not be *too* good a person. Otherwise his fate would be too shocking. Instead, the hero should be intermediate between good and bad. Not outstanding in *moral*

disposition, just someone, as we shall explore in our chapters on CHARAC-TER, who is slightly better than us.

And as the quote that begins this chapter indicates, key for Aristotle is that the hero finds bad fortune not due to some moral defect or depravity, but through some "error" in judgment. In other words, something that they DO, some mistake, a misunderstanding or misstep, brings about their fate.

For example, Oedipus misjudges the old man he tussles with at the cross-roads, and that mistake is what eventually brings about his downfall.

But what is vital to note is that a hero's error is not occurring spontaneously out of the blue, but rather is a result of what Aristotle refers to as *HAMARTIA*, often translated as FATAL or TRAGIC FLAW.

In the case of Oedipus, the reason he makes that fateful error at the cross-roads is not just bad luck, but because he has the identifiable trait of being rash and impulsive. That is his fatal flaw.

So for Aristotle, a sound plot must involve an imperfect character, like us, only better, who has a flaw or defect that affects their behavior and ultimately helps bring about their change of fortune.

Notice how well this fits in with the idea that events are always connected by probability and necessity. The change in fortune is NEVER the result of some *deus ex machina*, not an act of god or coincidence or convenience. Rather, the hero's ultimate fate is a direct result of the hero's actions, and those actions are themselves determined by the hero's qualities and characteristics.

And thus, for Aristotle, that's the best plot. A decent guy meets misfortune due to his own mistake brought about by a specific character flaw.

Simple enough. So go do that.

Ah, but not so fast. Aristotle isn't done talking about the ideal plot.

Next, he discusses what he considers an alternate, though inferior, plot resolution, one he calls the DOUBLE OUTCOME. He says:

> *"In the second rank comes the kind of tragedy which some place first. Like The Odyssey, it has a double thread of plot, and also an opposite catastrophe for the good and for the bad."*
> (Poetics, Part XIII)

He argues that Odysseus' change to GOOD fortune—that he makes it home safely to his family—only works because, in the subplot, things turn out so BADLY for the suitors. The rule here then is that things may end up positively for our hero as long as they end negatively for the "worse people."

But while this plot may be begrudgingly acceptable, it is certainly not the most desirable. Because again, what works best, according to Aristotle, is for our hero to meet with some kind of misfortune.

So let's table the notion of a *double outcome* for just a moment.

Aristotle then goes on to add that, in determining the specifics of the plot, the best choices involve conflicts that occur, not between indifferent strangers, but between friends and family members.

Why do you suppose that is?

Well, on the one hand, it's familial conflict that's likely closer to the personal experience of everyone in the audience. And on the other, more SUFFERING necessarily results when those we most trust do something that harms us. Thus we get more conflict. More drama. More catharsis.

Toss all that into the mix, and we've arrived at the following components of the ideal plot: Our hero, like us, only better, has flaws. Those flaws affect his behavior while he pursues an objective. And while dealing with the difficult relationships of those closest to him, things either end badly for our hero because of that behavior, or they end well, but badly for others.

Sounds like a legitimate, albeit extremely general, framework for a sound plot.

But cool your jets, Aristotle still isn't done.

He next discusses the actual ERROR that a character might perpetrate to bring about their change in fortune, and the various ways it may occur. He says the hero can either follow through with some intended action . . . or not. AND he can either act in full knowledge or in complete ignorance of what he is doing.

Once again, he weighs the various possible combinations.

First, *the hero KNOWS exactly what he is doing and then DOESN'T go through with it.* This, according to Aristotle, is the worst combination since it is "shocking without being tragic."

Second, *the hero goes through with the action and KNOWS just what he is doing all along.* This is a little better, but still not ideal. No surprise or recognition.

Third, *a hero goes through with the deed and DOESN'T realize what he is doing until a moment of revelation AFTER the fact.* This he considers even better for, though there's "nothing to shock us," at least the "discovery produces a startling effect."

And fourth, a hero is about to do an irreparable deed through ignorance, but makes the discovery BEFORE it is done, thus avoiding it.

And how does Aristotle deem that final combination? He says:

> *"The last case is the BEST, as in Iphigenia, the sister recognizes the brother just in time."*
> (Poetics, Part XIV)

So for Aristotle, with regard to the tragic deed that brings about the hero's change of fortune, the ideal arrangement of factors occurs when a character *starts* to do something in ignorance, but then *doesn't* go through with it because they have an awareness of the truth *before* they act.

You cool with that?

You darn well better not be.

Aristotle's example of Iphigenia recognizing her brother Orestes *before* she sacrifices him sure sounds a lot like GOOD fortune, doesn't it? Crisis

averted. How in the world can *that* be the model for an ideal plot when Aristotle has already asserted the best plots have to end with the hero going from good to BAD fortune?

It's a complete contradiction, right? You can't end a story with misfortune AND have the hero realize it's coming beforehand so that he can prevent it.

Can you?

Of course you can. And reconciling this contradiction reveals what makes for the *most* satisfying plot resolution, according to Aristotle.

It is a variation of the *double outcome*, one that is both negative in one respect and positive in another. Only in this case, both outcomes exist for the *same* character.

That's because, for Aristotle, the best ending is *not* the "happy" ending where the hero accomplishes his objective. As he maintains, that ending produces neither fear nor pity, thus no *catharsis*. Yet were the hero to gain nothing but SUFFERING, Aristotle claims that would only feel "disgusting." And we certainly don't want that.

So how can we have it both ways? How can a hero meet with some kind of misfortune yet simultaneously have an awareness that avoids it?

Simple. Because in the best stories, the hero doesn't achieve his objective, the goal that's been fueling his journey and pulling us through the narrative. He fails. That's the BAD fortune.

But in its place, he achieves something far more significant. He gains wisdom, a full and honest RECOGNITION of himself. And with that recognition, comes the possibility of being healed, of becoming whole. And that's the GOOD.

Or to put it more eloquently:

In the ideal plot, the hero doesn't get what he WANTS—

—he gets what he NEEDS.

And that need is directly related to *hamartia*, his fatal flaw.

The only question is whether or not that recognition comes in time for our hero to do anything about it.

So for Aristotle there are two possible outcomes in a sound plot. The one we find in *Iphigenia*, and the one found in *Oedipus Rex*. Put in modern terms, but traceable right back to his *Poetics*, is **Aristotle's Guiding Precept #10:**

IN THE BEST PLOTS, HEROES EITHER OVERCOME THEIR FATAL FLAW OR THEIR FATAL FLAW OVER-COMES THEM.

Oedipus can't overcome his *impulsiveness*, and it brings about his downfall. Same with Hamlet and his *indecisiveness*, Seth Brundle and his *ambition*. R.P. McMurphy and his *stubborn pride*.

On the other hand, Rick Blaine is able to overcome his *cynicism* and find peace of mind. Rocky overcomes his *self-doubt* and goes the distance. Phil Connors overcomes his *selfishness* and escapes perpetual Groundhog Day. And because Orestes manages to overcome his *hubris*, he escapes sacrifice.

What each of these characters eventually recognizes, either too late or just in time, is the nature of their flaw. And whether they triumph over it or not determines their success or failure. That success or failure, in turn, determines the moral character of the story, and ultimately, provides the essential emotional catharsis.

Got it? Good.

Okay, let's recap.

Through all those promised labyrinthine twists and turns of Aristotle's analysis, we've finally arrived at this basic plot paradigm:

> *A hero, like us, only better, hindered by a primary flaw, pursues a dramatizable objective through a causally connected sequence of events that advance the story and our understanding of the character until, whether overcoming that flaw or being overcome by it, the hero undergoes a change of fortune in which he fails to achieve what he wanted, but instead gets what he needed.*

And that, my friends, is the Aristotelian model for the ideal plot.

So go and do THAT!

But as you do, keep in mind that a plot is defined by the specific EVENTS, the reversals and recognitions needed to *tell* the story, to dramatize the hero's pursuit and subsequent transformation.

So how do we start making choices about those specific events?

As we shall soon see, it is the *biggest* moments of reversal and recognition that will define the SHAPE of our plot. And for that shape to be sound, to be satisfying, to lead to the best catharsis, we need to make sure that those biggest events are happening in the proper place and in the proper order.

And luckily for us, Aristotle has quite a bit to say on that subject.

ASSIGNMENT #3: A CHANGE IN FORTUNE

For each of the Loglines from the previous assignment, identify:

a. the hero's dramatizable objective
b. the hero's primary flaw
c. how the hero changed (or what they learned) as a result of the pursuit of their dramatizable objective

Structure

The Shape of Things to Come

"As for the story, whether the poet takes it ready made or constructs it for himself, he should first sketch its general outline, and then fill in the episodes and amplify in detail."

(*Poetics, Part XVII*)

As we've seen, a good story is made up of the necessary and connected events that pose a dramatic question at the beginning and answer it at the end, that give a hero a dramatizable objective, chronicle his pursuit of it, and ultimately resolve whether or not it's achieved. And we've seen that those same necessary and connected events also help produce a hero's change of fortune, getting him from who he is at Point A to who he's become at Point Z.

The STRUCTURE of a story, plain and simple, is the *arrangement* of those necessary and connected events.

And according to Aristotle, if you examine the stories that have stood the test of time, that we venerate as worthwhile, commercially or artistically, because they successfully accomplish the important goals of storytelling, the proper placement of those events follows observable patterns.

In fact, one could argue that the most significant contribution Aristotle makes in his *Poetics*, is to detail *precisely* what the proper structure of a good story well told is.

However, before we can explore just *what* that structure looks like, we must first absorb Aristotle's advice as to *how* to go about crafting it, indeed, the very way in which one goes about constructing a screenplay.

So look again at the quote that begins this chapter and let it sink in.

Go on, I'll wait . . .

And ladies and gentlemen, there you have it once more, how to write a screenplay in one simple sentence. Don't forget to thank Aristotle when you accept your Oscar.

Actually, let's examine this admonition a little closer. And since it's so fundamental to our process, let's proceed by repeating those crucial words:

"First sketch its general outline, and then fill in the episodes and amplify in detail."
(Poetics, Part XVII)

That is exactly how one crafts a plot, by first determining its general shape, and then filling in the finer details. And be warned, this is far from the last time you'll hear this important advice.

Aristotle goes on to give examples of this process, describing first the story of *Iphigenia*:

"A young girl is about to be sacrificed but disappears mysteriously. She is transported to another country where she becomes a priestess who performs sacrifices. One day she is about to perform one on a stranger who reveals that this fate was destined since it also befell his sister. She realizes it is her brother and he's saved."
(Poetics, Part XVII)

Then he does the same with *The Odyssey*:

"A certain man is absent from home, desolate, for many years, jealously watched by Poseidon. Meanwhile, at home his estate is being squandered by his wife's suitors who plot against his son. At length, tempest-tossed, he himself arrives, attacks the suitors, and is himself preserved while he destroys them."
(Poetics, Part XVII)

Recognize what Aristotle is doing here? Yeah, he's essentially giving us LOGLINES. In just a few sentences, he's describing these two stories by giving us the plot's biggest events while leaving out the myriad of moments in between.

Notice also that he's intentionally left out the proper names. As he insists, this isn't history, it's drama, so the stories are first set out in universal terms. These events could be happening to anyone anywhere, to Iphigenia or Odysseus, or to anyone else with similar traits and experiences, even to the readers and viewers themselves.

This then, for Aristotle, is the first step of crafting the plot, determining those biggest events, the *reversals* and *revelations* that give the story its general shape. A girl's escape, her priesthood, the arrival of the stranger, the recognition of her brother, and then the resulting reunion. A man's confinement, the suitors' scheme, the voyage home, the confrontation, and the final outcome.

Once these big moments are established, all that's left is to fill in the smaller events in between. Or as Aristotle puts it:

"After this, the names being once given, it remains to fill in the episodes."
(Poetics, Part XVII)

And guess what. That is exactly how we craft the plot of our screenplay. So it is **Aristotle's Guiding Precept #11:**

THE PROPER WAY TO CONSTRUCT A PLOT IS TO GO FROM THE GENERAL TO THE SPECIFIC, STARTING FROM THE BIGGEST MOMENTS OF REVERSAL AND RECOGNITION AND THEN FILLING IN THE EVENTS THAT CONNECT THEM.

If you learn one thing from this book, it's that when we're writing a screenplay, we don't start typing at page one and then write straight through until we get to the end.

Instead, we start with the general shape, with the biggest events that define that shape. Then we fill in the smaller events that bridge them. Then the even smaller ones between those. Until we've mapped out the entire plot, moment by moment. Only then do we start writing the actual pages, translating each of those moments, big and small, into scenes of dialogue and description.

In other words, the process of classical storytelling that Aristotle laid out in his *Poetics* 2,500 years ago still remains our process when crafting a modern screenplay today. We start with the general outline, fill in the episodes, then amplify in detail.

And now that we know where to start, mapping out the overall shape of the story, let's explore what Aristotle has to say about choosing the biggest moments that define that shape, and where, precisely, to put them.

The Three Acts

Let's Break It Down

"A beautiful object, whether it be a living organism or any whole composed of parts, must not only have an orderly arrangement of parts, but must also be of a certain magnitude; for beauty depends on magnitude and order."

(*Poetics, Part VII*)

Before we proceed, a word of caution.

Structure is *not* a formula.

Writing a good screenplay, or a good story in any medium, is *not* like constructing an IKEA® *Kejsarkrona*. It's not about plugging the right plot point into the right pre-determined slot, though students of mine are often anxious for that simple solution.

I've lost track of how many times I've been asked on what page *such and such* is supposed to happen. If it were that simple, if there were a foolproof equation, we'd all be screenwriters and we'd all be gazillionaires.

Unfortunately, there isn't. And we're not.

However, there do exist observable patterns in the stories that have stood the test of time, stories we've agreed are worthwhile from a commercial or artistic perspective. And it is these patterns that form the basis of the structure that Aristotle describes.

Still, as often as I'm pressed for the illusory (and nonexistent) formula for proper structure, I'm equally besieged by students who are resistant to these patterns. They don't want to even know about them, let alone emulate them. To these students, the very notion of an observable pattern *is* a formula, one from which they want to run screaming. THEIR story doesn't need to adhere to it, THEIR story is special, unique, and can't be pigeonholed into any traditional structure, however time-honored or universal.

Oh yeah, and THEIR story will usually *suck*.

As my esteemed UCLA colleague Paul Chitlick put it, as we commiserated about those stubborn students, "Look at all the cars in the parking lot. The Porsches. The Range Rovers. The Mini Coopers. No one's going to confuse one with another; they all look completely different. But do you notice they all have ROUND TIRES? Those round tires are what allow each of those cars to move. No reason to make them a different shape. Round tires work."

And that sums up traditional structure.

There's a reason for these observable patterns, a reason they exist from story to story and have persisted throughout the millennia, from before Aristotle first identified them, all the way to this very moment. And that reason is—they WORK.

And they work because, as Aristotle notes, there is a natural way to tell a story.

Truth is, sound structure is invisible to your audience. They don't notice it when it's functioning correctly because its rhythms and harmonies *feel* organic. But boy do they notice when it's not.

They might not be able to put their finger on what is wrong, but something feels off. And what's not working is simply that the big moments that shape the story aren't happening in the right order or in the right place or with the right emphasis.

And before you start shouting out names of movies that eschew the structure Aristotle describes, yes, some contemporary writers do indeed stray from it, and sometimes do so with effective results.

But Quentin Tarantino's *Pulp Fiction*, Christopher Nolan's *Memento*, and Barry Jenkins' *Moonlight*, just to name a few, are the rare exceptions that have found success. The vast majority of screenplays that forsake these patterns, whether by intentionally subverting them, as in the above examples, or through simple ignorance of them, invariably go the way of the countless ill-fated dramas Aristotle rebuffs, long forgotten, if they ever even saw the light of day.

Bottom line: Ignore Aristotle's observations of sound, satisfying structure at your own peril. And if you do, be darn sure you're aware of the consequences. You have been warned.

And now assuming you're not one of those aforementioned stubborn students—after all, you did pick up this book for a reason—let's stop discussing the value of this structure and start breaking down exactly what it is.

If you've been paying attention, you know we've already described traditional structure in general terms. It derives from Aristotle's definition of drama from which we began—that a good story has a *BEGINNING*, a *MIDDLE*, and an *END*.

These are the three individual components that make up the whole of the story. And as screenwriters, we've come to know them as simply ACT ONE, ACT TWO, and ACT THREE.

Sure, you can divide a story arbitrarily into the two acts of *Hamilton*, or the five acts of *Hamlet*, or the six acts of a *Law and Order* episode (with teaser and tag). But we are not talking about commercial breaks or chances to change scenery or get folks to order more Junior Mints. Those "acts"

aren't about story at all, but about the practicalities and economics of the particular medium in which the story is told.

But *most* good stories, strictly in terms of the constituent parts of their narrative, are told precisely as Aristotle describes, in three major movements.

Hmm, you say, but isn't this pattern true of any phenomena that moves through time? As we've said before, saying that something has a beginning, middle, and end seems so self-evident as to be meaningless.

Ah, but the true value of this structural paradigm derives from Aristotle's observations of the unique nature and purpose of each of those acts.

Take this story for instance:

A screwdriver walks into a bar. The bartender says, "Hey, we have a drink named after you." The screwdriver replies, "You have a drink named Murray?"

Badump bump. Like I said, don't forget to tip your servers.

Or try this story on for size:

I was preparing for my dinner party when, suddenly, the cat threw up on the rug. I tried everything to clean it up, but nothing worked. Finally, I used Karpet Klear; it cleaned the stain and the party was a huge success.

And finally, check this one out:

Investigating corrupt cops, John Book gets mortally wounded and finds himself recovering in an Amish farming community. While hiding out, he falls in love with Rachel and decides to make a life for himself there. But soon, the corrupt cops find him, leading to a final showdown where Book and his new friends use the lessons they've taught each other to prevail.

The stories I just related may have gotten more complex, but do you see the general pattern? It's there in a joke, a commercial, and a film. First we establish the circumstances of the story. Then some difficulties develop. Then things get resolved. And according to Aristotle, that is the fundamental structural pattern that exists in every good story.

Pose a dramatic question, discuss it, answer it.

Give a hero an objective, let him pursue it, reveal the outcome.

Or again: Toss a man overboard, pelt him with coconuts, drag him back in.

Accept it, embrace it, rejoice in it!

But we're just scratching the surface. Structure is all about breaking something down into smaller components to see how they function both individually and together to create the whole. So to truly understand these acts, we need to more closely examine the structure that exists within each.

So let's do that.

First, Aristotle breaks down Act One, the Beginning, into two components, the *PROLOGUE* and the *FIRST CAUSE*.

The *PROLOGUE* is not backstory, neither is it events that precede the narrative or occur outside of it. Rather, it's the initial section of any drama that establishes the characters and their everyday world *before* the actual plot kicks in.

Then once that world has been established, something that "does not itself follow anything by causal necessity" comes along to shake it up. This *FIRST CAUSE* is a sort of Big Bang since no moments prior have caused it,

and just as importantly, nothing that follows could have happened without it. It starts the chain reaction of cause and effect, of probability and necessity, which now links every subsequent event.

And it leads directly to Act Two, the Middle, which Aristotle refers to as the COMPLICATIONS.

In this section, we see the repercussions, the struggles and conflict that arise in the aftermath of that First Cause event. It forms the bulk of the narrative, depicting the journey of our hero in pursuit of his dramatizable objective, and it takes the story all the way up to the section that precedes the hero's CHANGE OF FORTUNE.

So Act Three, the END, consists of the events that extend from the start of the Change of Fortune all the way to the narrative's final resolution. Aristotle also breaks this section into two components.

First comes what he calls the UNRAVELING, the part of the story that dramatizes the consequences of all the prior complications, particularly focusing on the transformation of the hero. Following that comes the DENOUEMENT, the section that reveals the new situation that's arisen from that transformation, and which "has nothing following it."

For Aristotle, those are the big structural units of a good story well told, the components that make a plot *whole*.

So let's recap what we know about sound structure so far.

The story begins at a definitive, non-arbitrary place. And it ends at a similarly specific spot. And everything that happens in between leads from that first event to the last, from who the hero is at the start, to who they are at the finish.

It is broken into three major components: the Beginning (made up of the Prologue and the First Cause), the Middle (made up of the Complications), and the End (made up of the Unraveling and the Denouement).

And this story has a certain magnitude, consisting only of the events necessary to affect the Change of Fortune and answer the dramatic question posed by the hero's objective. Remember Aristotle's admonishment, that if you can remove any part without the whole thing crashing down, you remove it since it doesn't belong. Then what you are left with is simply what *does*.

So with ALL that in mind, let's take an even closer look at structure by continuing to break down these larger components into even smaller ones, and by identifying the key moments of reversal and revelation that help determine where each begins and ends.

And for goodness sake, let's stop with all the dang theory and generalizations and have a look at some actual movie plots, and see if we can discern the observable patterns that Aristotle describes.

SEVENTEEN

Anchor Points

A Pattern of Design

"Most important of all is the structure of the incidents."
(Poetics, Part VI)

This is where we start to get into the real nitty-gritty. So buckle your seat belts and pour yourself a tall mug of latte.

Let's start by taking a look at the following three plot descriptions. And as we do, think about the story elements that they share in common.

STAR WARS

Luke Skywalker is a moisture farmer on Tatooine, living with his aunt and uncle, and dreaming of a more exciting life. Then ONE DAY, while fixing a new droid, he discovers a Princess' distress message. This discovery leads to a series of events that culminates with Stormtroopers burning down the family farm. With nowhere else to turn, Luke teams up with Obi-Wan and they set out to deliver the Princess' stolen plans.

Luke has many adventures in that endeavor, he learns of the Force, makes friends with Han and Chewie, becomes a leader, finds the Princess, escapes a trash monster, and just when all seems to be working out, watches as his mentor Obi-Wan is cruelly cut down by the villainous Darth Vader.

Regrouping with the Rebel Alliance, Luke delivers the Death Star plans. He climbs into his X-Wing fighter and in an exciting trench battle, trusts fully in the Force for the first time, fires, and destroys the massive weapon. For his bravery, he's given a medal, feted as a hero of the galaxy.

Now try this one on for size.

```
SOME LIKE IT HOT

Joe and Jerry are Prohibition Era musicians, dreaming of
a big score that will deliver them from their hand to
mouth existence. Then ONE DAY, while preparing for a gig,
they witness a gangland execution. This leads to a series
of events that leaves the boys on the run from the mob.
Devoid of options, they put on women's clothing, join
an all-girl band, and hop a train to Miami in hopes of
escaping with their lives.

Joe and Jerry have many adventures in pursuit of that
goal; both fall for singer Sugar Cane, struggle to maintain
their female disguises, deal with randy male suitors, Joe
pretends to be millionaire Junior to seduce Sugar, and
Jerry gets engaged to wealthy Osgood. And just when all
seems to be working out, the Mobsters show up at the hotel.

Realizing they are sitting ducks, Joe and Jerry try to
hightail it out of there. A frantic chase ensues, but
before they can leave, Joe approaches Sugar and tells the
truth about himself for the first time. In the end, they
outsmart the gangsters and escape with Sugar and Osgood,
honest men for once, ready to live happily ever after.
```

And finally . . .

```
E.T.

Elliot lives in suburbia with his divorced mother and
siblings, ignored and unappreciated. Then ONE DAY, while
tossing a ball in the backyard, he discovers an alien
hiding in his woodshed. This meeting leads to a series of
events that ends with Elliot resolving to keep E.T. and
to protect him at all costs.

Pursuing that goal, Elliot and E.T. have many adventures;
they develop a psychic bond, keep one step ahead of
sinister governmental agents, build a communication
device so E.T. can "phone home," and just when all seems
to be going their way, agents invade the home, Elliot
falls deathly ill, and E.T. dies.

Grieving his lost friend, Elliot watches as E.T. comes
back to life. They steal a van and an exciting car chase
ensues, with Elliot corralling friends and family to
his cause, culminating in a moonlit flight, a tearful
farewell, and E.T.'s comrades taking him back home as he
promises his new pal "I'll be right here."
```

I can relate countless more examples, but hopefully, some recurring elements are already apparent.

First of all, notice what I'm doing here by describing the stories in this manner. Yeah, I'm doing precisely what Aristotle did back in Chapter Fifteen

with *Iphigenia* and *The Odyssey*, illustrating how the process of structuring a story begins by laying out the plot's BIGGEST reveals and reversals, the most essential moments, while leaving out the countless smaller ones in between.

And what is interesting and revealing is that those biggest moments follow a pattern, one that shows up again and again in story after story.

I like to refer to these moments as *ANCHOR POINTS*, as they are the big structural events that anchor, define, and shape the story.

Let's examine them in order.

First, as the examples show, good stories start in what Aristotle terms as *PROLOGUE*. Here we establish whose story this is, what their ordinary life is, their daily routine, their hopes, dreams, and fears.

And then along comes a *FIRST ACTION*, an unexpected event outside that normal world which disrupts it, compelling our hero to respond in some way.

And that action sets into motion a series of events, all connected causally, through the laws of probability and necessity, that lead to a big reversal that propels the hero into a completely *new circumstance* and onto the path toward a new dramatizable objective.

What I have just described, in very general terms, is the first paragraph of each of the above plot synopses. Hopefully you've recognized it as—

Act One

We call this act the *SET-UP*, since that is its narrative function, to set up the plot.

From our examples, the recurring moments in the Set-Up are the hero's ordinary world, the event that disrupts it, and the big reversal that launches the hero onto a new path with a new objective.

Aristotle refers to these Anchor Points as Prologue, First Cause, and End of the Beginning. In modern screenwriting terms, we often call them *EQUI-LIBRIUM*, *INCITING INCIDENT*, and *FIRST ACT BREAK*.

Let's look at each in more detail.

Equilibrium

This Anchor Point is not really a singular moment, but a sequence of moments. Think of it as an episodic collection of events that describes and reveals the hero's ordinary world, whether it's the world of a moisture farmer living on a desert planet and dreaming of adventure, Prohibition Era Chicago where two out-of-work musicians struggle to make ends meet, or suburban Los Angeles where a lonely boy longs to find respect.

It represents a sort of *stasis*, how the world is and how it will continue to be until the end of the hero's life, if nothing comes along to shake it up.

And then, lo and behold, something comes along to shake it up.

Inciting Incident

What mythologist Joseph Campbell terms the *Call to Adventure*, this event represents something OUTSIDE the character's normal routine that provokes a change in it. It represents the shift from prologue to story, from *sequence* to *consequence*, where we start that snowball rolling down the hill toward the eventual resolution.

Unlike the Equilibrium, it *is* an event, singular and specific. And just as Aristotle deems it the First Cause, it's caused by nothing that precedes it and is the cause of all that follows. By definition, NOTHING that happens after this moment could have happened without this event occurring.

Luke discovers Leia's message. Joe and Jerry witness the St. Valentine's Day Massacre. Elliot finds E.T.

It is the moment we feel in our gut, even if we're not the least bit conscious of it, "AH, THE STORY HAS STARTED."

Consequently, this event has repercussions as it forces the hero to make decisions, to take action. It causes Luke to leave the security of the farm to look for Ben, Joe to call up the Poliakoff Agency disguised as Josephine, and Elliot to lure the alien into his room with a trail of Reese's Pieces.

That response, in turn, causes something else to happen, which in turn causes something else to happen, and on and on, all based upon the laws of probability and necessity—

—until these events lead to the biggest event so far.

First Act Break

This event is a *big reversal*, a change in direction for the story that deposits the hero in a new circumstance, a new context, one as different from his world at equilibrium as possible. It constitutes the end of the SET-UP, the end of Aristotle's BEGINNING.

It's when Elliot, having discovered a stranded alien in his backyard, declares, "I'm keeping him," thus establishing a completely new familial order. Or when Luke, his family's farm burned to the ground, agrees to head out with Obi-Wan to aid the Rebellion. Or when Joe and Jerry, having witnessed a mob hit, dress up as women and join an all-girl band en route to Miami in order to escape repercussions.

Screenwriting guru Christopher Vogler calls this moment the *Crossing of the Threshold*, a very fitting metaphor. At UCLA, we like to call it the *POINT OF NO RETURN* because it depicts something the hero does or is done to him that prevents him from being able to simply return to the world of his equilibrium. He must now leave it behind and enter the unfamiliar world of Act Two.

But however you term it, it represents the end of the Set-Up since, as of this moment, we have provided all the information necessary to *set up* the Dramatic Question: Will our hero accomplish his new objective or not?

And structurally, what makes our story whole, complete, and unified is that the rest of it will now be concerned with answering that question. So just as the

Inciting Incident made us feel "Ah, the story has started," the First Act Break event should make us feel "AH, THIS IS WHAT THE STORY IS *ABOUT*."

That's because this Anchor Point, put simply, is the reversal that deposits the hero into the *plot* of the movie.

Think of it as a metaphorical curtain coming down to signal the end of the Set-Up. The *logline*, the encapsulation of the plot, has now been established.

And when the curtain comes back up, we'll be in that plot itself, the hero's pursuit of their dramatizable objective.

And that's exactly what is described in the second paragraph of each of our story samples, also known as—

Act Two

Now that we've tossed our hero overboard, it's time to lob those coconuts at him. Aristotle calls this act the COMPLICATIONS, and there's really no better way to put it. So screenwriters often call the Second Act—wait for it—*THE COMPLICATIONS*, since that's the act's narrative function.

If the first act is about depicting the events necessary to *give* the hero their objective, the second act is about all the obstacles, reversals, revelations, advances, set backs, subplots, alliances, betrayals, tests, and tribulations, that occur in the *pursuit* of it.

This act makes up the bulk of the story, and while it often contains several recurring elements that we'll be discussing at length in Chapter Twenty-Four, it always eventually leads to our next vital Anchor Point.

The Complications culminate in another big reversal, one that constitutes the *BEGINNING OF THE END*, as Aristotle puts it. And it, too, is a metaphorical curtain coming down on what has come before.

And since this event marks the end of Act Two, we have a clever name for it—

Second Act Break

Look closely at this Anchor Point in the stories we've been examining. Darth Vader kills Obi-Wan Kenobi. The mobsters find Joe and Jerry. E.T. dies.

Are you seeing a pattern?

Try these other Second Act Breaks on for size.

John Book is discovered by the corrupt cops. The only man that can exonerate Andy Dufresne is shot dead in the prison yard. Oedipus calls forth the Shepherd that tells him the very news he's spent his life desperate to avoid.

Seeing it now?

In all these examples, the second act ends with an event that deposits our hero *farthest* from his goal. His dramatizable objective, for all intents and purposes, becomes hopeless.

Or take a look at these variations of a Second Act Break.

In the romantic comedy *Sleepless in Seattle*, by Jeff Arch, Nora Ephron, and David S. Ward, our hero Annie simply wants to meet Sam, the owner of

the voice she once heard on the radio. That is the dramatizable objective of her more abstract goal to find true love, since she believes, as characters in romantic comedies are wont to do, that one will naturally lead to the other. At the end of Act Two, she finds herself across the street from him, her objective within her grasp. But what does she do? Upon seeing Sam's son happily embrace another woman, she's overcome with second thoughts, turns tail, and jumps on the next plane back home. In other words, just as she's about to achieve it, our hero ABANDONS her objective.

Or how about this instance? In one of my favorite comedies, *Liar, Liar*, written by Paul Guay and Stephen Mazur, our hero Fletcher is desperate to make partner at his law firm. To accomplish this, his dramatizable objective has been to win a divorce case for his horrible client, Ms. Cole. At the Second Act Break, he DOES, and his colleagues congratulate him as partner. He's accomplished what he wanted. Or has he?

Upon achieving his goal, Fletcher realizes that in order to win, he's robbed a decent man of custody of his children and left them in the hands of a scheming shrew. And worse, by spending all his time helping this horrible woman, he's lost the love and affection of his own son, something far more precious to him. Fletcher may have accomplished his objective, but too late he realizes it was a *FALSE OBJECTIVE*, one that's left him in an even bigger pit of despair than if he'd failed to accomplish it.

What is key with all these examples, whether the hero FAILS to achieve his goal, ABANDONS that goal, or actually ACHIEVES it only to realize it wasn't what he wanted after all, is that they all represent a specific event that *ends* the pursuit of the objective that began at the First Act Break.

And this event, arguably the worst thing that can happen to the hero, invariably results in them wallowing in a deep, dark pit of despair, what my colleague and screenwriting guru Professor Richard Walter has gloriously termed the *BIG GLOOM*.

So structurally, a story's two act breaks, the reversal that ends the beginning and the reversal that begins the ending, are bookends to the hero's pursuit of their objective. The First Act Break begins it, and the Second Act Break ends it. And together, they define the plot and shape its structure.

But that story isn't done yet.

When the metaphorical curtain comes back up after the Big Gloom, we now find ourselves in the third paragraphs of our story examples, in what we cleverly refer to as—

Act Three

Aristotle breaks this final section into the Unraveling and Denouement, where the hero undergoes his Change of Fortune and where we see the final outcome that results. It's where we pull our hero back into the boat and discover what he's become.

And since its narrative function is to resolve the dramatic question we posed at the Set-Up, we call this act *THE RESOLUTION*.

Looking at the story examples, what are the big events here? Do you see any patterns?

Luke battles the empirical forces to destroy the Death Star, and he does so by trusting fully in the Force for the first time.

Joe and Jerry outsmart an army of gangsters as they're pursued through the Seminole Ritz. And despite the risk to his own well-being, Joe manages to tell Sugar the truth about himself, something he's never been willing or able to do before.

Elliot flees the government agents, racing to rescue E.T. and get him safely back to his ship. Along the way, he manages to corral his friends and family into a ragtag group of levitating insurgents, working together with him as the leader, a far cry from the lonely and underappreciated middle child we met at the beginning.

In each of these cases, the act begins from that low point of the Big Gloom with our hero dealing with the consequences of the event that ended the second act. But pulling themselves out of it, they rise from that pit of despair for one final attempt at accomplishing their objective, our next Anchor Point—

Climax

Whether a chase, a fight, a heart-rending confession, or ultimate confrontation, this Anchor Point represents the HIGHEST point of physical and emotional action in the story. It's where the hero takes one final stab at accomplishing what has become most important to them. And in it, they do something they could NEVER have done before, something that requires the sum total of all they've encountered on their journey, something that demonstrates how much that journey has changed them.

And the result of that climactic event is our final Anchor Point—

New Equilibrium

Luke is lauded as a hero. Joe gets Sugar and Jerry gets Osgood. Elliot says goodbye to his friend, knowing that he will always be "right here." *Sniff sniff.*

In each instance, a NEW normal has been established, one in which Luke is now a warrior for the rebellion, Joe is a happy monogamist, and Elliot is no longer alone. We get an inkling of what life will be like for our hero, from this point on until the day they die (or find themselves in the inevitable sequel), as a result of all that they've done, experienced, and learned.

They have gotten what they NEED, their Change of Fortune is complete, and the dramatic question posed at the beginning has been resolved.

And our metaphorical curtain comes down for the last time. Fade Out. The End.

THAT is what makes a successful structure. It is whole, complete, and unified. It is propelled by the hero's objective, an objective formed in the first

act, pursued in the second, and resolved in the third. A dramatic question is posed at the top, and answered at the end. Our hero has transformed from who he once was to who he needs to be.

And between the beginning and the end, ALL the events are connected by necessity or probability, each causing the next and being caused by the previous, and all united by the central thread of our dramatic question.

Those events, big and small, move the story forward or in a new direction, with the BIGGEST reversals delineating the acts, and thus, the overall structure of the story.

And those structure-defining moments, according to Aristotle, are what we must start with in order to craft our plot, to give it a clear beginning, middle, and end, and to thereby "first sketch its general outline."

Our six ANCHOR POINTS:

EQUILIBRIUM (PROLOGUE)

Not an actual event, as we've said, but a collection of events, an episodic sequence that lays out the factual details and circumstances of our hero's normal life and world.

INCITING INCIDENT (FIRST CAUSE)

The singular event that *starts* the story into motion by disrupting that equilibrium and compelling the hero to action.

FIRST ACT BREAK/POINT OF NO RETURN (END OF BEGINNING)

The biggest reversal so far, set into motion by the Inciting Incident, that deposits the hero into a new world, launching him into the pursuit of his new goal and thus the plot of the movie.

SECOND ACT BREAK/BIG GLOOM (BEGINNING OF END)

The reversal that ends the pursuit of the hero's objective, leaving him in a hopeless situation.

CLIMAX (UNRAVELING/CHANGE OF FORTUNE)

The highest point of physical and emotional action, where the hero does something he never could before, that requires the sum total of all he's learned and that reveals his transformation.

NEW EQUILIBRIUM (DENOUEMENT)

The event that ends the story and establishes the hero's new equilibrium.

These are the plot's biggest moments, the ones that depict the general outline from which we will next begin to amplify in detail.

And they are the moments that you must first decide upon when crafting the structure of your own story.

So go do that.

ASSIGNMENT #4: ANCHOR POINTS

1. Take two of your loglines from produced movies from the last assignment and write the six Anchor Points that determine the big picture of the story, its beginning, middle, and end.

EQUILIBRIUM
INCITING INCIDENT
POINT OF NO RETURN
BIG GLOOM
CLIMAX
NEW EQUILIBRIUM

Note: You should try to use just one or two sentences, maximum, for each of these moments. Much of screenwriting is about ECONOMY of language. But more importantly, you don't want to get too married to too many specifics at this early stage. Here we're just looking for the big picture, the overall structure.

Consider this example from *Star Wars*.

EQUILIBRIUM—Luke is a moisture farmer on Tatooine living with his aunt and uncle, fixing droids, shooting womp rats, and wishing for excitement and meaning in his life.

INCITING INCIDENT—While fixing a broken R2 unit, Luke discovers a hidden distress call from Princess Leia, intended for someone named Obi-Wan.

POINT OF NO RETURN—His farm burned to the ground and aunt and uncle killed, Luke sets out with Obi-Wan Kenobi to deliver the stolen Death Star plans.

BIG GLOOM—Luke's mentor, Obi-Wan, is killed in a lightsaber duel, AND Darth Vader, the villain, now knows the location of the rebel base.

CLIMAX—In the final trench battle, Luke "trusts in the Force," turns off his onboard computer, and fires a photon into the Death Star's exhaust vent.

NEW EQUILIBRIUM—The Princess gives Luke a medal for saving the galaxy while the villainous Vader escapes to fight another day.

And that, my friend, is *Star Wars*. Or at least its general outline, the key events that define its structure, its beginning, middle and end.

Now—

2. Do the same with your OWN STORY.

Character

The Agents of the Action

"Again, Tragedy is the imitation of an action; and an action implies personal agents, who necessarily possess certain distinctive qualities of CHARACTER and THOUGHT . . . and these are the two natural causes from which actions spring, and on actions again all success or failure depends."

(*Poetics, Part VI*)

We'll get back to structure and delve much more deeply into it soon. But first, we need to switch gears.

As we've discussed, and then discussed some more for good measure, the most important element of any drama is the STORY.

And while the story may be predicated on a hero's objective, essential to every good one is that the pursuit of that objective *changes* them in some fundamental way.

Whether a moisture farmer becomes a Jedi or a powerful newspaper magnate gets reduced to a helpless child, pining for his lost sled, they are either different at the end or they have discovered, along with the audience, that they were different all along.

So as we've said, another way to look at the unity and wholeness of a story is that it starts with a hero being *one* way and ends with them being *another*, and everything that happens in between, connected by the laws of necessity and probability, contributes to that Change of Fortune.

Hence, who a character is at the beginning, what they want, what they do to get it, and how they end up as a result, are all intrinsically tied to that story.

Therefore, while we have already determined a premise and started to look at the big events that shape our story and give it a solid structure, we can't proceed any farther without discussing CHARACTER.

And just what does Aristotle have to say about this crucial element?

First, he observes that while drama is a representation of an action, it requires CHARACTERS to dramatize that representation since, unlike other mediums of writing, there is no narrator. We aren't *told* the story; we are *shown* it. Therefore, the primary role of characters in a drama is just that, to *dramatize* the story.

Look at the term Aristotle uses for characters: AGENTS OF THE ACTION. For him, story isn't there to serve the characters. On the contrary, story reigns supreme and the personages within it exist solely to advance the action.

And that lopsided relationship brings us to his first principal of character, **Aristotle's Guiding Precept #12:**

> **CHARACTER IS ALWAYS IN SERVICE OF STORY, SO
> ALL CHOICES MADE ABOUT CHARACTER SHOULD
> BE MADE TO FACILITATE IT.**

That shouldn't be a controversial notion, but for some reason it tends to be. In every class, I'll have a student who has created what they think is an absolutely *amazing* character. Their one concern is that they simply haven't yet found the right story to plug them into.

Guess what, no matter how fresh or interesting or funny or tragic that character might be, it is *not* an amazing character. It is not even a mediocre character since it isn't fulfilling its principal function, its reason for being, to be the *right* character for that particular story.

So as we've been saying from the outset, you must start with that story and only *then* craft a character by making choices that best serve it.

But what kind of choices are we talking about?

Well, we've already discussed several crucial elements of character. We revealed how our hero must have a dramatizable objective (AGP #6), how he must undergo a *change* in pursuit of it (AGP #9), and how he must ultimately overcome his fatal flaw or be overcome *by* it (AGP #10).

If you'd been wondering why we didn't put off discussing these elements of character until this chapter so cleverly entitled CHARACTER, hopefully by now you've understood the reason.

We simply couldn't avoid discussing these three guiding precepts earlier because they are also so fundamental to our understanding of PLOT. As we've seen, the character's objective *propels* that plot, which in turn affects the character, and ultimately leads to their Change of Fortune, for good or for ill.

So while STORY remains paramount, it simply can't exist without those Agents of the Action dramatizing and shaping it. Therefore, to get this far, we've already had to make significant choices about our characters, decisions that have already helped craft our story.

But we've only just begun.

For Aristotle, a story is all about the action, specifically the behavior of those Agents that moves the narrative forward. And as the quote that begins this chapter indicates, those actions are determined by the two core

qualities that every one of those Agents possesses: *CHARACTER* and *THOUGHT*.

While we've touched on these attributes briefly before, let's take a closer look at them, and determine exactly what they mean and how we can utilize them to our benefit as screenwriters.

You'll recall I mentioned that the term *character* here is not the same as we think of the word today. Aristotle is actually talking about *MORAL CHARACTER*, of both the Agents of the Action and of the story as a whole.

At UCLA, we often use the term *MORAL DISPOSITION* in place of Aristotle's term *character*. And I'll do the same here. That way I can continue to use the word character as we commonly know it, and dispense with the cumbersome Agents of the Action. Whew.

Moral disposition, just as it sounds, refers to where a person falls on the good/bad spectrum. For Aristotle, every *real* person falls somewhere between the extremes of pure EVIL and pure GOOD, and that unique moral center is key to describing *who* we are.

So characters in a drama, being representations of real people, must likewise fall somewhere on that scale. The closer they are to one of those two extremes determines their moral disposition, and thus for Aristotle, represents a critical element in defining them.

Thought, on the other hand, refers to how characters *think*, or more precisely, how they judge a given situation or circumstance. What is interesting about this term is that it implies Aristotle considers characters to be thinking entities. How is that possible when they're just constructs, products of a writer's imagination? Characters can't think. People think. *Real* people.

Ah, but once again, characters in a good story, being representations of reality, must give the *impression* of thinking, of having *reason*. For it is the imitation of that crucial aspect of our own humanity, that *our* actions are motivated by thought, that makes them credible facsimiles.

So for Aristotle, characters can't simply act for the purposes of advancing the narrative. Rather, their actions must be motivated from within, by their hopes, dreams, and fears, by their INNER LIFE. After all, if they appeared merely functional, it would destroy the illusion of the representation and reveal the artifice beneath our Golden Buddha.

Therefore, in stressing these two core elements, moral disposition and Thought, Aristotle emphasizes an inextricable corollary to his precept that the characters serve the story, **Aristotle's Guiding Precept #13:**

> **WHILE SERVING THE NEEDS OF THE STORY, A CHARACTER AND THEIR ACTIONS MUST ALWAYS REMAIN BELIEVABLE.**

Giving a character these two attributes that all *real* human beings possess, a clear *moral disposition* and the ability to *reason* (or more accurately, creating the impression of having that ability by ensuring all their words and deeds are motivated by *thought*), allows them to fulfill this dual mandate, maintaining *mimesis* while moving the story forward.

And they move the story forward because these two qualities, together, determine *how* a given character will behave in a given circumstance.

For instance, if a financially strapped character is cruel (moral disposition) *and* sees the surveillance camera is out of order (thought/reasoning), they may decide to mug the stranger in the elevator.

A different character, with a different moral disposition and different reasoning would have behaved very differently in that same circumstance. So it is vital to know these qualities in order to understand how a character will act or react in any given situation.

As the quote that begins this chapter reveals, that behavior then moves the story forward, resulting ultimately in a final resolution, success or failure, that reveals the *moral character* of the story as a whole (as we'll discuss later in our chapter on THEME).

But for now, you must be wondering, how do we apply any of this in practical terms?

How do these observations help us to actually craft our characters, to bring them to life so that they look, sound, and act credibly while serving the needs of the story? What must we do to imbue them with the traits, attributes, and experiences necessary to help the story fulfill *its* function of providing the joy of learning through the experience of feeling?

Well unsurprisingly, Aristotle provides some invaluable insight into the kinds of choices we need to make in order to accomplish just that.

So let's get to it.

Defining Traits

What's Good and Appropriate

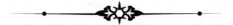

"In respect of character there are four things to be aimed at. Goodness, Appropriateness, Likeness, and Consistency."

(Poetics, Part XV)

Before we examine Aristotle's words of wisdom about those four essential attributes, let's get a clearer sense of the final product for which we are aiming.

I usually start my character classes by having students compile a list of ten memorable movie characters and then provide five attributes that best describe each. In this way we can start to think of just what KIND of characteristics go into shaping an effective character.

The list often looks something like this:

HANNIBAL LECTER: charming, monstrous, brilliant, perceptive, insane

GEORGE BAILEY: optimistic, disappointed, loyal, selfless, suicidal

RICK BLAINE: cynical, selfish, sentimental, solitary, generous

JAMES BOND: debonair, passionate, womanizing, lethal, ruthless

MICHAEL CORLEONE: loyal, naive, calculating, practical, deceitful

ATTICUS FINCH: honest, brave, self-righteous, humble, stern

ROCKY BALBOA: determined, resourceful, uncertain, imposing, innocent

CLARICE STARLING: intelligent, brave, naive, ambitious, cold

JOE (*Some Like It Hot*): womanizing, deceitful, loyal, manipulative, sensitive

LUKE SKYWALKER: callow, impetuous, daring, restless, powerful

A fairly decent list of some memorable, yet very different characters. Still, do you notice any patterns?

Of course you do. And as we'll see, those patterns relate directly to what Aristotle says about the essential qualities that every character must possess in order to remain believable while fulfilling the needs of the story.

As the quote that begins this chapter indicates, he says characters must have GOODNESS, APPROPRIATENESS, LIKENESS, and CONSISTENCY.

And as usual, within that list lies just about everything you need to know about crafting effective characters. So let's break them down.

First, they must have GOODNESS.

> *"This is possible in each class of person; there is such a thing as a good woman and a good slave, even though one of these is perhaps deficient and the other, generally speaking, inferior."*
> (*Poetics, Part XV*)

Ignoring the appalling sexism, recall from the definition of drama at the beginning of this book that the action being imitated must be an admirable one. Here Aristotle stresses that so, too, must the agents of that action be admirable. And significantly, that doesn't depend on the character's station in life, their job or gender, or any other specific quality or attribute.

As he puts it, what makes a character admirable is that they are simply BETTER THAN US. Not because of *what* they are, but because of *who* they are, in terms of their *moral disposition*. Why?

So we can CARE about them. So we can want them to succeed. They need to be worthy of our interest, and ultimately our pity or fear for what befalls them. And this is achieved if they are people to whom we not only can relate, but can also aspire.

So yes, a prince may be *good*. But so might a slave. A ruthless gangster even. A conman. A beggar. A factory worker. Salesman, farmer, musician, prostitute. Anyone can have goodness.

And for Aristotle, they *must*, if we're to want to spend 120 minutes in the dark with them.

So whether it be loyalty, honesty, steadfastness, generosity, bravery, or any other virtue we admire, first and foremost we must imbue our characters with specific attributes that make them, in some way, our betters.

Just look at the list of memorable characters above, and you'll see how this bears out. From the integrity of Atticus Finch to the brilliance of Hannibal Lecter, effective characters have virtues we find admirable.

Of course, it's worth noting that this doesn't mean we need to LIKE a character in order for them to be effective. I always bristle at the complaint that a character isn't likeable, and that this fact somehow makes them badly drawn or unusable. It doesn't.

Scrooge isn't likeable. He is the *antithesis* of likeable. Does that mean he isn't an effective hero for the story in which he appears? Of course not.

Travis Bickle. Michael Corleone. Nurse Ratched. Walter White. The pantheon of memorable movie characters is full of despicable characters doing despicable things. But even the lowliest and most contemptible of them possess qualities we can look up to.

For whether we like them or not, the key to *goodness* is that we need our characters to elicit EMPATHY. And when we empathize, we aren't necessarily making a judgment about them. Rather, we are able to *recognize* them, to understand the motivations behind their desires and their actions.

Only then are we able and willing to put ourselves in their shoes and to ultimately root for them to achieve whatever reward they deserve.

But imbuing them with some admirable qualities is just one aspect of building a character.

They must also have *APPROPRIATENESS*.

> *"The second thing to aim at is propriety. There is a type of manly valor; but valor in a woman, or unscrupulous cleverness is inappropriate."*
> (Poetics, Part XV)

There are two ways of looking at this idea that characters must have the *appropriate* or *proper* characteristics.

The first is that, as Aristotle elaborates, a woman can be brave, just not in the same way as a man. He would be considered a coward if he were brave in the same way as a woman.

Looking again beyond the antiquated sexism, Aristotle is saying that in nature, we associate certain qualities with certain types of people, and if a drama is an accurate imitation of life, we must adhere to those appropriate qualities. In other words, a character should have traits and qualities that the character would naturally have in the real world, based upon their gender, class, race, economic background, education, etc.

It goes back to *mimesis*. If they have qualities that *aren't* appropriate or proper, as we know them according to the laws of probability and necessity, then they won't be accurate representations of our own experience.

But recall Aristotle's admonition that we must always prefer "probable impossibilities to possible improbabilities." That means what makes the most logical sense in the story (the probable) is not necessarily what makes the most logical sense in reality (the possible), and we should always choose the former.

So the *better* understanding of the idea of appropriateness isn't that your character must have qualities that we'd expect them to have in nature, but that the writer should choose characters with the qualities that are most appropriate to the STORY.

After all, character is always in service of the story. You don't just plug in anyone. You plug in the character that is going to help facilitate the elements that make a story more effective. For instance, you'd choose a character with the most at stake, who is going to encounter the most difficulty, and who is going to have the most opportunity to grow and change.

For example, you're going to have a story about a shark terrorizing a community. You could make your hero an avid sports fisherman who lives for this kind of challenge. Ho hum, wake me when it's over, about five minutes after it starts. OR you could choose to center your story around someone who is terrified of the water, who's never seen a shark and who gets seasick at just the thought of being on a boat.

Which choice makes for the better story?

Who's most appropriate to anchor a story about the power vacuum left by the attempted hit on a mafia don, the ruthless criminal son, eager to take his place? Or the college boy who wants nothing to do with his family's business?

A pair of heroes needs to dress up as women and join an all-girl band in order to escape killers. What kind of characters best fill that role? Chameleons adept at disguise and skillful at fitting in? Or clueless cads who can't control their libidos?

The answers should be obvious. It isn't about who is best suited for the circumstances, but for the DRAMA. That is the better understanding of appropriateness, finding the characters that best suit your story's needs.

Again, look back at the list of memorable characters. What attributes do you see that fulfill this quality, that enhance the dramatic potential within each character's story? Which will make things harder for them? Or result in the bigger Change of Fortune? The greater catharsis?

So now you see how specific traits that satisfy the requirements of *goodness* and *appropriateness* help accomplish Aristotle's precept that a character must SERVE THE STORY. For these qualities make us care about them while also helping increase the requisite conflict, stakes, and transformation.

But that's only half the battle.

After all, the function of a good story is to reflect our audience's lives back to them through an emotional experience. So the process of crafting characters cannot simply be a matter of imbuing them with a handful of useful traits that serve the needs of the story.

No, to be truly effective, to help achieve *mimesis* and *catharsis*, always our goal, Aristotle insists we must also make them believable.

And the two remaining qualities he describes, *LIKENESS* and *CONSISTENCY*, help to accomplish just that.

The 5 Ps

They Help Build Character

"Character must be true to life: for this is a distinct thing from goodness and propriety, as here described."

(Poetics, Part XV)

The quality of *LIKENESS* is usually taken to mean *like us*. After all, if the goal of character is to serve the story and the goal of the story is to reflect something universal of our experience back to us, then it makes sense that the character experiencing these events be one that allows an audience to say, "Ah, that is me."

But just what makes a character identifiable, true to life, in a way that is different from the previous concepts of Goodness and Appropriateness?

For Aristotle, it simply means they possess qualities and traits that *real* people possess. And central to his analysis is that, while he insists a character must be good, he quickly adds the disclaimer that they not be TOO GOOD.

After all, who can really relate to Mr. Perfect? We want to see ourselves, warts and all. We want *mimesis*.

Aristotle likens character to the work of a portrait painter who reproduces the original by depicting both its beauty and defects. So, too, must the writer depict both the good and bad aspects of its subjects, as he lauds Homer for portraying Achilles as both a good man and a "paragon of *hubris*."

Take a look back at our list of memorable characters from the previous chapter. Notice how each is characterized by both positive and negative attributes. Notice how at times these qualities may appear downright contradictory. After all, aren't YOU full of contradictions? That dichotomy goes a long way toward making them real, making them like us.

And as we've discussed before, Aristotle takes the idea of imperfection one step further, saying that characters must not only have flaws, but must have some singular, specific frailty that brings about their misfortune. So just as Achilles has hubris, Oedipus is rash, Hamlet is indecisive, and Macbeth ambitious.

That frailty is the *HAMARTIA*, what we've come to know as our hero's tragic or fatal flaw, or what I like to call their PRIMARY FLAW. It's an explicit defect—an *Achilles Heel*—that at the outset prevents them from being whole, from being who they *need* to be.

And throughout the story, this flaw provides a tremendous source of conflict, as well as an opportunity for the character to grow and change. And just as importantly, it provides us an opportunity to identify with them. For we all are flawed.

So look again at our list of memorable movie characters. What would you say are their primary flaws?

The bottom line, when it comes to Aristotle's notion of *likeness*, is that characters should be like us, only better, yet not so good that we cannot relate or identify. If they are better than us, but still imperfect, then we can recognize ourselves in them, both in terms of who we are and who we want to be. And that combination makes them worthy of our attention.

But in practical terms, how do we accomplish this? How do we imbue our characters with all the characteristics, traits, qualities, and experiences, good and bad, that actual people, people we can recognize, possess?

Quite simply, we do that by building them, layer by layer, from the ground up.

Thankfully, no one says we need to start with a completely blank slate. Still, let me warn you *not* to base your characters on other characters. They are already removed from reality, and a representation of a representation can't help but show the artifice.

No, to have your characters seem *real*, like living, breathing creatures, two-dimensional on screen, but three-dimensional in our hearts and minds, you must draw them from your *own* reality.

Hmm, where have we heard that before? Just as our original discussion of story was all about striking a balance between fiction and personal truth, the same holds true for CHARACTER.

You must create a fictional construct that serves your story, yet build it from the reality of personal experience.

So draw inspiration from people you know, people whom you've met. And whom do you know the best?

YOU, of course.

One of my earliest memories of film school occurred on the first day in my first writing class. The instructor, screenwriting guru Hal Ackerman, went around and had everyone confess why they'd decided to pursue this crazy profession. When it was my turn, I thought I'd try to make everyone laugh, being the insecure cut-up that I was. So I cheekily said, "Writing is the only way to silence the voices in my head."

No one laughed.

I chuckled embarrassedly to myself, and then saw the reason they weren't laughing was that they were all nodding in sober agreement. They hadn't realized I was joking, since I'd actually inadvertently spoken a truth.

I know some writers who will argue that *every* character they write is some voice in their head, some facet of their own personality. And add me

to that list. Because when you're writing, the best way to know how your character would respond in a given situation is to be able to put yourself in their shoes.

So begin with yourself. That's how you make a character universal, real, and identifiable. Since, believe it or not, YOU are all those things. But to your own qualities, you must mold and shape and add the ones that serve your story, that compel your character to act in ways that move it in the direction it needs to go.

And whether you base a character on aspects of yourself or someone else you know well, one thing is certain. To make a character *seem* real on the screen, you must treat them as if they *are* real on the page, and that requires knowing them inside and out, backwards and forwards.

To that end, there are TWO ESSENTIAL STEPS to fully forming a character.

The first involves making specific choices about all the various qualities, traits, and attributes a character possesses. And as usual, we can look to Aristotle for a guide.

As I said back at the intro, Aristotle wrote treatises on just about every subject under the sun. But one for which he was most prolific was *biology*. He wrote many works on the anatomy of animals, how they moved, reproduced, what made them tick. Check them out some time; they're fascinating.

But for our purposes, one of the most interesting aspects of these various treatises is that he makes absolutely no distinction between a subject's physiology and their psychology. Indeed, his approach to dissecting an organism, human or otherwise, is very holistic, incorporating the body, mind, and soul, as if every aspect of an organism's being is relevant to understanding any one part.

And that same philosophy should be applied to crafting fully fleshed-out characters. To make them "like us" we must make choices about *every* aspect of them.

To that end, most writers I know make use of some kind of *worksheet* to help separate the countless qualities real people possess into different categories.

James Egri set the bar for such a character breakdown in his indispensible *The Art of Dramatic Writing*, in which he created what he called "The Character's Bone Structure," separating attributes into the three dimensions of physiology, sociology, and psychology.

Building from his foundation, and incorporating Aristotle's admonition to look at the totality of the individual, I like to break down a character's attributes into FIVE general categories, the 5 Ps, always keeping in mind that the primary consideration for any choice is to help maintain BELIEVABILITY while SERVING THE NEEDS OF THE STORY.

Those categories are:

Physical Presence

Here we list the traits that relate to how we actually perceive a character in visual terms.

Within this category, you'd determine their age, gender, race, and nationality. Their height and weight, and hair color. Their general appearance, including how they hold themselves and what they wear. Any physical defects or assets. Everything we can see simply by looking at them, particularly any outward physical traits that affect or manifest their *inner life*.

Persona

This is our character's public face, how they relate to and represent themselves in society. So in this category, we determine the facts that reveal their connections to the outside world.

Here we make choices about their religion, their occupation, political affiliation, educational background, marital status, economic class, their hobbies and memberships, their relationship with their spouse, parents, or children. Again, think in terms of choices that reveal who they are inside.

Psyche

Under this heading we delve deeper into our character's inner life, listing their psychological qualities and traits.

Here we determine their I.Q. Their fears and phobias and obsessions. Disappointments and frustrations. Their hopes and dreams and ambitions. Any mental abilities or deficiencies. As usual, be specific. We are getting even closer to defining what really makes them tick.

Personality

Here we detail the specific qualities and attributes that *manifest* all the previous choices by describing more precisely *how* your character behaves. This is the real nitty-gritty, the types of traits we assigned to the memorable characters in the previous chapter.

Decide if your character is ambitious, caring, cheerful, courageous, courteous, decisive, enthusiastic, faithful, focused, friendly, generous, hardworking, honest, humble, optimistic, realistic, reliable, self reliant, selfless, trusting? Or are they the opposite? Or somewhere in between?

Primary Motivating Factors

This is the category that truly defines *who* your character is, while helping ensure they fulfill Aristotle's dictate of being believable while serving the story.

As you may have guessed, these factors are the character's dramatizable objective and their primary flaw, or put another way, their WANT and their NEED.

We've already discussed how these two elements shape the story, define the plot, and establish the structure. The *want* is what gives a story unity and what propels it forward. The *need* provides conflict and determines the Change of Fortune.

And these two Primary Motivating Factors are deeply connected to all the other qualities previously enumerated. For a character's want and need are both *reflected* in their physical presence, persona, psyche, and personality, just as they are *determined* by them.

And those then are the 5 Ps, the Aristotelian dissection of an individual, both in real life and as a construct *imitating* real life.

But a vital point to make about all these choices, just as Egri asserts is that while some might be significant to your story, others might not factor into it at all.

In fact, there may be stories in which *none* of these qualities are relevant. Do we need to know Dorothy Gale's political affiliation? Or Indiana Jones' religion? Neither is ever specified.

But the whole point is that *real* people have these qualities, and so must your characters for them to be real to you. For the simple truth is, when you treat your characters as living, breathing, three-dimensional beings, they will invariably come across as such on the page.

So make decisions about all these qualities that real people possess, ideally for each character, big and small. For only when you know what your characters are like in any given situation, even those that don't arise in your story, will they be fully credible, and not simply constructs to move your story along.

But making choices about all these qualities and attributes is just the first step. As I said, there are *two*.

Just as important as knowing what your character is like is knowing WHY they are that way.

And what accounts for a character being who they are when your story starts? Well, what accounts for you being who *you* are at this very moment?

EVERYTHING that's ever happened to you.

All that you've done, that you've experienced, every disappointment and frustration, every success, humiliation, and triumph, the enemies you've encountered, the allies, tests, trials, and tribulations, it has *all* led to your current *moral disposition*.

So the same holds true for every real, believable character in a well-written narrative.

Like you, your characters lived before page one. And everything that's happened to them before the story started determines who they are when it does.

By way of example, Aristotle observes how the facts of Oedipus' birth, the Oracle's prediction, his parents' actions, even the slaying of Laius, all occur prior to anything presented in front of the audience.

But while these events may occur *outside* of the plot, they are inarguably as significant as anything within it.

Now your characters may not have had as dramatic an upbringing as Oedipus, but just as with you, me, and every character we hope to represent

us, somewhere in their biography, their BACKSTORY, are the events that shaped them, that account for the qualities they possess, that make them need what they need and want what they want, and that compel them to take this journey and ultimately become who they turn out to be.

So to make your characters truly effective in the way Aristotle dictates, to ensure they remain believable while serving the needs of your story, you must not only make choices about the specific attributes they possess, but also about the specific incidents and encounters that have motivated those characteristics.

So go ahead and make them.

ASSIGNMENT #5: CHARACTER TRAITS AND BACKSTORY

1. Fill in the following 5 Ps Character Worksheet for your hero.
2. Write a one-page backstory for your hero, paying particular attention to any traumas, successes, regrets, and relationships that account for your hero's MORAL DISPOSITION at the start of your screenplay. Specifically, what events in their early life account for their flaw and their objective, their need and their want?

5 Ps Character Worksheet

PHYSICAL PRESENCE
Age:
Gender:
Race:
Nationality:
Height:
Weight:
Appearance/Demeanor:
Wardrobe:
Physical strengths:
Physical weaknesses:
Tics/Mannerisms:
Distinguishing features:
Other important physical attributes:

PERSONA
Religion:
Job:
Political affiliation:
Education:
Marital status:
Economic class/Income:
Hobbies:

Clubs/Memberships:
Talents/Skills:
Other important social interactions:

PSYCHE
Intelligence:
Fears/Phobias:
Ambitions:
Obsessions:
Disappointments:
Frustrations:
Pet peeves:
Secret delights:
Mental abilities:
Other important psychological traits:

PERSONALITY
Out of the countless number of possible personality traits, list the five to ten most defining ones for your character.

For example: ambitious/unmotivated, caring/insensitive, cheerful/moody, courageous/timid, courteous/rude, decisive/hesitant, enthusiastic/dispassionate, faithful/untrustworthy, focused/scattered, friendly/cold, generous/stingy, hard-working/lazy, honest/deceitful, humble/arrogant, optimistic/cynical, realistic/idealistic, self-reliant/needy, selfless/selfish, trusting/suspicious

PRIMARY MOTIVATING FACTORS
Dramatizable Objective (want):
Primary Flaw (need):

TWENTY-ONE

Motivating Behavior

Goooooaaal!!

"A person of a given character should act in a given way, by the rule either of necessity or of probability; just as this event should follow that by necessary or probable sequence."

(*Poetics, Part XV*)

As we've seen, three of the essential qualities every effective character must possess are *GOODNESS*, *APPROPRIATENESS*, and *LIKENESS*. Or put another way, someone we can care about, with characteristics that serve the story, and that make them identifiably real.

If you've completed the assignment from the previous chapter, you've gone a long way to accomplishing these dictates.

Still, it's one thing to fill out a worksheet and construct a bio, it's another to make use of those decisions in the actual crafting of your story. So, for all the choices we've made, the question arises, how do we reveal and utilize them in the narrative?

Well, we reveal character in very specific ways: by how they *look* (which we'll discuss at greater length in our chapter on DESCRIPTION), by what they *say* (which we'll cover in our chapters on DIALOGUE), by what others say *about* them (again, stay tuned for those dialogue chapters, I've been hearing good things), but most importantly—by what they *do*.

As Aristotle stresses, while story remains paramount, it is the characters' ACTIONS that move that story forward. Therefore, it is essential that a character's actions not only take the story where it needs to go, but also always remain believable.

Which is why the fourth quality that all effective characters must possess is *CONSISTENCY*.

By that term, Aristotle isn't simply stating that their *traits* must have continuity. Of course they do. Unless they're in a Mel Brooks movie, that hump

on their right side better stay on their right side. Rather, Aristotle means that an effective character must ACT with consistent behavior.

Keep in mind our essential precept that all the decisions you make about a character are always in the service of the story. But just as critical, characters must never *appear* simply functional.

For there may be no greater danger to disrupting the believability of a story than to have your characters react or respond based purely upon what you, the writer, need them to do at a particular moment to keep the story moving forward, rather than upon what they'd credibly do given the character you've set up.

Now that doesn't mean characters can't surprise us or do things we aren't expecting. Of course they can. They better. It means that whatever they do must be *grounded* in all the choices you reveal about them.

We must believe that any action the character makes is precisely how *this* character with *these* qualities would behave in *this* given circumstance.

Sounds simple enough, right? But how do we know how they *would* act, and not simply how we *want* them to act?

Well, certainly knowing them inside and out, backwards and forwards, as you would after completing the last assignment, helps. But according to Aristotle, there's more to it than that.

As the quote that begins this chapter emphasizes, a character's behavior moves the story forward, and since events must succeed one another according to the laws of probability and necessity, a character must also behave according to those same laws.

And circling back to the very beginning of our character conversation, a character acts according to the laws of probability and necessity whenever their actions appear motivated by their *moral disposition* and *thought*—in other words, provoked from within, by *who they are* and *how they perceive the situation*.

Now that may be all well and good from a theoretical standpoint, but what does it mean for us as screenwriters? How do we utilize our understanding of goodness, appropriateness, likeness, and consistency, of probability and necessity, *moral disposition* and *thought* to determine in practical terms how our characters will behave in a given circumstance?

To answer that, let's examine an effective movie character, how that character is revealed, and what ultimately determines their actions.

I often screen a few character introduction scenes in class and ask my students to write down every time they discover a new characteristic about them. And I ask them to think about how they learned it.

So let's look at one such introduction, when we meet Marge Gunderson about forty minutes into the Coen brothers' *Fargo*. If you inexplicably don't have the movie on hand, here's what happens:

After a pan across painted birds on the bedroom wall, we see Marge sound asleep at 4 a.m., her husband Norm's arm stretched comfortingly across her.

Then the phone rings, startling her awake. She answers. There's been a murder and she's needed at the scene. She starts to get up, revealing her pregnant belly. Her husband offers to make her eggs. She declines. He insists.

What do we know about her job by *how* she talks on the phone? She's in law enforcement, sure. But listen to how calm and professional she is when hearing the news, how quick she is to jump from sleep to business. What do those things tell us about her as a character?

At breakfast, they eat their eggs in complete silence.

But it's a comfortable silence, not the least awkward. What does that tell us about their marriage? About how long they've been together?

So without anyone ever *talking* about what kind of person Marge is, we've learned: She's married. She's pregnant. She's a cop. She wears the pants in the family. She's professional, good at her job, unflappable, calm and cool, and in a sturdy relationship.

These elements of her physical presence, persona, psyche, and personality are all things we SEE. They are revealed by how she answers the phone, how she eats breakfast, how she treats her husband, how she gets her Prowler started. We aren't told anything about her, but rather *shown* who she is by what she does and how she does it.

Then we cut to the crime scene.

Her deputy stands in the distance, holding her coffee while she examines the wrecked car and the dead bodies inside. Considering the evidence, she surmises the events that must surely have happened the night before.

From her dialogue we might learn some exposition about the incident, but more importantly, we learn just how good she is at her job. Because we *see* her being good at her job. And we *see* others respecting her for it.

And when she looks at the dead traffic cop and says, "Looks like a nice enough fella," we get a sense that she is sensitive. Maternal even. Would a cop like Dirty Harry or John McClane have *that* response to a dead body? Not a chance. Their responses would reveal *different* moral dispositions and reasoning. Her comment about the dead cop isn't revealing anything significant about the dead cop, but it sure is revealing a lot about *her*.

At one point, after looking at a particularly grisly corpse, Marge bends over, complaining, "I'm gonna barf." An honest reaction to such a situation. She is a woman, after all, and woman get queasy when looking at a corpse, right? *Appropriateness*. But *au contraire*. She immediately stands back up and says, "That passed. Now I'm hungry again." It wasn't the sight of the body that made her sick. It was morning sickness. A delightful surprise, but completely consistent with the stalwart character we've seen up to this point.

Then, before getting into the squad car with her deputy, Marge dumps out the coffee he'd brought her. But interestingly, she first waits until his back is turned. Why? The coffee was obviously making her ill, yet she didn't want to hurt his feelings by jettisoning it in front of him. What does *that* say about her as a character?

As they drive, the deputy tries to impress her by showing her his deductive skills. But he's made a faulty assumption about what the dead officer had written in his notebook. It wasn't a license plate number, it was a dealer plate identification.

She corrects him. "Oh," he says, realizing he'd made a dumb mistake.

And then what does Marge do? Does she scold him? Tell him not to do it again? Does she dismiss him? Laugh at him? Or do they just drive on in awkward silence? ANY of those behaviors would have revealed something about her.

But she doesn't do any of them.

Instead, she tells a joke.

Why? Because the writers want to show she has a good sense of humor? Because they'd heard a good joke and wanted an excuse to cram it in?

No. Marge tells a joke because she'd made her deputy feel bad after correcting his police work. And because she's sensitive and caring, and she sees that he's upset and embarrassed, she wants to make him feel better, to lighten the mood. Her moral disposition coupled with her judgment of the situation motivates her behavior—to tell a joke.

Notice how this whole sequence illustrates how events are made up of actions that are connected causally through necessity or probability. There was a crime, she was called in, she investigated, her deputy offered an observation, she corrected him, he felt bad, she tried to lighten the mood. Everything is built upon what came before and causes what follows.

And notice how these actions reveal character. Everything Marge says or does demonstrates some truth about her, *peels back a layer of the onion* that is her very real and fully dimensional character. If Marge had a different moral disposition or reasoning, she would have reacted differently. So given a character with her specific traits, *this* is how she acts.

What other pattern is evident? Marge shows up at this location because she wants to solve the crime. She tosses the coffee when the deputy isn't looking because she wants to spare his feelings. She tells a joke because she feels bad after correcting him and so wants to cheer him up.

What word do I keep repeating over and over again with each of Marge's actions?

Yeah, we've played this game before.

Marge *behaves* because of who she is and because of how she judges the circumstances, her moral disposition and thought. And the interaction of these two crucial character elements creates—a WANT. And the ensuing behavior is an action intended to accomplish that goal.

That point is so important, that I'm compelled, due to *my* moral disposition and reasoning, to repeat it.

The intersection of a character's *moral disposition* and *thought* creates an immediate, clear and specific GOAL.

And it should be no surprise that this truth leads us to **Aristotle's Guiding Precept #14:**

A CHARACTER IS BELIEVABLE AND SERVES THE STORY WHEN THEIR ACTIONS ARE ALWAYS MOTIVATED BY AN IMMEDIATE GOAL.

Characters don't reveal themselves by simply articulating their attributes or traits. Rather, they endeavor to achieve something they WANT at any given moment.

And the behavior they employ to accomplish that goal reveals those qualities, just as it moves the story forward.

Now those goals can change. They always do, as the circumstances themselves change. But they are always present. Marge wants to solve the crime, and through *how* she goes about it, we learn she's capable, calm, cool, and collected. Later her goal is to make her underling feel better, and by how she goes about accomplishing that, we learn she's sensitive and caring.

And as we shall soon see, the different ways in which a character approaches their changing goals during the course of the story provide the primary indicator of how *they* are changing throughout it.

And that will help us break down the story's proper structure even more.

ASSIGNMENT #6: TWO-PAGE SYNOPSIS

Write out your story in prose, in just two pages, double-spaced, tracking your hero's journey, the pursuit of their objective, and their transformation.

Think of it as a short story in three parts, the Set-up, Complications, and Resolution, in which you incorporate all the elements we've discussed so far—character, plot, and structure—particularly with regard to how those elements are shaped by your hero's primary flaw and dramatizable objective.

Make sure you're answering the following questions:

How does it begin? What are the important facts of the world at equilibrium? Who is the main character? What happens to disrupt that equilibrium and start the story into motion? How does the hero respond? When can't the hero go back to the beginning? What does he now want and set out to achieve? What are some of the big complications, reversals, and recognitions along his journey to accomplishing it? What happens to leave him farthest from it, with all hope lost? What re-inspires his goal? What is he finally able to do that he couldn't before? How does it end? How has he changed?

Note: You can describe a lot in two pages, double-spaced. But if you can relate *everything* that happens, you don't have enough story for a feature-length film. So you must make choices about what to leave out. By doing so, you are deciding what is absolutely essential to leave in, the important events *required* to describe the big picture of your story. And it's that big picture, told with an *economy of language* that makes an effective synopsis.

Structure Revisited

Filling in the Gaps

"The parts of Tragedy which must be treated as elements of the whole have been already mentioned. We now come to the quantitative parts—the separate parts into which Tragedy is divided."
(Poetics, Part XII)

Now that we've discussed Aristotle's observations and advice on story, structure, and character, it's time to roll up our sleeves and dive into how these three crucial elements work together to help us further develop our screenplay.

Once more recall that Aristotle says the process requires us to:

> *"First sketch its general outline, and then fill in the episodes and amplify in detail."*
> (Poetics, Part XVII)

By crafting the BIG PICTURE of our story, defined by a hero's pursuit of a specific objective and structured according to its biggest reversals and recognitions, we've started to sketch that general outline.

Next, we need to break the story down further in preparation of filling in the episodes.

At the end of the last chapter, we introduced the concept of a character's IMMEDIATE GOAL. Specifically, we discussed how character is revealed and the story advanced due to a character's actions, and that those actions are motivated by the intersection of their *moral disposition* and *thought* which creates a WANT in their current circumstances.

And while a character's immediate goals change throughout the story, at any given moment, they want *something*. What that something is, and how the character goes about getting it, reveals *who* they are at that moment.

I stress "at that moment" because what a character *does* to accomplish a particular goal in a given circumstance may not be the same action they would have undertaken had that same circumstance occurred earlier.

Why?

Because a character *is changing* throughout the story. That means their *moral disposition* and *thought*, the core qualities that determine who they are and how they act, are changing too.

A character's metamorphosis doesn't occur all at once in a Change of Fortune at the story's end. It is a gradual and constant change, what we call the Character Arc, the event-by-event transformation from who they were at the outset to who they've become at the resolution.

And a good story should allow us, as readers or viewers, to track at all times *where* the character is on that arc by how their immediate goals and their strategies to accomplish them change as the story progresses.

Keep in mind, Aristotle says that every event must in some way contribute to our hero's transformation. If it doesn't, it can be discarded without affecting that Change of Fortune, and so, according to Aristotle, doesn't belong.

At the same time, every event must in some way change the circumstances of the plot, the hero's pursuit of their objective. That means everything that happens in a good story either brings the hero closer to or farther away from that objective. Again, if it does neither, it too doesn't belong as it can be removed without affecting the whole.

What all these observations add up to, is that for Aristotle (*deep breath*), the events that are the building blocks of a story must get us from the Beginning to the End, with none being inessential, all connected according to the laws of probability and necessity, with the bigger ones determining the overall structure, and each one moving our hero closer to or farther away from their objective while also serving as an opportunity to demonstrate how the character is changing by how they deal with the new circumstances they encounter.

Whew. How about we put that in simpler terms? And let's call it **Aristotle's Guiding Precept #15**:

> A SOUND PLOT IS MADE UP OF CAUSALLY CON-
> NECTED EVENTS THAT CHANGE THE CIRCUM-
> STANCES OF THE STORY AND OUR UNDERSTANDING
> OF THE CHARACTERS.

Nothing radically new here, right? After all, we already established that every event must be connected by the laws of probability and necessity (AGP #7), that plots are made up of reversals and recognitions (AGP #8), and that characters change as they pursue their objective (AGP #9). So in a way, the above precept is merely a consolidation of those earlier ones.

But a vital consolidation to be sure. Since what we are describing here is the fundamental unit of every screenplay story, what we refer to as a BEAT.

You can think of BEATS as episodes, as Aristotle does, or as plotpoints, as many screenwriters do. But regardless of what you term them, their function

remains the same. They are distinct and discreet units of action, dramatizable events, that advance the story and the characters.

And they are the building blocks of a screenplay plot.

We've already discussed some of the major beats, like the Inciting Incident and the Climax. Now let's talk about some other key events that help define the structure, move our story forward, and reveal character, the major episodes that make up the connective tissue *between* our six Anchor Points.

To do that, let's take another page from Aristotle's playbook and look for patterns in successful movie stories, dissecting them into still smaller units, going from that three-act sketch of a general outline to filling in the episodes.

And let's start appropriately at the Beginning.

TWENTY-THREE

Set-Up

Stepping Stones of Act One

"A beginning is that which does not follow anything by causal necessity, but after which something naturally is or comes to be."
(Poetics, Part VII)

As we've seen, the *function* of Act One is to provide the necessary events to launch the hero into the plot of the movie. This is where we establish the dramatic question that will be debated through the second act and answered in the third, and where we provide the hero the objective that will be pursued through Act Two and either accomplished or not at the resolution.

If one were to examine the principle events of the first act of *Some Like It Hot*, they would look something like this:

 There's an exciting car chase and shoot-out between police
 and bootleggers, establishing we are in Chicago, 1929.

 Joe and Jerry are introduced, performing at a Speakeasy
 that is raided by the police.

 Out of work, Joe and Jerry seek employment at a talent
 agency, where they learn of a Florida gig. Only catch,
 it's an all-girl band.

 Picking up a car at a garage, Joe and Jerry witness a
 bloody mob hit, barely escaping with their lives.

 Realizing they are marked men and can't go to the police,
 Joe comes up with a plan to elude the mobsters. They
 board a train bound to Florida dressed as Josephine and
 Daphne and join Sweet Sue and Her Society Syncopators.

 Onboard, they meet the girls of the band, especially
 Sugar who both boys clearly lust after. Sweet Sue finds
 the new girls suspicious.

```
During rehearsal, Jerry comes to Sugar's aid, claiming
her fallen flask is his own. The band accepts the
new girls into their ranks, both professionally and
personally.
```

There. That's the sequence of events in the Set-Up of *Some Like It Hot*, the events necessary to deposit the heroes into the plot of the movie and into the complications of a new world.

Now let's look at the Set-Up of *Star Wars*.

```
A rebel spaceship is attacked by Darth Vader and his
Stormtroopers. Before she's captured, Princess Leia
leaves a message in the droid R2D2 and jettisons it from
the ship.

We meet Luke Skywalker, living on Tatooine on a moisture
farm with his aunt and uncle. He buys the droids R2D2 and
C3PO from the Jawas who've captured them.

While performing maintenance on R2, Luke discovers the
Princess' distress message, "Help me, Obi-Wan, you're my
only hope."

After R2D2 runs away, Luke goes to look for him and is
captured by the Sand People. A hooded figure rescues him,
revealing himself to be Obi-Wan, an old friend of Luke's
father. He gives Luke a lightsaber and asks him to join
him on an adventure, but Luke turns him down.

Luke discovers that Stormtroopers, looking for the
droids, have killed his aunt and uncle and burned down
their farm. He tells Obi-Wan he'll join him.
```

Notice any similarities between events of this story and the previous example?

Of course you do.

And the truth is, we could do this for movie after movie and we would see the same correlations. For in any effective Set-Up, while the specific details will vary drastically, certain kinds of beats show up with great frequency. I like to call them the STEPPING STONES of Act One, as they are the major beats that take us from the beginning of the act all the way to its end.

Let's examine them in order.

First comes the beat that *opens* the movie. Note that this is *not* the event that starts the story. As we've seen, that event comes only after we've established the hero's stasis. So the very first beat is the event that starts the Prologue, that introduces us to the normal world of the story.

We refer to this event as the OPENING HOOK (OH), as its primary purpose is to "hook" the viewer or reader into the story, making them eager to know what happens next.

In our two examples, that hook is a car chase and a space battle.

The Godfather opens with a mortician asking Don Corleone for brutal revenge against the men who harmed his daughter. *The Shawshank*

Redemption opens with an illicit tryst and a murder. *American Beauty* opens with Lester gliding through the air, discussing the facts of his recent death. *Jaws* with a shark attack. *Lawrence of Arabia* with a motorcycle accident. *Citizen Kane* with a close-up of dying lips and the mysterious word "Rosebud."

What do these effective Opening Hooks all have in common?

I like to think of the Opening Hook, just as its acronym implies, in terms of either an *exclamation point* (as in OH!) or a *question mark* (as in OH?). In the former, like *Jaws* and *Shawshank*, we see something exciting, dramatic, and engaging that grabs us by the shirt collar and pulls us in. In the latter, like *American Beauty* or *Citizen Kane*, we see something odd, curious, mysterious, that makes us desperate to learn more.

But in all cases, it is a dynamic moment of conflict that gives us vital, *defining* information about the world of the movie, when and where it takes place, the tone and genre, and oftentimes, the primary source of conflict within it.

And then what action follows that opening event?

In our two examples, we have beats where we meet the protagonists in their equilibrium, in events that reveal their normal life. And in that daily routine, we learn important information about them.

From Joe and Jerry's bickering, we learn the dynamic of their relationship. In the casual way they deal with the vice raid, we learn this is just part of their normal world—womanizing, gambling, living a hand-to-mouth existence.

When we meet Luke, we see him toiling on the family farm, fixing droids, and staring at the stars, wishing for something more to give his life meaning. These are important elements that make up his equilibrium.

In each case, we learn our heroes are *missing* something, that in their normal, static lives, they are incomplete, even if they are unaware of it. We also learn, through how they deal with conflict, the primary qualities that define them. Joe the schemer. Luke the dreamer.

Similarly, in *The Graduate*, we meet Benjamin, aimless and adrift, hungry for direction. In *Fargo*, we meet Jerry, crafty car salesman, desperate for cash. In *Harold and Maude*, we meet Harold, rich, obsessed with death, and longing for a connection. In *The Godfather*, we meet Michael, clean-cut war hero, wanting nothing more than an honest life for himself.

And we follow this character introduction with additional events that further peel back the layers of the onion of who they are, that establish more details of their everyday existence, their hopes and dreams and fears in the life that will continue from now until the day they die until—

—an event occurs that shakes up that stasis. Witnessing a mob hit. Finding the Princess' message.

Mrs. Robinson makes the moves on Ben. Jerry's father-in-law steals his business idea. Harold meets Maude and Alvy meets Annie. Don Corleone gets shot.

Marion Crane steals the bank money. Dr. Kimble's prison transport is struck by a train. Mrs. Mulwray hires Jake Gittes to spy on her husband. Olive gets invited to the Miss Sunshine Pageant.

It's the First Cause. The moment of "Ah, the story has started."

And then the events that follow, according to the laws of probability and necessity, show the results of that event, the hero's response to it, the events then engendered by that response. Luke goes in search of Ben. Joe and Jerry plan their escape.

Ben books a hotel room. The kidnappers nab Jerry's wife. Harold's mom tries to find him a more appropriate girlfriend. Michael plots revenge.

Marion flees town with the stolen loot. Elliot shows his new friend the wonders of suburban life. Dr. Kimble escapes into the woods.

Consequences. Until—

—an event occurs that propels the hero into an entirely new circumstance. For Luke, it's an alliance that takes him far from the only home he's ever known. For Joe and Jerry, it's not just a new gig, but a new gender.

Ben and Mrs. Robinson start their affair. The kidnappers commit a triple homicide that puts Marge on the case. Harold and Maude become friends. Michael assassinates his family's enemies.

Marion checks into the Bates Motel. Michael Dorsey gets the soap opera gig, but as Dorothy Michaels. Olive's family sets out on their road trip. The real Mrs. Mulwray shows up and Jake realizes there is much more going on than meets the eye.

It's the biggest event of our story so far, as our heroes pass a Point of No Return. It's the moment of "Ah, that's what the story is about," as they are launched into the plot, into a new world with a new objective, engaged in the imitation of an action defined in the story's logline.

And the curtain comes down on our Set-Up.

That is the pattern of events, the sequence of STEPPING STONE beats that recurs over and over again in the first acts of successful movies. Once more they are:

OPENING HOOK (OH)/HERO'S INTRO (HI)
EQUILIBRIUM
INCITING INCIDENT
CONSEQUENCE
POINT OF NO RETURN

Of course, there are plenty of variations to this pattern, according to the dictates of any particular story.

For instance, in some cases, the Opening Hook INCLUDES the introduction of the hero, as in *The Graduate* or *Chinatown*, while in others it is separate, like *Jaws* or *Some Like It Hot*. But in all instances, whether introducing the world and hero separately or together, we enter the world with a HOOK, and meet the hero with a REPRESENTATIVE BEHAVIOR.

Remember, characters are revealed through what they do, and so what they are doing when we first meet them has tremendous import. It defines them. So when introducing a character, always ask yourself, what action can they be engaged in that gives us the most insight into them?

Maybe it's adventurer Indiana Jones showing off his dogged derring-do as he escapes a booby-trapped cavern. Or Mark Zuckerberg of *The Social Network* arrogantly and awkwardly dealing with an unexpected break-up. Or desperate lawyer Frank Galvin of *The Verdict* handing out his business cards to increasingly hostile strangers at a funeral.

For my money, the best openings are the ones where the writer has determined the most important quality that the audience needs to know about the hero, then puts them in the most interesting scene of conflict that reveals that quality. From the get-go, we're hooked into the action and the character.

Then the number of events in the Equilibrium can vary too, according to the needs of the story. Some worlds, like Frodo's Shire, need more events to establish them. Others, like Dr. Kimble's, need little more than an opening credit sequence. But one thing is certain; we need beats of equilibrium BEFORE we can have an Inciting Incident.

That event is a crucial opportunity for the audience to identify with your hero, but only if the audience actually FEELS the disruption in the hero's normal world along with them. And that requires getting to spend adequate time in that world, to get a sense of their routine, before things get shaken up.

The number of events after that Inciting Incident can vary as well, depending on what is required to get us to the First Act Break. Sometimes, as in *Star Wars*, that requires several events since Luke requires his circumstances to change a LOT before he's equipped to make the decision to go on this adventure. Conversely, a film like *The Graduate* requires very few events in between these Stepping Stones, as Ben doesn't need a lot of coaxing before entering into an affair with the seductive Mrs. Robinson.

But in every case, the Inciting Incident and the First Act Break are two distinct, separate events. One disrupts the status quo; the other obliterates it. And in between, events are connected by the laws of probability and necessity, each event causing the next, hence our term for the intervening beats, CONSEQUENCE.

By the end of the act, we've been provided all the information necessary to set up the plot. And when our metaphorical curtain rises again, we'll be in it.

Again, it's not a formula. Just an observation, one that corresponds nicely to Aristotle's description of the Beginning, and one we see repeated over and over again in movies that have stood the test of time.

But don't take my word for it. Why not see for yourself?

ASSIGNMENT #7: FIRST ACT BEATS

Watch Act One of two of the movies in the Recommended Movie List (see Appendix), noting the various events that make up the Set-Up. Can you identify the major Stepping Stone beats? Do the same patterns emerge?

Complications

Stepping Stones of Act Two

"A middle is that which follows something as some other things follow it."

(Poetics, Part VII)

Act One was all about the Stepping Stone events necessary to introduce the hero and his world, and then to launch him into the PLOT of the movie. So it ends with a big reversal, a Point of No Return that pulls him from the world of the equilibrium, and deposits him in a new one, on the path toward the new objective that provides the dramatic question the rest of the story will resolve.

In Act Two, we will experience all the hero does to achieve that objective, the obstacles that stand in his way, and the opportunities he has to change and grow while attempting to overcome them, until that pursuit leads to the Beginning of the End.

Aristotle calls this act the Complications, as it details the difficulties and dilemmas that result from all the disruption, chaos, and heightened stakes spun from the Set-Up.

But *complications* is also a fitting title from a screenwriter's perspective, since the sheer scope of the act, and what must be accomplished in it, can seem incredibly daunting. It is, after all, the bulk of the story.

Again, it helps to break things down into their component parts, to see how they function individually and then together to create the whole. So let's dissect some second acts and pay close attention to any patterns that might emerge, to hopefully help guide us through it.

From the second act of *Star Wars*:

```
Luke and Obi-Wan travel to Mos Eisley, having a close
call with some unfriendly aliens before hiring Han Solo
and Chewbacca to pilot them to Alderaan. Meanwhile,
```

Princess Leia witnesses helplessly as the Death Star
destroys her home planet.

Aboard the Millennium Falcon, Obi-Wan teaches Luke about
the Force, and Luke uses it successfully for the first
time while practicing with his lightsaber. They discover
Alderaan has been destroyed, but before they can react, a
tractor beam draws them into the Death Star.

After Darth Vader fails to find our heroes aboard the
ship, they disguise themselves as Stormtroopers and make
their way deeper into the Death Star.

Obi-Wan tells Luke and the others to lock themselves in
a command post while he goes off to disable the tractor
beam. But when he's gone, Luke discovers the Princess
is on board and scheduled for execution that evening. He
resolves to rescue her, and despite Obi-Wan's admonition,
convinces the others to join his plan.

Luke and Han make it to the prison block and find the
Princess. There's a big shoot-out and our heroes escape
into a garbage depot where they encounter an unfriendly
trash monster and some unfriendlier walls. Eventually, R2
shuts down the power and saves them.

Obi-Wan manages to disable the tractor beam as Luke
battles scores of Stormtroopers. At one point, he finds
himself at the edge of a chasm, but manages to swing
across heroically with the Princess in his arms and a
kiss for luck.

Darth Vader finds Obi-Wan and they have an intense
lightsaber duel. Luke watches helplessly as his mentor is
struck down. After another laser battle, the heroes board
the Falcon and escape.

Aboard the Death Star, Darth Vader gloats. There's a
tracking device on the Falcon, and soon the Empire will
know the location of the rebel base and squash the
rebellion once and for all.

And that's the second act of *Star Wars*.
 See if you notice any similar events as we look at Act Two of *Some Like It Hot*:

Their first night on the train, Sugar climbs into Jerry's
bunk to thank him, thinking he's Daphne. He tries to
seduce her, inadvertently drawing the attention of
the other girls, all of whom climb into his berth. As
Joe learns of Sugar's plans to marry a millionaire in
Florida, Jerry pulls the emergency cord before his
disguise gets revealed.

The band arrives in Florida and a rich playboy,
Osgood, immediately falls for Daphne. Sharing a hotel
room, Joe and Jerry argue. Jerry wants to end this
ruse now that they've escaped the mobsters, but Joe
wants to keep it up.

As Daphne and Sugar frolic on the beach, Joe shows up, now disguised as rich playboy Junior. He arouses Sugar's interest.

Back in their room, Jerry tries to expose Joe's true identity but gets outfoxed. Joe declares that he's going to win Sugar, and Jerry's going to help him do it.

The band performs that night. Joe sends Sugar the flowers intended for Daphne, and invites her onto Osgood's yacht. After the concert, he has to hurry out of Josephine's clothes and into Junior's and beat Sugar to the dock.

After a backward dinghy ride, Joe and Sugar have their yacht date, with each pretending to be someone else. Joe convinces Sugar that he is impotent in order to get her to become the seducer. They spend the night in each other's arms, while Jerry actually enjoys his date with Osgood.

At the end of the evening, Osgood returns to his yacht, barely missing Joe. Joe and Sugar kiss goodnight. Jerry reveals to Joe that he's engaged to Osgood. Sugar tells the "girls" about her amazing night.

Spats Colombo and his goons show up at the hotel for a mobster convention. The cops are also there, hoping to arrest the gang as soon as they can locate the two witnesses to the garage killings.

As Joe and Jerry try to sneak away, still dressed as women, the mobsters corner them in an elevator and get their room number. Our boys are toast.

And those are the beats of the second act of *Some Like It Hot.*

Notice any correlations to the Act Two beats of the previous example? Silly question, right?

In both our examples, our heroes start off the act dealing with the repercussions of the event that occurred at the end of the Set-Up. That is, they find themselves in a completely new circumstance, filled with obstacles outside of their usual experience.

For Luke, it's a world filled with dangerous aliens and even more deadly Stormtroopers. For Joe and Jerry, it's girdles and brassieres, lecherous men, and a world of women to whom they're attracted yet powerless to pursue for fear of exposure. In either case, one false move and the consequences are dire. They are fish out of water, strangers in a strange new land.

And they don't know the rules to *survive.*

So the difficulty in these early Act Two beats revolves around the fact that our heroes are still whom they were in Act One, yet dealing with a whole new world of problems they are ill equipped to handle.

Until—

—our heroes do something that demonstrates they are starting to FIGURE OUT these new rules, to begin to navigate this strange and dangerous territory.

For Luke, that involves using the Force for the first time, something he barely knew existed in Act One. For Joe, showing similar growth, it involves adopting a clever new persona that manages to attract Sugar's interest.

It is a beat of ADAPTATION. And we see it in movie after movie.

Benjamin realizes he actually cares about someone, unfortunately it's Mrs. Robinson's daughter. Maude teaches Harold to play the banjo, the first life-affirming action he's undertaken. Andy opens a prison library, bringing a little sunshine into his otherwise dreary surroundings. Alvy finds the nerve to meet Annie's parents. Olive and her family, working as a team for the first time, get their broken-down van to start.

In each instance, after dealing with the intense conflict of being in a circumstance in which they don't know the rules, our heroes finally do something new, something they couldn't have done back in Act One, that demonstrates they are beginning to adapt to their new circumstances.

Or as Obi-Wan puts it, "You've taken your first step into a larger world."

From that point on, with each event causing or affecting the next, our heroes continue to grow stronger, smarter, and more capable, as they face increasingly difficult obstacles and rising stakes. Until—

—our heroes reach a fork in the road, faced with a crisis that forces them to make a big decision, to choose a path, *to take a stand*.

For Luke, this moment occurs when he refuses to stay put as Obi-Wan had ordered and instead takes command of the group, devising a rescue plan and convincing his reluctant companions to take part. Prior to that moment, Luke was a follower, doing what he was told. But from this moment on, he's the one giving the orders.

For Joe, a similar moment occurs when he makes clear to Jerry that he's no longer running from the mobsters, now all his focus will be directed toward one aim, winning over Sugar. And Jerry is going to help him do it.

In each instance our heroes find themselves at a CROSSROADS.

And the path they choose shows them seizing control of their own destiny and committing fully to the objective they'll pursue the rest of the act.

Let's take a moment to more closely examine this particular beat, as it's incredibly useful for managing and anchoring our complicated second acts. And let's give credit where credit is due for identifying it.

Esteemed UCLA Professor Emeritus, Howard Suber, like Aristotle before him, is renowned for his examination of the dramatic works of his time, in this case, movies, and for his analysis of the observable patterns found within them. Many of these he describes in his must-read work *The Power of Film*.

And one particular event that he notes recurs over and over again in films that have stood the test of time, he calls the *One-Hour Crisis Point*. His students, however, have given it a different name in his honor, one coined by another colleague, screenwriting guru Hal Ackerman.

So at UCLA, this beat is called the *PT. HOSH*, the backward acronym for Howard Suber's One-Hour Turning Point.

But whatever you call it, its description and function remain the same. About an hour into a movie, often halfway through the second act, the hero

faces a major crisis, usually a moral or ethical quandary, and the decision he makes as a result determines the direction of the rest of the story.

And just as significantly, that choice marks a very particular *change* in the central character.

For example, at the midpoint of Michael Arndt's *Little Miss Sunshine*, Olive's family finds themselves stuck at a hospital with poor Grandpa's corpse, having been told by an administrator that their journey to the pageant has come to an end. So what does family patriarch Richard Hoover say in response? "We've come too far to quit now!" And, spoiler alert, he then proceeds to DEMONSTRATE his commitment to getting to that pageant by stealing his father's body from the hospital.

What's significant here is that prior to that moment, Richard didn't care at all about the pageant. This road trip was just an excuse for him to try and sell his goofy motivational program. But from this moment on, all his focus, attention, and energy will be devoted to the objective of getting to that pageant on time.

Andy Dufresne, previously the model prisoner, always doing what he's told, halfway through Act Two is ordered to turn off the opera music he's been broadcasting over the prison PA. After a moment's hesitation, instead of obeying this simple order, he locks the warden and guards out of the office, and turns the volume up full blast so all the prisoners might enjoy it.

Prior to this event, Andy just wanted to get along, to not make waves. But from this moment of defiance onward, he won't be anyone's docile prisoner anymore. He's getting out of Shawshank one way or another.

John Book, the big-city cop, the man who's lived by his gun, about one hour into *Witness* hands his revolver to Rachel, his Amish love interest, and asks her to hide it from him. At this midpoint, he makes the choice to no longer simply bide his time here until the heat dies down, but to endeavor to make a life for himself in this rural community that eschews violence.

Do you see a pattern?

As Professor Suber points out, prior to this moment, these heroes have been essentially *reacting* to events. Since entering the new world of the second act, things have happened, largely out of their control, and they have dealt with them accordingly. But from this moment on, they will be *causing* those events, driving the action rather than simply responding to it.

That's why I said this CROSSROADS beat anchors Act Two. It essentially divides it into two parts: Act 2a, in which our hero is REACTIVE, and Act 2b, where he is PROACTIVE. And the action that dramatizes the hero's new and whole-hearted commitment to their objective serves as the dividing line.

By thinking of Act Two in this way, it becomes much more manageable, allowing us to see it in still smaller, more discrete units, as Aristotle advises.

And just as Act 2a centers around its own midpoint, the Beat of Adaptation when our hero demonstrates he's starting to get along in his new surroundings, so does Act 2b center around its own midpoint.

In *Star Wars*, while attempting to rescue the Princess, Luke finds himself trapped in a corridor with a missing bridge. Being the hero he's now become, he valiantly swings across the chasm, with Leia in his arms and a kiss for luck.

In *Some Like It Hot*, after committing to win Sugar's heart, Joe pulls off the perfect date aboard Osgood's yacht, convincing Sugar to seduce HIM, and ending the night with her unable to keep her hands and lips off him.

What do these two beats have in common? Besides kissing.

In each example, in a moment of great conflict and potential peril, our hero accomplishes something significant that, while falling short of achieving their actual objective, at least makes that objective now seem attainable.

Luke doesn't defeat the Empire in this beat, nor does Joe win Sugar's heart. But they each perform some action halfway through Act 2b that demonstrates their objectives may be within reach.

And as with the other events we've been describing, we see this beat of ACHIEVEMENT repeated over and over again, in movie after movie.

Rocky Balboa, whose objective is to "go the distance" with Apollo Creed, in the film's most iconic scene, manages to run up the Philadelphia Art Museum steps, a feat he'd failed to perform earlier in the story.

John Book, who's been hoping desperately to make a life with the Amish who've taken him in, helps them erect a barn, taking part in a traditional rite as if he's one of the community. Heck, his romantic rival even offers him a glass of lemonade for his effort, making it seem this dream might not be so elusive after all.

Andy Dufresne meets and befriends a new prisoner, one who not only knows who actually committed the crime of which Andy's accused, but who is also eager to testify to that fact. For the first time, there's real hope of Andy achieving the exoneration he's long sought.

Like Luke swinging across that chasm with the Princess in his arms, in movie after movie our hero experiences a similar moment of accomplishment that propels him forward toward potential success.

So there is all the more emotional resonance when that heroic swing sends our hero crashing into a brick wall.

And that's exactly what happens in the next Stepping Stone beat, the devastating defeat that ends the act.

For Luke, his mentor and father figure dies right in front of him. And if that's not bad enough, the villain now knows the location of the rebel base, meaning everyone and everything they've worked so hard for is doomed.

For Joe, just when he's won Sugar's heart, and more significantly, realized he loves her too, the mobsters return. Joe has no choice now but to flee for his life, even though it means giving up his one chance at happiness.

In both of our examples, our hero encounters the worst thing imaginable, short of their own death, an event that leaves them as far from their goal as possible.

And as we've noted previously, in movie after movie, Act Two ends with this BIG GLOOM.

Andy's potential liberator is shot dead in the prison yard and he's tossed into solitary, told he'll be doing the warden's bidding for the rest of his life or be tossed down with the sodomites.

The crooked cops discover where John Book's been hiding out, endangering not only him but his newly adopted family as well. He knows he must leave.

Mrs. Robinson informs Ben he's lost Elaine forever. Maude tells Harold she's taken a lethal dose of sleeping pills. Michael's bride, and his hope for a peaceful future, gets blown to bits. Olive and her family finally arrive at the pageant, but too late to register. Dr. Kimble discovers his best friend and only ally is the person trying to kill him.

E.T. freaking dies.

As we've said, the act can end with the hero farthest from his objective, abandoning that objective, or achieving it only to realize it's a false objective. But in all cases, when the pursuit of that objective ends, they find themselves at their absolute lowest point.

Once more, a metaphorical curtain comes down, signifying the end of the act, the end of the Complications, and the end of the pursuit of the hero's objective that began at the start of the act.

And when that curtain comes back up, we will be in that deep, dark pit of despair that starts the Beginning of the End.

These then are the recurring events of a solid Act Two:

STRUGGLE IN THE NEW WORLD
ADAPTATION
CROSSROADS
ACHIEVEMENT
BIG GLOOM

Just as we noted with Act One, the actual number of beats may vary. But as it dramatizes the bulk of the story, the second act invariably contains the largest number of episodes of any of the acts.

It might not contain ALL the elements we just described, and it may contain them in a different order. Again, it all depends on the individual story and its unique requirements. Still, over and over, in movie after movie, we can observe a similar pattern of beats, one that corresponds nicely to Aristotle's description of the Middle.

Again, don't believe me? Then see for yourself.

ASSIGNMENT #8: SECOND ACT BEATS

Watch the second acts of the two movies from the previous assignment, noting the various events that make up the Complications. Can you identify the major Stepping Stone beats? Do the same patterns emerge?

TWENTY-FIVE

Resolution

Stepping Stones of Act Three

"An end . . . is that which itself naturally follows some other thing, either by necessity or as a rule, but has nothing following it."
(Poetics, Part VII)

Act Two was all about the pursuit of the hero's objective that had been set up in Act One, and it concludes with the end of that pursuit. So as our metaphorical curtain rises, we find our hero now in Act Three, the Beginning of the End.

Once again, let's follow our film examples to their resolution and look for useful patterns.

Act Three of *Star Wars* goes something like this:

> With the Empire closing in, and no time to mourn his lost friend, Luke and the rebels are debriefed on the Death Star's one weakness. Thinking the plan to be a suicide mission, Han says so long and takes off. Luke says goodbye to the Princess and boards his X-Wing.
>
> On the Death Star, Vader deploys Tie Fighters to deal with the threat, and in the first Trench Run battle, Vader manages to destroy all the rebel ships.
>
> As Luke attempts to reach the ventilation port, his wingmen are all disabled, leaving him alone. Then, trusting in the Force, he turns off his instruments. Before Vader can blast him, a returning Han Solo disables Vader's ship. Luke fires with pure intuition. Hits. The Death Star is destroyed.
>
> Luke and Han receive a hero's welcome, complete with medals. The rebellion and the galaxy have been saved.

And that's the end of *Star Wars*, at least until the sequels and prequels. Let's compare it to Act Three of *Some Like It Hot*.

```
As the boys hastily pack to flee, Joe, pretending to be
Junior on the phone, breaks things off with a devastated
Sugar.

While discussing whacking Little Bonaparte, Spats and his
goons spy Joe and Jerry escaping and recognize them as
the witnesses.

A wild chase ensues through the hotel.

Joe and Jerry hide in the banquet room as the Mob
Convention convenes. Little Bonaparte has an assassin
kill Spats and his gang. Joe and Jerry flee while federal
agents descend on the room.

Another chase, with more mobsters this time, ensues. Our
boys realize their only hope is to escape on Osgood's yacht.

But while they almost make it out, Joe, dressed as
Josephine, watches Sugar sing, and despite the fact that
it will expose him, he kisses her and tells her not to
give up on love.

The mobsters chase Joe and Jerry who escape on Spats'
gurney.

On the dinghy to the yacht, Joe finally comes clean to
Sugar, telling her who he really is and that she deserves
better. But she chooses him anyway. And despite learning
that Daphne is actually Jerry, Osgood wants to marry him
still. After all, nobody's perfect.
```

And that concludes *Some Like It Hot*.

So what beats do these Act Threes share in common?

First, we start the act in a similar place, with our heroes dealing with the immediate consequences of the defeat that ended Act Two. For Luke, it is the death of his mentor. For Joe, the end of his relationship.

At the start of Act Three of *Shawshank*, Andy actually confesses to killing his wife. Of course, he didn't really do it. But he's lost all sense of his innocence, the one thing that's been giving him hope. That's the emotional consequence of how much his captors have broken him.

Benjamin searches desperately for Elaine, only to find she's quit school. Harold, hysterical, takes Maude to the hospital. Michael mournfully returns home to his family's compound. Elliot gives a tearful goodbye to his only friend.

In each case, what we see is the AFTERMATH of the Big Gloom, a beat that reveals what life for our hero is like due to their loss—

—until some new event snaps them out of it and reignites their commitment to a goal.

Luke learns what must be done to stop the Imperial threat once and for all, just as his departing buddy wishes, "May the Force be with you." Joe

and Jerry, witnessing yet another mob hit, realize they've escaped one threat only to become ensnared by a larger one.

In *Shawshank*, while talking to Red in the prison yard, Andy's own words convince him that he must either *get busy living or get busy dying*.

E.T. miraculously returns to life. Benjamin learns where Elaine's wedding will be held. Jerry flees, convincing Marge of his guilt. Harold learns his soul mate has died.

In each instance, some kind of CATALYST engages, either internally or externally, that makes our hero realize they simply can't persist in this Gloom, but must redouble their efforts to accomplish either their original objective, or one that has emerged as more urgent.

As a result, they put some kind of PLAN into action. For Luke, that involves exploiting the Death Star's vulnerabilities. For Joe and Jerry, it means figuring out a way back onto Osgood's yacht.

For Andy, it's putting the final touches on an elaborate escape. For Elliot, it's finding a way to the UFO landing site. For Ben, it's getting to the church on time. For Jake, it's luring the police away so he can arrange passage for Evelyn to Mexico.

But by now, the forces aligned against our hero are more powerful than ever, truly testing their resolve and ability, requiring them to make use of all they've learned and all the ways in which they've changed to even attempt to overcome them.

And this leads to our CLIMAX. For Luke, it's an exciting trench battle on the surface of the Death Star. For Joe and Jerry, it's a madcap chase for their lives through the hotel corridors.

It's the rain-choked passage through putrid sewers into freedom. It's a desperate bike ride across a moonlit sky. A shoot-out with ruthless kidnappers. A drive off a cliff. A church brawl.

It could be a fiery courtroom speech. A bold declaration of love. A priest demanding the devil take him instead. Climaxes come in all shapes and sizes. But in all of them, some things are fairly consistent.

First, as it represents the ultimate confrontation between the hero's desire for their objective and the forces opposing it, this beat has the greatest stakes and the most conflict, resulting in the highest point of physical and emotional action.

And in the beat's final moments, as the action builds to a crescendo, the hero will DO something that they could never have done before, something that demonstrates how far they've come, how much they've changed.

So Luke, whose job was once maintaining the technology back on the farm, *turns off* his ship's computers, fully trusting in the Force, in his own intuition, for the first time.

Joe, knowing full well he's compromising his chance at escape, exposes his true identity to Sugar in order to prevent her from giving up on love. For the first time, he puts *someone else's* welfare ahead of his own.

John Book, without a weapon, uses non-violence for the first time to stop the corrupt cops from harming his new community.

Richard Hoover gets up on stage and dances with his daughter with wild abandon, for the first time unafraid of what others think of him.

In each instance, we see a character put themselves on the line, take a tremendous risk, make a sacrifice, maybe even abandon the thing they had sought for so long, to accomplish something much more significant.

And win or lose, as a result of this action, a new character emerges. Luke the callow, impetuous farm boy is now Luke the daring, galaxy-saving warrior. Joe the deceitful, selfish cad is now Joe the selfless and honest monogamist.

Rick Blaine, the apathetic cynic, has become the optimistic patriot. Andy Dufresne, the meek pushover, is now the stalwart man of action. Benjamin Braddock, once aimless and adrift, has purpose and resolve. Harold, obsessed with death, has a newfound love of life. And Michael Corleone, the man who wanted nothing to do with his family's business, is now its ruthless patriarch.

In Aristotle's terms, this climax reveals the hero's Change of Fortune, manifested by the character overcoming or being overcome by their primary flaw, their *hamartia*.

And as a result, a NEW EQUILIBRIUM is revealed.

We see Luke receiving his medal, lauded as the hero he's become. We see Joe and Jerry heading off into the sunset, matrimonial bells ringing for them both.

Andy and Red embrace on the Mexican beach that will be their new home. Ben and Elaine stare off into space as they sit in the back of the bus, their exciting future now once again fraught with anxiety and uncertainty.

Harold dances, full of life. Jerry is taken into custody, case closed and onto the next. Michael shuts the door on his wife as his associates now kiss his ring as their new Godfather.

Oedipus, blinded, staggers off into the wilderness, destined to be a despised outcast for the rest of his days.

And as the curtain comes down on our story for the last time, we've resolved the dramatic question posed at the beginning.

Did he get the girl? Did he get the guy? Did he escape? Win the battle? Solve the crime? Pull off the crime? Get his buddy home? Make partner? Finish the race? Did she get what she wanted? Did she get what she needed? Or did she get something else entirely?

Fade out. The End.

And those are the Stepping Stones of Act Three. Once more, they are:

AFTERMATH
CATALYST
PLAN
CLIMAX
NEW EQUILIBRIUM

Again, the precise number of beats may vary, depending on the unique needs of the story.

For instance, a character might remain in the aftermath of the Big Gloom for longer, as in *Some Like It Hot*, or they might immediately snap out of it and start pursuing their Act Three goal, as in *Star Wars*.

The catalyst that provokes that goal might be abrupt, as in *E.T.*, or it might be more gradual, requiring several different events, as in *Chinatown*.

The final climactic confrontation could be reached quickly, without need for much planning, as in *Fargo*, or it might require lengthy preparation, as in *The Shawshank Redemption*.

And we might get a sense of the new equilibrium in just a single brief episode, like in *The Graduate*, or it might require tying up many loose ends, as in *The Return of the King*.

But what is almost always certain is that the Third Act will have the fewest number of beats of the three, since the story's momentum is now at its highest, driving relentlessly from that Big Gloom to our final resolution.

And while it may be the shortest act, over and over, in movie after movie, we can observe a similar pattern of episodes, one that corresponds nicely to Aristotle's description of The End.

Once more, don't believe me? Then see for yourself.

ASSIGNMENT #9: THIRD ACT BEATS

You guessed it, watch the third acts of the two movies from the previous assignments, noting the various events that make up the Resolution. Can you identify the major Stepping Stone beats? Do the same patterns emerge?

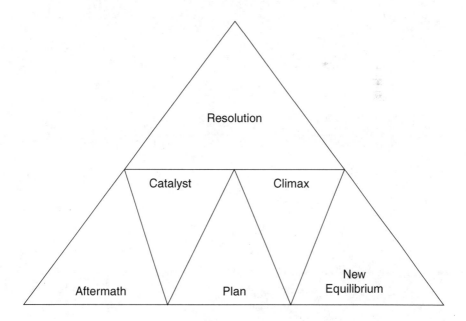

TWENTY-SIX

Stepping Stones

Building the Great Pyramids

"Narrative . . . should have for its subject a single action, whole and complete, with a beginning, a middle, and an end. It will thus resemble a living organism in all its unity, and produce the pleasure proper to it."
(Poetics, Part XXIII)

Now that we've followed Aristotle's advice, determining the general shape and then filling in the episodes, we have an even clearer sense of the solid structure of a successful movie story.

It contains events that take us from one equilibrium to another, with everything in between connected through the laws of probability and necessity. And the biggest structural moments, the Stepping Stone beats, often follow an observable pattern.

Those beats are:

SET-UP

OPENING HOOK/HERO INTRO
EQUILIBRIUM
INCITING INCIDENT
CONSEQUENCE
POINT OF NO RETURN

COMPLICATIONS

STRUGGLE IN THE NEW WORLD
ADAPTATION
CROSSROADS
ACHIEVEMENT
BIG GLOOM

RESOLUTION

AFTERMATH
CATALYST
PLAN OF ACTION
CLIMAX
NEW EQUILIBRIUM

These fifteen episodes recur over and over again, in story after story, movie after movie, as hopefully your own investigations and the examples at the end of this chapter demonstrate.

And as you examine those examples, structural diagrams of a diverse collection of movies, you might notice an interesting phenomenon. Just as in nature, when you look closer at some objects, a fractal, a sunflower, a *nautilus* (upon which Aristotle also famously wrote a treatise), you'll discover that it is made up of smaller parts that look astonishingly like the whole.

So, too, do the individual parts of a story reflect its larger overall shape.

The story proper is made up of a beginning, middle, and end. And each of those components, the three acts, is itself made up of a clear beginning, middle, and end. And, spoiler alert, as we shall soon see in our chapter on SCENES, the components that make up each of these beats also bear an identical form and function.

It's just as Aristotle maintains, a proper structure resembles a living organism in all its unity.

But before we get too esoteric, we should reiterate that not every story HAS to have all fifteen of these specific moments. Nor must they always follow this precise order.

It's simply vital to acknowledge the pattern, to see that it exists in stories that have stood the test of time, to help make choices for your own, or at least to know you are standing on firm ground when your stories organically demonstrate a similar pattern.

But one thing that is inarguable is that your story is made up of events, specific, dramatizable units of action.

These beats both advance the story and reveal character since each changes the story's circumstances in some way while tracking your character's arc by revealing how they behave differently than in previous beats.

And there's a particular tempo to these beats.

As Aristotle says:

> *"Imitation, then, is one instinct of our nature. Next, there is the instinct for 'harmony' and rhythm."*
> (Poetics, Part IV)

If you observe that your average film these days is about two hours long, then these bigger events tend to happen with some consistent 'rhythm.' The midpoint is at the one-hour mark. The first act break is often about thirty minutes in, the second act break about ninety minutes in. The beats of adaptation and achievement at forty-five minutes and seventy-five minutes, respectively, being the midpoints of the two halves of the second act.

So that means a major reversal or revelation is happening approximately every fifteen minutes or so.

And that can be a useful guide.

Think of it in these terms, every fifteen minutes or so something will occur to turn your story in a new and unexpected direction. And every fifteen minutes or so, your hero will do something differently than he would have, had he encountered that complication fifteen minutes earlier.

As we'll see, a minute of screen time is the equivalent of a page of a screenplay. So from a writer's perspective, that means some major event will be occurring every fifteen pages or so. For whatever reasons, that's become the natural rhythm of a contemporary movie story, one that, as the examples at the end of this chapter reveal, an audience finds harmonious.

Again, think of this as a useful insight, an observation, a helpful guide. Your story doesn't HAVE to go this way. It has to go how it has to go, unique to your story and your characters. But it does need to track a character's change through the pursuit of a specific objective, and it does need to be made up of the events that allow for that pursuit and for that change, no more, no less.

However you get there.

ASSIGNMENT #10: STEPPING STONES

Now that you've identified these moments in movies that you've watched, it's time to further refine your OWN story by making these critical choices for your own screenplay. So use the following guide (and the provided samples) to identify the major Stepping Stone beats of your original story.

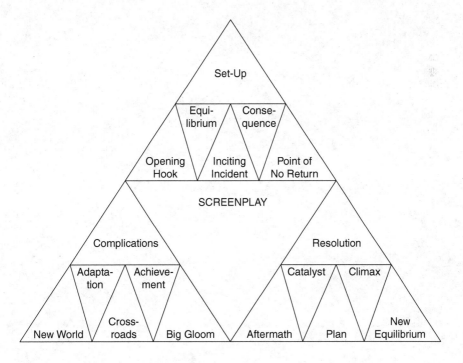

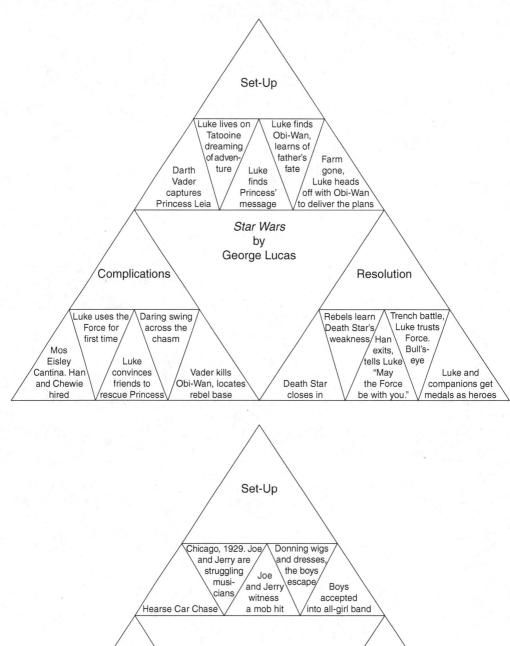

Set-Up

Luke lives on Tatooine dreaming of adventure

Luke finds Obi-Wan, learns of father's fate

Darth Vader captures Princess Leia

Luke finds Princess' message

Farm gone, Luke heads off with Obi-Wan to deliver the plans

Star Wars
by
George Lucas

Complications

Luke uses the Force for first time

Daring swing across the chasm

Mos Eisley Cantina. Han and Chewie hired

Luke convinces friends to rescue Princess

Vader kills Obi-Wan, locates rebel base

Resolution

Rebels learn Death Star's weakness

Trench battle, Luke trusts Force. Bull's-eye

Han exits, tells Luke "May the Force be with you."

Death Star closes in

Luke and companions get medals as heroes

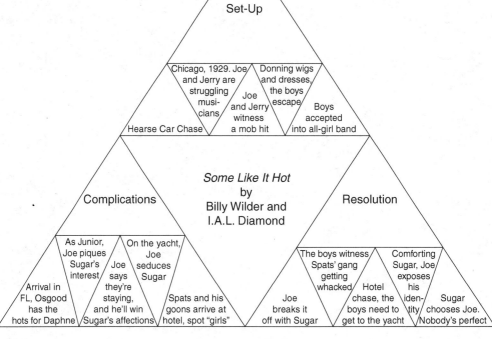

Set-Up

Chicago, 1929. Joe and Jerry are struggling musicians

Donning wigs and dresses, the boys escape

Hearse Car Chase

Joe and Jerry witness a mob hit

Boys accepted into all-girl band

Some Like It Hot
by
Billy Wilder and
I.A.L. Diamond

Complications

As Junior, Joe piques Sugar's interest

On the yacht, Joe seduces Sugar

Arrival in FL, Osgood has the hots for Daphne

Joe says they're staying, and he'll win Sugar's affections

Spats and his goons arrive at hotel, spot "girls"

Resolution

The boys witness Spats' gang getting whacked

Comforting Sugar, Joe exposes his identity

Joe breaks it off with Sugar

Hotel chase, the boys need to get to the yacht

Sugar chooses Joe. Nobody's perfect

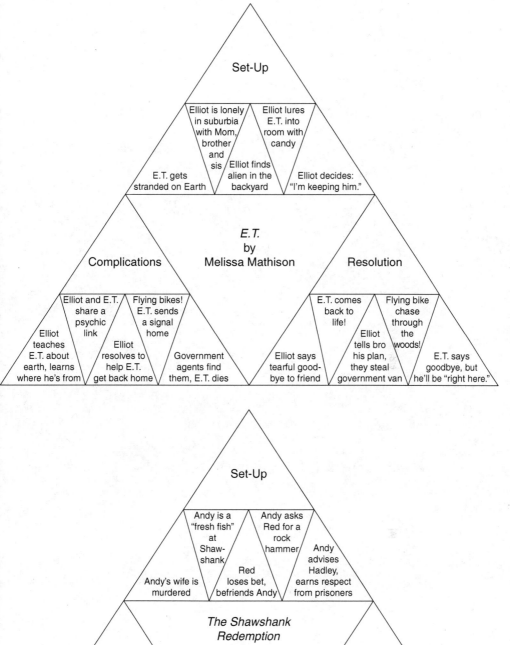

Set-Up

Elliot is lonely in suburbia with Mom, brother and sis

Elliot lures E.T. into room with candy

E.T. gets stranded on Earth

Elliot finds alien in the backyard

Elliot decides: "I'm keeping him."

E.T.
by
Melissa Mathison

Complications

Resolution

Elliot and E.T. share a psychic link

Flying bikes! E.T. sends a signal home

Elliot teaches E.T. about earth, learns where he's from

Elliot resolves to help E.T. get back home

Government agents find them, E.T. dies

E.T. comes back to life!

Flying bike chase through the woods!

Elliot tells bro his plan, they steal government van

Elliot says tearful goodbye to friend

E.T. says goodbye, but he'll be "right here."

Set-Up

Andy is a "fresh fish" at Shawshank

Andy asks Red for a rock hammer

Andy advises Hadley, earns respect from prisoners

Andy's wife is murdered

Red loses bet, befriends Andy

The Shawshank Redemption
by
Frank Darabont

Complications

Resolution

Andy's letters pay off, gets new library

Tommy has evidence of Andy's innocence

Hadley beats Andy's tormentors, Warden gets him job

Disobeying Warden, Andy turns up opera

Tommy killed, Andy sent to the hole

Andy decides to "get busy living or get busy dying."

Andy climbs to freedom, gets revenge on Warden

Andy, broken, tells Red, "I killed her."

Andy completes elaborate escape plan

Red reunites with Andy in Mexico

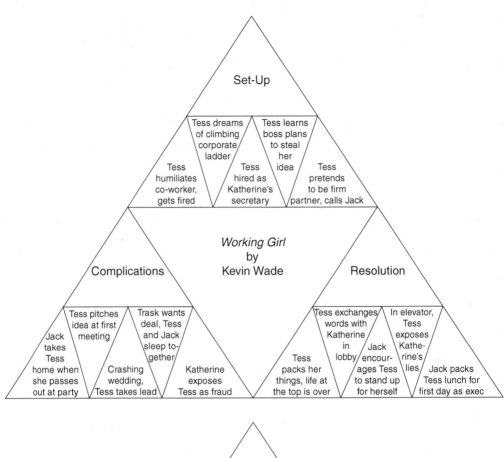

Set-Up

Tess dreams of climbing corporate ladder

Tess learns boss plans to steal her idea

Tess humiliates co-worker, gets fired

Tess hired as Katherine's secretary

Tess pretends to be firm partner, calls Jack

Working Girl
by
Kevin Wade

Complications

Tess pitches idea at first meeting

Trask wants deal, Tess and Jack sleep to-gether

Jack takes Tess home when she passes out at party

Crashing wedding, Tess takes lead

Katherine exposes Tess as fraud

Resolution

Tess exchanges words with Katherine in lobby

In elevator, Tess exposes Katherine's lies

Tess packs her things, life at the top is over

Jack encour-ages Tess to stand up for herself

Jack packs Tess lunch for first day as exec

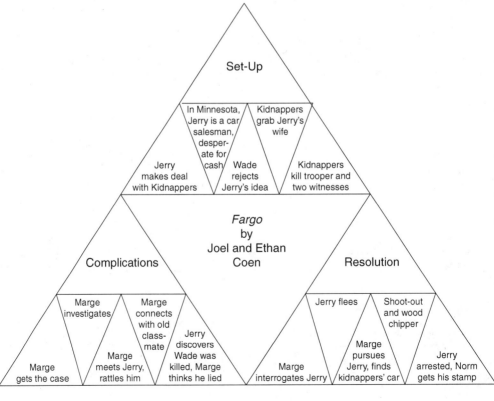

Set-Up

In Minnesota, Jerry is a car salesman, desper-ate for cash

Kidnappers grab Jerry's wife

Jerry makes deal with Kidnappers

Wade rejects Jerry's idea

Kidnappers kill trooper and two witnesses

Fargo
by
Joel and Ethan Coen

Complications

Marge investigates

Marge connects with old class-mate

Marge gets the case

Marge meets Jerry, rattles him

Jerry discovers Wade was killed, Marge thinks he lied

Resolution

Jerry flees

Shoot-out and wood chipper

Marge interrogates Jerry

Marge pursues Jerry, finds kidnappers' car

Jerry arrested, Norm gets his stamp

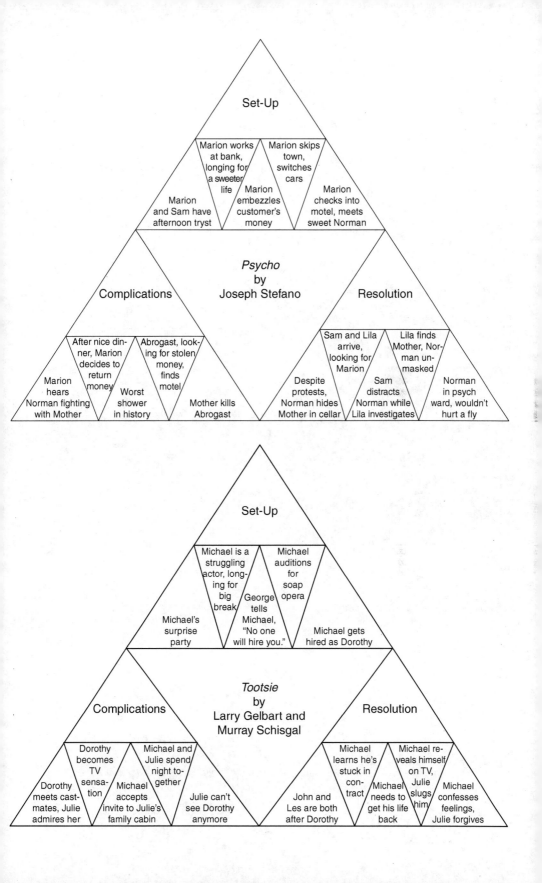

Set-Up

Marion works at bank, longing for a sweeter life

Marion skips town, switches cars

Marion and Sam have afternoon tryst

Marion embezzles customer's money

Marion checks into motel, meets sweet Norman

Psycho
by
Joseph Stefano

Complications

Resolution

After nice dinner, Marion decides to return money

Abrogast, looking for stolen money, finds motel

Marion hears Norman fighting with Mother

Worst shower in history

Mother kills Abrogast

Sam and Lila arrive, looking for Marion

Lila finds Mother, Norman unmasked

Despite protests, Norman hides Mother in cellar

Sam distracts Norman while Lila investigates

Norman in psych ward, wouldn't hurt a fly

Set-Up

Michael is a struggling actor, longing for big break

Michael auditions for soap opera

Michael's surprise party

George tells Michael, "No one will hire you."

Michael gets hired as Dorothy

Tootsie
by
Larry Gelbart and
Murray Schisgal

Complications

Resolution

Dorothy becomes TV sensation

Michael and Julie spend night together

Dorothy meets castmates, Julie admires her

Michael accepts invite to Julie's family cabin

Julie can't see Dorothy anymore

Michael learns he's stuck in contract

Michael reveals himself on TV, Julie slugs him

John and Les are both after Dorothy

Michael needs to get his life back

Michael confesses feelings, Julie forgives

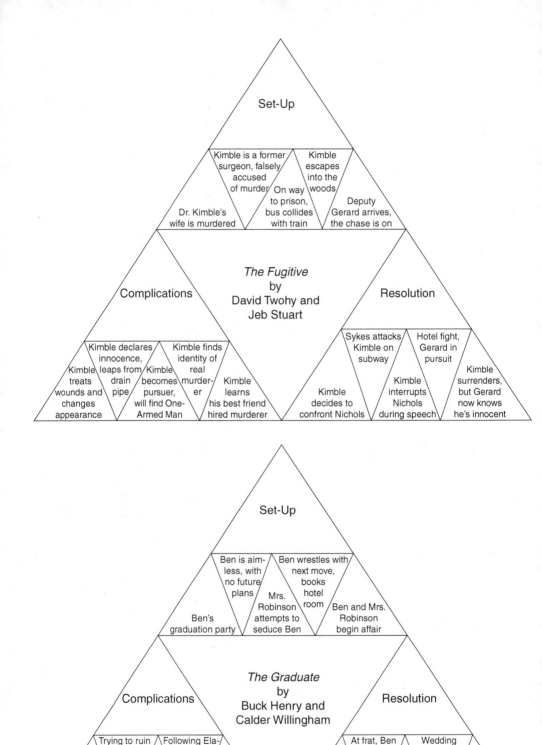

Beat Sheets

Putting It All Together (Part 2)

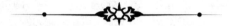

"It remains to fill in the episodes [and] we must see that they are relevant to the action."

(Poetics, Part XVII)

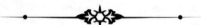

Wow. Now that you've made your initial choices about your Stepping Stone scenes, you've accomplished something tremendous, you've created the overall shape of your story.

Great job!

But don't be getting too cocky just yet, there's still a ways to go.

Once again, remember Aristotle's dictate for how to create your screenplay.

> *"First sketch its general outline, then fill in the episodes and amplify in detail."*
>
> (Poetics, Part XVII)

And that's the exact process we've been undertaking.

We sketched the general shape with our Anchor Points and then refined it with our Stepping Stones. Now it's time to take the next step in preparation for the actual writing of the screenplay, filling in the episodes.

Those episodes, the moment-by-moment development of the story, comprise our outline, or more precisely, what we call the Beat Sheet.

For many, this is the hardest part of the process, but as any screenwriter worth their salt knows, it is also the most important. Everything up till now has been leading to this point, the final step of crafting the story before transferring it to the screenplay page, where we will then "amplify in detail" with *diction* and *spectacle*.

But before we set out on this final step of story development, let me share some words of advice.

Screenwriting is all about making choices. You start with a blank canvas and an infinite number of possibilities. Then you add things to that canvas by making decisions about what should be on it. Trust your instincts. Trust your brilliance. But always be aware, you will most likely *change* almost every one of those choices before all is said and done.

That's because REWRITING is an integral part of the screenwriting process.

So while staring at any blank page can be terrifying because of all the possibilities, take comfort. It is exponentially easier to correct, revise, improve, and hone what's already there, than to start from nothing. So have faith that it will eventually get where you need it to go.

And till then, give yourself permission, each step of the way, to be less than perfect. To be a *lot* less than perfect, especially with those initial choices.

For while rewriting will be a crucial step after completing your first draft, each and every part of the story development process is a chance to make changes and improvements, to the big moments and the small.

So as we start to craft our Beat Sheet, let's seize the opportunity to rethink and improve the choices we've already made. After all, if we remain married to our initial decisions, we are hardly *developing* a story at all.

Look back at the moments you've chosen. Are the reversals and revelations as strong as they can be?

Do we have a clear sense of our hero's normal world before the inciting incident disrupts it? Does the first act break constitute the crossing of a threshold into a completely different world? Is the second act break the absolute worst thing that can happen to your hero? Do those act breaks bookend the pursuit of a clear, urgent, and dramatizable objective?

Is the climax the highest point of physical and emotion action? Does the resolution give a sense of the new equilibrium? Has the hero changed? Has every event leading up to the resolution been connected through the laws of probability and necessity? Did your ending answer a dramatic question that you'd set up at your beginning?

In other words, do the decisions you've made so far add up to a story that is an imitation of an action, whole, complete, unified, and with a particular magnitude?

Hopefully the answers are yes. Still, before proceeding, take each and every choice you've made, and make them *better*.

There, well done. Now, on to the BEAT SHEET.

First, if you learn only one thing from Aristotle and me, it should be that every good screenplay is the result of meticulous and deliberate planning, never simply made up as you go along.

And the ultimate manifestation of that plan is the Beat Sheet. It is your story broken down into all its component episodes, EVERYTHING that happens in the story from the Opening Hook to the final image.

That may seem daunting, but it is essential. For only once you know your story moment by moment, and are confident that it *works*, can you then focus your creative energies on *how* those moments will actually play out on screen.

And keep in mind, that plan can and *will* change as you translate your completed story into dialogue and description. You will discover things you hadn't thought of and you will realize that things you'd planned just won't work. But before you can embark upon the journey of writing screenplay pages, you need a detailed road map.

And a road map is as good a metaphor as any for a Beat Sheet. For it is the guide with which you will always know where you're headed, or at least where you *intend* to head. And just as with a cross-country road trip, you may change your mind along the way, take a side trip to visit the House of Mud or a short-cut through a more picturesque town. But still, thanks to your map, you always know how to get back on the highway and to your eventual destination.

So what precisely does a Beat Sheet *look* like?

The answer to that question requires we first make sure we're crystal clear about what constitutes a BEAT. And that's far from an easy task.

Contrary to what some beginning writers believe, a beat is *not* a scene (which we will discuss in more detail in the next chapter). A scene is defined by a change in location or time. So when you move to a new location or a new time in your story, you are moving to a new scene.

Beats, on the other hand, do not have such an easily definable beginning or ending. They are *made up* of scenes, which taken together, constitute a single event or plotpoint, a discrete unit of action.

A beat can be big or small. It can be Jake hiring Curly to ferry Evelyn to Mexico, a brief but vital EVENT in the plot of *Chinatown*. Or it can be as massive as the storming of Omaha Beach that opens the flashback of *Saving Private Ryan*.

It can be a fraction of a screenplay page or be several pages, can represent one scene or many, all depending on that event's requirements.

But what all beats have in common is that they represent a singular unit of action that advances the story and our understanding of the characters.

You already know the most significant beats in your story, the ones that comprise your Stepping Stones. Each of those is an event that reveals character while moving the story forward. And each one may be made up of one or several scenes.

What makes a beat hard to define is that different writers may have a different sense of just what constitutes a given unit of action. It is, in fact, very subjective.

For example, in a future screenplay, I might decide that a particular beat is the one in which Bill discovers that his wife Sarah is cheating on him. That is clearly a significant event, a revelation that will move the story in a new direction.

And it may be made up of the following moments:

Bill leaves work early. Stops at a florist to buy some flowers. Drives home to find a strange car in the driveway. Goes inside and hears a sound upstairs. Grabs a bat from the closet and stealthily climbs the stairs. Opens the bedroom door. Discovers Sarah in bed with his mother.

I just described several scenes, each represented by a change in time or location. But in terms of events that make up the story, I really only described one plotpoint, one significant event, the BEAT where Bill discovers Sarah is cheating on him.

What makes the concept of a beat so subjective is that what one writer may deem significant, another may not.

For instance, in the above example, one writer might say all of those scenes together are components of one beat, the discovery of the affair. But another writer may decide no, the scene at the florist is itself a separate beat because of some important development or revelation that occurs there. Still, its unlikely any writer would say the drive to the house or the walk up the stairs is a separate beat since those smaller scenes are clearly part of a larger unit of action.

So while the choice of what constitutes a beat can vary from writer to writer, there are certain characteristics about them that do not, characteristics firmly rooted in what we've already learned from Aristotle about what makes for a good story.

Your story is composed of beats, dramatizable events.

Each beat is caused by what precedes it and causes what follows, according to the laws of probability and necessity.

Each beat advances the plot or turns it in a new direction.

Each beat advances our understanding of character, revealing new aspects or facilitating change.

If a beat doesn't change the circumstances of the story, by leaving our hero closer to or farther from their objective, or by contributing to their eventual Change of Fortune, it is not part of the whole and doesn't belong.

And though the actual make-up of a beat may differ from writer to writer, it is important that you be consistent with what *you* consider a beat, so that you can be aware of the actual NUMBER of unique events or episodes that comprise your story.

For with regards to a story's *magnitude*, the principle that a story must be made up of the proper number of events needed to bring about a hero's Change of Fortune, we can make some useful generalizations by looking at patterns in successful contemporary movies.

For instance, your average feature-length film contains anywhere from thirty to sixty beats.

The difference in number is often tied to a story's genre. Given an average length of two hours, a drama will have fewer, yet larger, more dramatic events, around thirty beats. Comedies and action films, due to their quicker pacing, given equal length, could have up to sixty.

Act One is usually made up of about five to fifteen beats. The first is obviously the Opening Hook. Then half the beats lead up to the Inciting Incident, peeling back the layers of the onion of the equilibrium, and half lead from the Inciting Incident to the First Act Break, detailing the consequences of that disruption until the hero is launched into the plot of the movie.

Act Two, the bulk of the movie, contains the most beats, usually about fifteen to thirty. Half lead up to the midpoint Crossroads, with the hero reactive, and half lead from there to the Big Gloom, with the hero now proactive. The beats in this act are propelled by the hero's dramatizable objective, and

the obstacles and stakes continuously rise, in direct opposition to the continual growth of the hero.

Act Three contains the fewest number of beats, usually from three to ten. With accelerated momentum, they will take us from the Big Gloom to the Catalyst to the Climax, the beat of highest emotional and physical action. And immediately after, we'll have the "falling action," beats that resolve the dramatic question and establish a New Equilibrium.

Now the above "count" may seem mathematical and soulless. But the truth is that an audience comes to a film with certain expectations. Even if just subconsciously.

So they may not be aware of the nature of a beat, or the number of them within each act, or of the concept of an act altogether. But they sure are aware when something feels off, lacking that "harmony and rhythm" that Aristotle describes as naturally pleasing.

So the job of the screenwriter is to provide an experience that either satisfies those expectations, hopefully in a surprising way, *or* deprives an audience of that satisfaction, but with full knowledge of the consequences.

And as you go about selecting your beats, here are some additional thoughts to help guide you (with a tip of the hat to screenwriting guru Lew Hunter, who first impressed many of these upon me).

1. While the fundamental function of a beat is to advance story and character, it is also to keep the audience from falling asleep. So create beats that are fresh, interesting, and entertaining.
2. Create beats that give actors and directors things to *do*, that communicate their meaning through what we *see* and *hear*.
3. Variety is the spice of life, and of movie stories. So give yours a healthy variety of beats. Big ones, small ones, talky ones, silent ones, active ones, staid ones, indoors, outdoors. Keep us on our toes by mixing things up.
4. Speaking of keeping us on our toes, SURPRISE us. Don't be predictable with where the story goes. If I can accurately guess what will happen on page sixty after reading page two, you've got problems. Remember, Aristotle says that the primary tools we have for building a story are *reversals* and *revelations*, so let the story take sudden, unexpected, but always motivated, turns. Zig when we expect you to zag.
5. Set up and pay off. Not every beat needs to be self-contained, resolving itself by its end. Some beats are necessary to tee up future ones. If Fluffy is going to go missing in Act Two, you'll need beats in Act One to establish how much Timmy loves that rascal. If the ship's flare gun is going to kill the intruder in the climax, you'll need an earlier beat to reveal it nestled in the galley closet. Audiences love the tension that's built from anticipation, whether you give them what they anticipate or thwart it.
6. Keep in mind that films are called "moving picture" for good reason, so keep things *moving*. To that end, avoid beats of characters simply sitting around and talking to each other. They may work well in a play, but in a movie tend to grind things to a screeching halt, especially if solely intended to convey exposition. We want to *watch* the story, not hear people talk about it.

7. Don't forget that beats have a causal connection. What precedes must cause or affect what follows. But also remember that you may have various narrative threads progressing simultaneously, not all dealing directly with your hero. There are supporting characters, parallel actions, subplots, even an antagonist or two. Some beats allow you to take a break from your hero to see what's up with one of these other story threads.

8. And finally, always keep in mind that your Beat Sheet is a living, breathing, organic document. It will be constantly changing, evolving, and growing.

I usually start with an outline that's about six pages long, with just a few sentences to describe each beat. As I work on it and fill in detail, it grows longer and more explicit, with details of behavior, dialogue, action, and description included, until it grows to about sixty pages, a full page devoted to each beat.

But even then it's not done. I'll continue working on my Beat Sheet even while writing the screenplay pages. And I'll make changes to it whenever I notice that I'm veering dramatically from it in those pages, so that I'm always ahead in the outline, always knowing where I'm heading.

So as with every other part of the process, don't get married to your choices. They will change.

But you have to start somewhere.

Now let's put all these observations into practice.

Every writer I know does it slightly differently, but when constructing a Beat Sheet, most stick close to the following format:

Number each individual beat.

Give each beat a TITLE that describes its principle focus or function, as in ELLIOT MEETS E.T. or POOLE DEACTIVATES HAL. You can also title a beat simply with a slugline that describes its primary location, as in EXT. BACKYARD—NIGHT or INT. POD BAY.

Follow that title with two or three sentences that describe the events of the beat in greater detail.

Divide the outline into acts and identify each structural beat as such (inciting incident, crossroads, climax, etc.).

Put each new character's name in ALL CAPS when first mentioned.

And have fun with it. Enjoy watching your story come to life in all its details. Just remember, as good as your initial decisions might be, they will only get better.

ASSIGNMENT #11: BEAT SHEETS

1. The best way to get a handle on Beat Sheets is to see them in action. So watch a movie from the recommended movie list and write a Beat Sheet from it, according to the given format.

Use the following examples as guides.

SOME LIKE IT HOT BEAT SHEET

ACT ONE

1) EXT. CHICAGO STREET - NIGHT

A hearse filled with a coffin and pallbearers, turns out to be gangsters and booze. Cops give chase and a shoot-out ensues. The gangsters get away. It's 1929, the heart of Prohibition.

2) INT. MOZARELLA'S FUNERAL HOME - NIGHT

SPATS COLOMBO and his GOONS enter the establishment. A DETECTIVE confers with TOOTHPICK CHARLIE about the illegal speakeasy inside. He tells his men to give him ten minutes, then burst in. Inside, we meet JOE and JERRY, two musicians with the band who are having money troubles. Joe wants to put their paycheck on a dog at the track. Jerry sees the cop's badge and the two start nonchalantly packing up. The raid occurs. Spats is arrested, as are the dancers and the rest of the band.

3) INT. TALENT AGENCY - DAY

Out of work again, and having lost their overcoats at the track, the boys try to get a gig. Meanwhile, SWEET SUE and her manager BIENSTOCK are looking for a sax and bass player for their all-girl band. NELLY tells the boys there's a gig in Florida, but when they try to get the agent to book them, he informs them it's for women only. Instead, they take a one-night gig in Urbana.

4) INT. GARAGE - NIGHT (Inciting Incident)

As Joe and Jerry try to pick up Nelly's car for their gig, they witness Spats Colombo and his goons kill Toothpick Charlie and his men. The two barely escape with their lives.

5) INT. TOBACCONIST - NIGHT

Realizing that they are marked men and that they can't go to the police, Joe comes up with a plan. He calls his agent, disguising his voice as a woman's.

6) EXT. TRAIN STATION - DAY

Joe and Jerry show up in drag, as Josephine and Daphne. Jerry doesn't think they'll be able to pull this off, but a NEWSPAPER BOY warns of a feared bloody aftermath to the gangland slaying. Jerry gives in. They see SUGAR CANE, a sexy member of the band, and manage to convince Sweet Sue and Bienstock that they are the "new girls" hired for the gig.

7) INT. TRAIN - DAY

Joe and Jerry are introduced to the other girls in the band. Jerry feels like he's fallen into a candy shop. Joe tells him to behave, and rips one of Jerry's "chests."

They talk to Sugar Cane, who's secretly drinking in the bathroom. They learn that she's running away from something and will be kicked out of the band if she's caught drinking again.

8) INT. TRAIN - NIGHT (Point of No Return)

Sweet Sue and the Society Syncopaters rehearse. At first, Joe and Jerry play rather lamely, but when Sue asks them to goose it up a bit, they comply, to her satisfaction. At the end of Sugar's singing, her flask shimmies loose. Bienstock tells her she's fired, until Jerry comes to her aid, pretending the flask is his. Sugar smiles at Jerry appreciatively as the boys are officially accepted into the band.

ACT TWO

9) INT. TRAIN - NIGHT

Their first night on the train, Sweet Sue has suspicions about the two new girls. Jerry has to keep reminding himself he's a girl to control his sexual urges.

10) INT. TRAIN - JERRY'S BERTH - NIGHT

After Sugar climbs into Jerry's berth to thank him for saving her, Jerry decides to seduce her. But his attempts fail and result in an all-girl slumber party.

11) INT. TRAIN - BATHROOM - NIGHT

Joe and Sugar make ice in the sink while she confesses to him why she's running away and that she has a thing for sax players. She wants to find a helpless millionaire to marry in Florida. Joe clearly has the idea to woo her.

12) INT. TRAIN - JERRY'S BERTH - NIGHT

The party ends abruptly when Jerry pulls the emergency brake. The girls scatter back to their beds before Sue catches them.

13) EXT. SEMINOLE RITZ - DAY

The band arrives in Florida. Sugar is disappointed that the millionaires ogling them are so old. One of them, OSGOOD, has eyes on Daphne and makes a pass at her on the elevator.

14) INT. HOTEL ROOM - DAY

The girls are given room assignments. Joe tells Sugar he knows she'll find a young millionaire. The BELLHOP comes on to him. Joe and Jerry complain about lecherous men and how difficult it is to be a woman. Jerry wants to quit the ruse but Joe insists they maintain it, saying they have safety and free room and board. But Jerry suspects it's really all about Sugar. Sugar shows up and she and Daphne head for the beach while Joe puts on Bienstock's stolen resort clothes.

15) EXT. BEACH - DAY (Adaptation)

As Jerry and Sugar frolic in the surf, Joe appears in the guise of millionaire JUNIOR. Sugar runs into him and he convinces her he's a disinterested Shell Oil heir with a yacht. She pretends to be a society girl. Jerry catches on to Joe's ruse and they both threaten each other.

16) INT. HOTEL ROOM - DAY (Crossroads)

Jerry tries to expose Joe, but he outfoxes him. They threaten each other some more. When Osgood calls to invite Daphne for dinner on his yacht, Joe comes up with a scheme to win Sugar, with Jerry's help.

17) INT. BALLROOM - NIGHT

The Society Syncopators perform "I Wanna Be Loved By You." Sugar is disappointed that Junior isn't there, but Jerry is disappointed that Osgood is. Joe gives Sugar the flowers sent for Daphne, and invites her to Osgood's yacht.

18) EXT. SEMINOLE RITZ - NIGHT

Joe hurries to change into Junior and sneaks out the window to get to the dock before Sugar. Daphne convinces Osgood to spend the night off the yacht.

19) EXT. DINGHY - NIGHT

Joe and Sugar meet up, but Joe doesn't know how to drive the boat so they have to journey to the yacht backwards.

20) INT. YACHT - NIGHT (Achievement)

Joe and Sugar have their late night date, each pretending to be someone else. Joe has to think fast on his feet to explain his lack of knowledge about the yacht. When Sugar shows concern about being alone with a man, Joe manages to convince her that, since the tragedy, he doesn't like girls. Sugar decides to take up the challenge. Thus he seduces her by convincing her to be the seducer.

21) EXT. RESTAURANT - NIGHT

Meanwhile, Jerry and Osgood have their date, dancing the night away. Jerry is clearly getting into it.

22) EXT. DOCK - MORNING

At the end of the evening, Osgood returns to his yacht, passing Sugar and Junior who are returning from it. Junior and Sugar kiss good night, and Joe scurries back up the balcony.

23) INT. HOTEL ROOM - DAY

Jerry reveals he's engaged to Osgood, and plans a wedding and annulment. Sugar shows up and tells the "girls" about her amazing night.

24) INT. HOTEL LOBBY - DAY

Spats Colombo and his goons show up to attend the Friends
of Italian Opera Convention (a front for a mob meeting),
and their guns are confiscated by Little Bonaparte's men.
The cops are waiting for them, threatening that as soon
as they find the two witnesses, they'll arrest them for
the St. Valentine's Day Massacre. Joe and Jerry discover
the mobsters are here.

25) INT. HOTEL ELEVATOR - DAY (Big Gloom)

As Joe and Jerry try to beat a hasty retreat, the goons
corner them in the elevator, thinking they look familiar.
The goons get their hotel number and say they'll be in
touch.

ACT THREE

26) INT. JOE AND JERRY'S HOTEL ROOM - DAY

Joe and Jerry pack to escape the mobsters. Joe feels
remorse about leaving Sugar, and calls her, disguised
as Junior, to tell her he's marrying someone else. He
gives her the bracelet and corsage that Osgood had given
Daphne. Sugar enters, heartbroken, to borrow some bourbon
to drown her sorrows at the breakup.

27) INT. SPATS' HOTEL ROOM - DAY

Spats and his goons discuss Little Bonaparte, the head of
the mobsters. They want to "retire" him. As they plot,
they spy Joe and Jerry escaping out the upstairs window.
They recognize them and decide to kill them.

28) INT. HOTEL - VARIOUS - NIGHT

Joe and Jerry attempt to flee the hotel. They re-enter
through Spats' room, disguise themselves in another
room as an invalid and a bellhop, try to make it
through the lobby, get recognized, get chased through
the hall, and finally hide under the table in the
banquet room.

29) INT. BANQUET ROOM - DAY

All the mobsters gather for a banquet. Spats and his men
don't realize that Joe and Jerry are right under their
feet. LITTLE BONAPARTE gives a speech about his great
leadership and asks for a moment of silence to remember
Toothpick Charlie and his men. Spats and his goons are
reluctant to stand. In the KITCHEN next door, a gunman
is put into a giant cake. Little Bonaparte chides Spats
for letting the two witnesses get away, then leads a
round of "For He's a Jolly Good Fellow" for Spats. The
gunman inside the cake emerges and kills Spats and his
men. Joe and Jerry emerge from under the table, and the
goons give chase. The cops come in to make a "federal
case" of the hit.

30) INT. HOTEL - VARIOUS - DAY

Again, Joe and Jerry are chased through the hotel. This time, they emerge from the elevator as Josephine and Daphne, and slip through the lobby. Since they can't go to the airport or train station, they decide to escape on Osgood's yacht, which means that Jerry has to elope with Osgood.

31) EXT. BANDSTAND - DAY (Climax)

Jerry watches as Sugar sings "I'm Through With Love." Still dressed as Josephine, he kisses her. As Sweet Sue screams for Bienstock, mobsters recognize him and give chase. Sugar realizes that Josephine is Junior.

32) INT. LOBBY - DAY

Mobsters chase Joe and Jerry through the hotel again. They manage to escape by hiding under Spats' gurney as he's wheeled out.

33) EXT. BOAT - DAY (Resolution)

Joe and Jerry, still disguised as Josephine and Daphne, race to Osgood's dinghy. Sugar, on a bicycle, arrives as well. They escape just in time. Joe tries to convince Sugar to hold out for a millionaire, saying he's one of those no-goodniks she keeps running away from, willing to give up the thing he wants for the first time so that SHE can be happy. But Sugar wants him anyway. Jerry confesses to Osgood he's a man, to which Osgood says "Nobody's perfect."

STAR WARS BEAT SHEET

ACT ONE

1. THE EMPIRE ATTACKS

A small Rebel starship is chased by a massive Empirical Star Destroyer. IMPERIAL STORMTROOPERS board the starship, laying waste to the Rebel soldiers. PRINCESS LEIA gives her droid R2-D2 the plans to the Death Star before being captured by DARTH VADER. C3PO and R2D2 blast away in an escape pod.

2. DROIDS ON THE LOOSE

The droids land on TATOOINE, argue and part ways. JAWAS capture R2, and he finds himself reunited with his buddy.

3. MEETING OUR HERO

LUKE SKYWALKER and UNCLE LARS buy 3PO from the Jawas. He convinces them to buy R2 as well.

4. A DISTRESS CALL (INCITING INCIDENT)

While cleaning the droid, Luke discovers Leia's message, "Help me, Obi-Wan Kenobi. You're my only

hope." R2 refuses to play more as it's meant for Obi-Wan Kenobi.

5. CRAZY OLD BEN

At dinner, Luke wonders if Obi-Wan refers to Old Ben, the hermit in the desert. His Uncle and AUNT BERU dismiss Ben as crazy. Luke wants to attend THE ACADEMY, but they say they need him for one more season. Luke storms off and Aunt Beru comments that he's too much like his father. Outside, Luke gazes up at the sky, eager for purpose.

6. OBI-WAN TO THE RESCUE

Discovering R2 is missing, Luke sets off with 3PO to find him. They are attacked by TUSKEN RAIDERS. A strange old man scares the sand people away, revealing himself to be Obi-Wan Kenobi.

7. A GIFT FROM DAD

At Kenobi's place, Luke learns his father was Kenobi's student, and that he was killed by another student, Darth Vader. Obi-Wan gives Luke his father's LIGHTSABER. They hear Leia's entire message in which she implores Obi-Wan to deliver stolen plans to her father on Alderaan. Obi-Wan tries to convince Luke to come with him. Luke refuses.

8. DON'T MESS WITH DARTH

Darth Vader psychically chokes a COMMANDER for mocking the Force. Vader promises to find the stolen plans, and GRAND MOFF TARKIN intends to vaporize the rebel's base.

9. LUKE ACCEPTS THE CALL (POINT OF NO RETURN)

Luke finds a Jawa transporter destroyed by Stormtroopers. He races back to the farm, only to find the burnt remains of his aunt and uncle. Newly motivated, Luke tells Obi-Wan he will help him.

ACT TWO

10. A DEN OF SCUM AND VILLAINY

After using the Force to pass a checkpoint, and literally disarming a drunken patron, Obi-Wan and Luke meet and hire pilot HAN SOLO and his wookie companion CHEWBACCA.

11. LEIA HOLDS FAST

When Vader proves unable to successfully probe Leia's mind for the location of the Rebel Base, Tarkin orders the Death Star to her home planet of Alderaan.

12. ESCAPE FROM THE DESERT

After a shoot-out with Stormtroopers, the gang makes it onto the Millennium Falcon and escapes into warp speed.

13. A STEP INTO A LARGER WORLD (ADAPTATION)

Despite Leia's lie that the Rebel Base is on Dantooine, Tarkin orders the destruction of Alderaan. On board the Falcon, Obi-Wan feels a great disturbance in the Force. Luke spars with a remote, successfully deflecting its blasts with his helmet down, by trusting the Force for the first time.

14. I'VE GOT A BAD FEELING ABOUT THIS

The gang discover Alderaan's been blown to bits. On the Death Star, Tarkin sets Leia's execution for that evening. The Falcon gets trapped in the Death Star's tractor beam.

15. SMUGGLER'S BLUES

Stormtroopers search every part of the Falcon, but come up empty. Our heroes have been hiding in secret compartments. Luke and Han ambush two Stormtroopers and steal their armor.

16. LUKE TAKES CONTROL (CROSSROADS)

Our heroes seize a control room, and find the location of the tractor beam controls. Obi-Wan tells Luke and the others to remain here while he goes alone to deactivate it. But as soon as he leaves, R2 discovers that Leia is here. Luke hatches a plan and convinces his companions to help him rescue her before she's executed.

17. A LITTLE SHORT FOR A STORMTROOPER

Despite Stormtroopers, and a skeptical Leia, Luke manages to rescue the Princess. Meanwhile, Vader senses Obi-Wan's presence.

18. OUT OF THE FRYING PAN

Stormtroopers corner our heroes. Leia blasts a hole in the wall, and the heroes escape into a trash compactor. A trash monster drags Luke under the water, but then unexpectedly lets him go. The compactor walls start closing in. Before they're crushed, R2 manages to deactivate the compactor.

19. A KISS FOR LUCK (ACHIEVEMENT)

The heroes engage more troops as they rush to the Falcon. Leia gives Luke a peck as he swings across an empty chasm with her in his arms. Obi-Wan turns off the tractor beam.

20. NOW I AM THE MASTER! (BIG GLOOM)

Darth Vader finds Obi-Wan and the two duel. As Luke watches helplessly, Vader strikes down his former teacher. Luke's cries alert Stormtroopers and another shoot-out erupts. The Millennium Falcon escapes. Tarkin

reveals that a homing beacon in the ship will now lead them to the Rebel Base for its final destruction.

ACT THREE

21. THANK HEAVEN FOR EXHAUST PORTS

Our heroes arrive on the moon of Yavin, and the Rebel troops learn the Death Star's one weakness. The clock is ticking as the Death Star closes in. Han tells Luke, "May the Force be with you," as he takes off.

22. THE BATTLE COMMENCES

Luke blasts off in his X-Wing, fitted with R2D2, as Obi-Wan's voice reassures him. The first attempt to hit the exhaust port fails.

23. THE TRENCH RUN (CLIMAX)

Luke's fellow pilots are shot down by Vader and his troops. The rebellion's final hope, Luke heeds Obi-Wan's advice, turns off his guidance system, and trusts entirely in the Force. As Tarkin prepares to destroy the Rebel Base, and Vader gets Luke in his crosshairs, the Falcon appears and blasts Vader's ship away. Luke fires a torpedo at the exhaust port. Bull's-eye. The Death Star is history.

24. HAIL THE CONQUERING HEROES (RESOLUTION)

Princess Leia gives medals to Luke and Han in a grand military celebration. Vader may still be out there, but thanks to Luke, the Rebels have scored an important victory.

Great. Now that you've outlined a produced movie, you should have a better feel for BEATS, what they are, and how they add up to tell a story that is complete, whole, and of a certain magnitude.

But of course, the assignment is only half over—

2. Now write the Beat Sheet for YOUR STORY.

SECTION IV
AN END

(Wherein we turn our Story into a SCREENPLAY)

Scenes

The Building Blocks

"In constructing the plot and working it out with the proper diction, the poet should place the scene, as far as possible, before his eyes. In this way, seeing everything with the utmost vividness, as if he were a spectator of the action, he will discover what is in keeping with it, and be most unlikely to overlook inconsistencies."

(Poetics, Part XVII)

Up to this point, we've been discussing how a successful screenplay follows the classical principles laid out by Aristotle. It is an imitation of an action that is complete, unified, whole, and of a certain magnitude. It charts a hero's Change of Fortune through the pursuit of a dramatizable objective, and ultimately, it provides an emotional experience.

And we've used his observations to make effective choices about the critical elements of our own stories.

Along the way, we've followed his admonition to build our screenplay from the general to the specific, to "sketch its general outline and then fill in the episodes and amplify in detail." We've now fulfilled the first two parts of that process by creating a logline for our story, expanding it into Anchor Points, refining it with Stepping Stones, and then ultimately creating a Beat Sheet, the realization of our entire story in detail, episode by episode.

So now it's time to tackle the final part of the process he describes: to "amplify in detail."

This step is all about translating the individual story beats into SCENES, the expression of those beats on an actual screenplay page. And that requires a discussion of two more elements from Aristotle's original definition of drama. We've discussed story, character, and thought—

—so now let's explore *SPECTACLE* and *DICTION*.

Spectacle refers to the actual stagecraft, the visual action that physically dramatizes the story and moves it along.

Diction, on the other hand, refers to the words that characters speak to communicate with each other. It also refers to the words that the screenwriter uses to communicate with the reader.

Together, these two elements make up what we SEE and what we HEAR, and as such, are the most fundamental components of our screenplay. In modern parlance, they are the DESCRIPTION and the DIALOGUE, the tools with which we create our scenes.

So what precisely is a scene?

As we mentioned in the last chapter, it is a discrete unit of action WITH A UNITY OF TIME AND PLACE. When you change the time or location, you've got a new scene.

And as the components of beats, the function of any given scene is either to help advance the plot by portraying events that move it forward, help advance our understanding of characters by showing how they behave in those events, or help advance our understanding of the story by providing necessary expository information.

The *best* scenes accomplish all three, moving the plot forward while revealing important information about the characters and story. But if a scene doesn't accomplish any of these functions, it's not part of the unified whole, and as Aristotle demands, must be removed if its removal doesn't affect the story in any way.

And since a scene contains only what we hear and see, that means there are quite a few things it does *not* include, such as what a character is thinking or feeling, or any supplemental background information about the setting or story.

In short, anything that doesn't actually occur on screen, you must keep off the page. So all that is left is precisely what we see and hear, as we see and hear it.

But since film is predominantly a visual medium, we should always emphasize the visual to communicate meaning. It may be a cliché, but when it comes to good scenes, actions do indeed speak louder than words.

Moreover, like that fractal or *nautilus* we discussed in our chapter on Stepping Stones, the elements that go into crafting an effective scene look remarkably like the important elements of the screenplay as a whole.

For instance, just as Aristotle insists a story be about ONE thing, a good scene is also about ONE thing, one point, one primary purpose.

We call this the WRITER'S INTENTION (with the appropriate acronym WI, as in "*Why?*").

It may be to advance the plot in some specific way. To reveal particular information about a character. To emotionally impact the audience somehow. To introduce a new complication or character. To pay off something that has been previously set up or to *do* the setting up.

As a writer, you must know your Writer's Intention before you can start writing that scene. Sure, other elements may come into play, but *too many* purposes will overburden a scene. Save them for another one.

Furthermore, just as the story has a central hero driving the action, so too does each individual scene. So before you can write it, you need to know not only who's present, but of those characters, whose scene is it?

We call this character the SCENE PROTAGONIST.

He or she doesn't necessarily have to be the protagonist of the story, but they are the one driving the action of the particular scene. And they are driving it because they have an objective in the scene, something they hope to accomplish in it.

We call this their SCENE GOAL.

That goal may be one step along the way toward achieving their overall story objective, or it might simply be something they need in the immediate circumstance. They may want a kiss. Or information. Maybe they want to get to the dock before Sugar, or to make their deputy feel better. To seduce. To hurt. To extract a confession. They may simply want to get the door open before the masked killer reaches them.

And since conflict is the essence of drama, a good scene must have OBSTACLES that stand in the way of accomplishing that goal.

Those obstacles can be external. Someone doesn't want to be kissed or to give up that info. Sugar might want to get to the dock first, or her past history with men might make her too guarded to be seduced. The door could be locked, and the killer supernaturally fast.

Or the obstacles could come from within. Joe wants to convince Sugar not to give up on love, but that desire is at odds with the selfish one to save his own skin. Scottie wants to save Madeleine, but his paralyzing acrophobia keeps him from reaching her in time. Often, INNER CONFLICT provides the best obstacles, because success necessitates a change in the character.

But regardless of the source, a Scene Protagonist having to overcome obstacles in pursuit of a Scene Goal is what provides the essential conflict that engages an audience, advances the story, reveals character, and changes the circumstances in some way, leaving characters closer to or farther from their Objective, and one step nearer their Change of Fortune.

Now have I made my point? That as with Aristotle's precious *nautilus*, whose individual parts resemble the whole of the organism, the same holds true for a screenplay.

For just as a screenplay contains a Unity of Action, a Protagonist with a specific dramatizable objective, conflict, and ultimately a Change of Fortune, so too do the individual scenes that make it up.

But that's not all. Like the whole of which it is a part, a scene also has a particular structure, one that should come as absolutely no surprise.

A good scene starts with some description to set the stage, then something happens to provoke an action, leading to conflict, and climaxing when the Writer's Intention is achieved.

In other words, scenes consist of a Set-Up, Complications, and a Resolution.

And finally, like the whole of a screenplay, a good scene doesn't arrive spontaneously out of the blue, nor is it simply made up as it goes along, but rather, it's the result of deliberate planning.

So before you can write one, you need to make the following choices:

What is the WRITER'S INTENTION for the scene?
Where is it set?
What characters are present, and who is the SCENE PROTAGONIST?
What is that Scene Protagonist's SCENE GOAL?
What OBSTACLES are keeping the Scene Protagonist from accomplishing that goal?
What are the STAKES or consequences of failing to achieve it?
What are the various ACTIONS or tactics the Scene Protagonist must attempt to overcome those obstacles?
What is the latest point we can enter the scene, and the earliest we can leave it, and still accomplish the Writer's Intention?

Once you've made decisions about these critical details, the question now becomes how to execute them on the page. And to do that, we must re-examine the quote that begins this chapter.

What Aristotle is stating so eloquently there is that, prior to writing a scene, a writer must see it play out in his mind's eye.

So close your eyes and imagine it. What does it look like? Where is it set? Who is there and what are they doing? Now hear their words. What do they say to achieve their goals? Observe their behavior, soak up the tiniest detail. Watch the action rise, witness the climax and resolution as you let it all play out on the darkened screen behind your eyelids.

There. Ready to convey it in words on a page? Not so fast.

Aristotle continues his practical advice by saying:

> "One should also, as far as possible, work plots out using gestures. Given the same natural talent, those who are actually experiencing the emotions are the most convincing; someone who is distressed or angry acts out distress and irritation more authentically."
> (Poetics, Part XVII)

In other words, to write a successful scene, writers must not only SEE it all play out in their mind's eye, but they must also EXPERIENCE the events in order to keep them, and the characters' actions within them, consistent and authentic.

Hmm, where have we heard that before?

From the outset of our entire discussion, we stressed that we want our audience to both *observe* and *participate* in the story. And here, Aristotle insists that the WRITER must share those two experiences as well. To write an effective scene, they must simultaneously *watch* the action and *feel* the various emotions within it.

Yep, *mimesis* and *catharsis*. First as the *what* of it all. Then as the *why*. And now coming full circle to the *how*.

Stop into any Starbucks in Hollywood and you will see this phenomenon, writers at their laptops, yelling, crying, laughing, *talking* to themselves. Even centuries later, knowingly or not, these writers are taking Aristotle's advice to heart, envisioning the scene, its physical makeup, while acting it out, feeling what the characters are experiencing.

And that's precisely what *you* must do to write an effective scene. Both watch it and transport yourself into it so you can best determine what it all should look like, and how the characters would behave given who they are, what they want, and what is keeping them from getting it.

Still, once we know what needs to happen, the question remains how to translate those images and sounds in our head into the actual WORDS that we'll use to tell the story through spectacle and diction, description and dialogue, so that our readers can see and feel it all too.

And luckily for us, Aristotle has quite a few useful things to say about these most fundamental of elements.

TWENTY-NINE

Description

What You See Is What You Get

"Tragedy, like epic poetry, produces its effect even without action; it reveals its power by mere reading."

(Poetics, Part XXVI)

Any discussion of writing effective description must begin with a simple truth that for some reason gets barely mentioned in screenwriting books.

Screenplays are meant to be READ.

Aristotle asserts that one of the qualities that makes drama superior to any other literary form is that it not only can be PERFORMED, unlike those other mediums, but also:

> *"has vividness of impression in READING as well as representation."*
>
> (Poetics, Part XXVI)

Sure, you could argue that he's talking about plays, a literary form that exists independent of production, texts you'll find in any bookstore or classroom for a general readership to enjoy as they would a novel.

And true, a screenplay is probably *not* going to be consumed in its written form by a large public audience, by Grammy on the beach or young Gabi for her third grade book report. That's because a successful screenplay is ultimately the blueprint for another medium, a film production, directed, performed, and translated into celluloid or digital code.

But before it ever reaches that point, it is going to be read. A LOT. If not by the public, then by far more *important* people (or so they'll tell you), *movie people.*

It will be read by your peers for notes, by an agent or manager to determine where to send it, by professional readers at a production company who will then recommend it, fingers crossed, to their superiors to read before

THEY send it up the ladder, reader by reader, until it finally reaches someone with the power to green-light it. And then hopefully, it will be read some more, by producers, directors, and actors.

So sure, if all goes according to plan, it will eventually be transformed into an actual movie. But until then, it will be READ. And you had better make that read as easy, as riveting, as *enjoyable* as possible.

WHAT you write is critical. But so is HOW you write it.

And that, my friends, leads us to **Aristotle's Guiding Precept #16:**

A SCREENPLAY SHOULD BE EQUALLY AFFECTING TO READ AS TO WATCH ON SCREEN.

As the quote that begins this chapter indicates, Aristotle believes that all the qualities required to make a successful story, particularly the emotional experience it provides an audience, must exist in the read as much as in the actual performance.

Keeping that precept in mind should inform *all* your choices from this point on. Since once you know what needs to happen in a given scene, your task becomes to find the best words to communicate on the page what you envision in your mind. You want your reader to see precisely what you want the viewing audience to see, and subsequently, to *feel* precisely what you want them to feel.

So what kind of words are the *best* words? For Aristotle, the answer is simple. He says:

> *"The perfection of style is one that is clear without being mean."*
> *(Poetics, Part XXII)*

He explains that a CLEAR STYLE is one that utilizes only current and common words, everyday speech and idioms in general use. He cautions, however, that the result of writing solely in this manner can't help but be vulgar.

On the other hand, the use of what he considers EXOTIC EXPRESSIONS, foreign or rare words, metaphor, ornamentation, and anything else *out* of the ordinary, makes a style too solemn or elevated. He warns that if you write only in this loftier vein, the result is riddle or jargon, paradox or gibberish.

What is called for, he says, is a combination of these styles. He says:

> *"A certain infusion, therefore, of these elements is necessary to style; for the strange (or rare) word, the metaphorical, the ornamental, and the other kinds above mentioned, will raise it above the commonplace and mean, while the use of proper words will make it comprehensible."*
> *(Poetics, Part XXII)*

In other words, surprise, surprise, he wants a balance. And to illustrate, he examines different renditions of similar passages.

For instance, Aeschylus wrote in his *Philoctetes*, "the tumor which eats the flesh of my foot." In his own version, Euripides changed "EATS" to "BANQUETS UPON," to which Aristotle responds:

> *"Aeschylus and Euripides each composed the same iambic line. But the alteration of a single word by Euripides, who employed the rarer term instead of the ordinary one, makes one verse appear beautiful and the other trivial."*
> (*Poetics, Part XXII*)

He goes on to give more examples:

> *"A small fellow, weak and ugly . . ."* becomes *"A puny man, worthless and unseemly . . ."*

> *"Setting a bad couch and a tiny table . . ."* becomes *"Setting a wretched couch and a meager table . . ."*

By comparing these different versions of similar descriptions, he's stressing that the precise choice of words is critical, that our task as writers is not simply a matter of conveying an image accurately, it's about crafting that depiction in a way that is most appealing to read.

Sure, a man may be small, weak, and ugly. But isn't it so much more evocative, not to mention, more enjoyable, to read that he's puny, worthless, and unseemly? The meaning remains the same, but the *experience* is so much more specific, more vivid, more interesting.

So what is the lesson here?

First and foremost, Aristotle is stressing *moderation*. Don't be too grandiose, but don't be too boring. Don't distract from the story with your verbiage, but don't put your reader to sleep.

What this means for writing description is that the words should paint a crystal clear picture of what we see, but not simply be a dull recitation of visual facts.

What is called for is an economy of language, description that is specific, minimal, and without extraneous detail. But the chosen words should be vibrant, active, and expressive. They should set a tone, create a mood, evoke the other senses, and even convey a point of view.

So the task when describing anything in your screenplay is to select words that are loaded, never generic, that paint the picture you see in your head and create the feeling you wish it to provoke.

And that brings us to **Aristotle's Guiding Precept #17:**

WHEN WRITING DESCRIPTION, BE FOCUSED, PRECISE, AND CLEAR, BUT NEVER BORING.

Never forget that you are writing for a reader, and your goal on each and every page is to make that reader excited to turn to the next one. So make the effort as easy and as entertaining as you can.

But now what precisely *do* we describe?

Well, since we are describing what an audience can SEE, the elements at our disposal are somewhat limited. Specifically, we can describe CHARACTERS, SETTINGS, and ACTIONS.

So let's look at how we describe these different visual elements individually.

Character Description

Characters will ultimately look like whichever actor gets cast in the role. And that's rarely up to you. So when describing a character, we need only the important details of their physical appearance that are relevant to understanding them, that give us insight into *who* they are. External details that reveal their inner being.

First, we need to know their GENDER, most easily communicated through their name.

Next, we need to know their AGE. The convention is that the younger they are, the more specific you need to be about their age. After all, there's a far greater difference between a 6-year-old and a 10-year-old then there is between a 46-year-old and a 50-year-old.

And then we need any detail about their APPEARANCE that reveals their character. Think of their body type, how they dress, their grooming, whatever physical elements might be significant. Are they fat or thin, tall or short, slovenly or neat, plain or striking? If it's not relevant to understanding them or the story, it is not necessary to describe. We are looking for the outward manifestation of interior truths.

So be precise, be revealing, and be economical.

And keep in mind, ACTIONS speak much louder than words. What a character *does* is far more revealing than what they look like. So depict your characters through *representative behavior*. Remember, what a character is doing when we first meet them will stick with us throughout the story. So make sure to introduce each character with actions that tells us something vital about them.

What *can't* you describe? Well, as we discussed in our chapter on SCENES, anything that we can't see on the screen.

Don't describe a character's occupation or relationship to another character. Don't use backstory in your description, or tell us what a character is thinking or feeling.

In short, if we can't SEE it on screen, you can't WRITE it in the description. So if there's a detail about a character you need a reader to know, you have to find ways to reveal it through what a viewer would *see* and *hear*, not just what the reader will read.

Let's look at some effective character descriptions, shall we?

First, from *Some Like It Hot*, screenwriters Billy Wilder and I.A.L. Diamond introduce us to the story's romantic interest.

```
Just then, a member of the girls' band comes hurrying
past them, carrying a valise and ukulele case. Her name
is SUGAR. What can we say about Sugar, except that she
```

```
is the dream girl of every red-blooded American male who
ever read College Humor? As she undulates past them,
Jerry looks after her with dismay.
```

What have we learned about Sugar? She plays the ukulele. She's drop dead gorgeous. She doesn't walk, so much as "undulate." These are all things we can SEE. And they are all things that tell us vital character details that will have an impact on the story, particularly her effect on the men she undulates past.

Sure, the writers could have just called her "gorgeous," but that would do little to convey the true power of her attractiveness, a power that will be central to the plot, and which is so beautifully conveyed by calling her the "dream girl of every red-blooded American male." We not only know what that looks like, we can *feel* what that looks like.

In other words, as Aristotle advises, Wilder and Diamond use words that are clear and precise with just the right amount of ornamentation to elevate the description from the commonplace to the sublime.

From the same screenplay, let's meet the antagonist.

```
The side door opens, and a dapper gent emerges. He wears
a tight-fitting black suit, a black fedora, and gray
spats. The spats are very important. He always wears
spats. His name is SPATS COLOMBO. He cases the street,
motions the men inside. As they carry the coffin past
him, he removes his fedora, holds it reverently over his
heart. Then he follows the men, his head bowed.
```

Again, drink in the detail. He's "dapper," he doffs his fedora and "reverently" holds a hand over his heart. And of course, he wears spats, the ubiquitous article from which he gets his moniker.

What are we learning about him from his outward appearance? He takes it extremely seriously, doesn't he? A defining *personality* trait gleaned from a *physical* description. The outward reveals the inward.

Check out Frank Darabont's description of the hero in *The Shawshank Redemption*, as adapted from Stephen King's novella.

```
ANDY DUFRESNE, mid-20s, wire rim glasses, three-piece
suit. Under normal circumstances a respectable, solid
citizen; hardly dangerous, perhaps even meek. But these
circumstances are far from normal. He is disheveled,
unshaven, and very drunk. A cigarette smolders in his
mouth. His eyes, flinty and hard, are riveted to the
bungalow up the path.
```

Wow, from that brief and vivid description we not only get a clear sense of his normal bearing (wire rim glasses, three-piece suit, respectable, solid, harmless, meek) but we also get an insight into his current psyche (disheveled, unshaven, drunk, flinty, hard, staring).

These are all things we can *see* on the screen, the suit, the cig, the stare, and the sense that these elements are oddly out of place. And they are chosen as descriptors because they tell us not only about this individual, what

makes him tick, but just as importantly, what is going on with him at this precise *moment*. Outward description gives insight into what's going on *inside*.

The words are economic, clear, with just the right amount of poetry to take it from cold empirical facts to something that is not only more vivid, but fun to read as well.

What does screenwriter George Lucas reveal about a character in this example from *Star Wars*?

```
His face is obscured by his flowing black robes and
grotesque breath mask, which stand out next to the
fascist white armored suits of the Imperial Stormtroopers.
Everyone instinctively backs away from the imposing
warrior and a deathly quiet sweeps the Rebel troops.
Several of them break and run in a frenzied panic.
```

Sure, we get a sense of what Darth Vader *looks* like, all in black, with that iconic mask. But what part of this description gives us the best sense of *who* the character is? It's the reaction of the others around him, "deathly quiet" or running away in a frenzied panic. It's one thing to describe that he is scary or imposing, but how much more vivid is that description when we SEE that quality's effect on those around him?

Let's look at a few other examples. Briefer, but just as evocative. Think about *what* they evoke and *how* they evoke it.

From *The Graduate*, by Calder Willingham and Buck Henry:

```
MISS DEWITTE, who, from the looks of things, always has
been and always will be, Miss DeWitte, takes Ben's hand.
```

Frank and Dorothy from David Lynch's *Blue Velvet*:

```
He's got on a pair of blue jeans and boots. He has a raw,
mean sexuality—a "bomb about to go off"—presence.
```

```
She has a beautiful full figure, dark eyes, black thick
wavy hair. Full red lips. Right now, however, she looks a
bit tired and a bit frumpy in an old terrycloth robe.
```

Hannibal from Ted Tally's adaptation of Thomas Harris' *Silence of the Lambs*:

```
He turns, considers her . . . A face so long out of the
sun, it seems almost bleached—except for the glittering
eyes, and the wet red mouth.
```

And finally, Rose from James Cameron's screenplay *Titanic*:

```
Her face is a wrinkled mass, her body shapeless and
shrunken under a one-piece African-print dress. But her
eyes are just as bright and alive as those of a young
girl.
```

Take a second and third look at these descriptions. Study them. What elements do they have in common? How do they use physical details of what we can SEE on the screen to give insight into the vital, defining qualities we need to know about each of the characters?

Consider how they hold to Aristotle's dictum of description, clear but elevated, common words mixed with poetry. Neither vulgar nor abstract, but a happy medium, always economic, of words that describe the facts, yet go beneath the surface. Revealing and fun to read.

Setting Description

A lot of the same principles from character description apply when describing a scene's location. We're looking for an economy of words that paint a clear but expressive picture. We want the external to reveal the internal.

When choosing what to describe, think about what can simply be assumed. Don't most ALLEYS look alike? What is unique or fresh about yours? Concentrate on the elements that will aid in understanding character and story through what a location looks like. Anything extraneous, redundant, or unnecessary should be eliminated, as it hinders the read and distracts from what IS revealing.

And as Aristotle says, find that balance between common words and exotic expression, clarity and elevation, to give us the facts, but to also dig deeper.

Let's look at some good examples of effective setting description.

From *Star Wars*, here's Luke's home planet of Tatooine.

```
A death-white wasteland stretches from horizon to
horizon. The tremendous heat of two huge twin suns
settles on a lone figure.
```

Sure, Lucas could have described the setting as a "desert planet," or mentioned its sand and rocks. But how much more descriptive, more *visceral* does it become to describe it as a "death-white wasteland," and to concentrate on the twin suns and their tremendous heat that we can not only see, but *feel* in his choice of words?

More to the point, what does Lucas' choice of *what* to describe in the setting reveal about the CHARACTERS who inhabit it, how does it add insight to the lives they are living here?

Look at his description of the iconic Mos Eisley cantina.

```
The murky, moldy den is filled with a startling array
of weird and exotic creatures and monsters at the long
metallic bar. At first the sight is horrifying. One-eyed,
thousand-eyed, slimy, furry, scaly, tentacled, and clawed
creatures huddle over drinks. Ben moves to an empty spot
at the bar near a group of repulsive but human scum.
```

Again, Lucas could have simply described the facts, a bar filled with aliens. But words like "murky," "moldy," "startling array," "repulsive but human,"

and everything in between, creates a *sense* of this place. The description never strays from what we can *see*, but the choice of words adds the poetry, that elevation, that creates a mood and an insight into the characters that populate this environment.

Look at Wilder and Diamond's description of Mozzarella's funeral home/ speakeasy.

```
The chapel is jumping. A small band is blaring out SWEET
GEORGIA BROWN. The musicians are not the slick, well-
fed instrumentalists you would find in Guy Lombardo's
band—they have all been through the wringer, and so have
their threadbare tuxedos. On the stamp-sized dance floor,
six girls in abbreviated costumes are doing a frenetic
Charleston. Crowded around the small tables, mourners in
black armbands are drowning their sorrows in whatever
they drink out of their coffee cups.
```

Can you see that dance floor? Can you hear that Charleston? Can you FEEL what it's like to be in that noisy, smoky den of vice and liquor?

The band isn't playing, it's "blaring." The dance floor isn't small, it's "stamp-sized." The dancing is "frenetic," the customers are "drowning their sorrows," and the chapel is "jumping" to the sounds of musicians who have "all been through the wringer."

How do the screenwriters use words to go beyond a mere factual account of the images on screen? How does mixing the clear and common with the elevated and "exotic" create the opportunity for the visuals to reveal *more* than what can be seen, without ever violating that sacrosanct rule that we can only describe what *appears* on screen?

And how much more *enjoyable* is it to read?

Here's a description of the Seminole Ritz, the hotel Joe and Jerry find themselves in as Josephine and Daphne.

```
The sprawling gingerbread structure basks in the warm
Florida sun, fanned by towering palm trees, and lulled by
waves breaking lazily on the exclusive beach frontage.
Wintertime and the livin' is easy, fish are jumpin', and
the market is high.
```

Do I need to point out how the hotel basks, or the palm trees fan, or the waves lull lazily? And with that final line of poetry, a play on *Summertime*, need I emphasize how the writers manage once more to say something crucial and defining about the lives of the people that inhabit this oasis through what we can SEE?

No, you get the picture. Quite literally.

In *Shawshank*, here's Andy's cell:

```
A stone closet. No bed, sink, or lights. Just a toilet
with no seat. Andy sits on bare concrete, bruised face
lit by a faint ray of light falling through the tiny slit
in the steel door.
```

Notice how sparse and cold the description is, perfectly befitting this prison, as well as the tone and mood weighing so heavily on our protagonist. That faint ray of light falling through that tiny slit may be something we can *see*, but in his choice of what to describe, Frank Darabont provides insight into the *story*, into a character who is desperately holding on to a similarly thin ray of hope.

Compare that description to this one from *Titanic*:

```
The gleaming white superstructure of Titanic rises
mountainously beyond the rail, and above that the buff-
colored funnels stand against the sky like the pillars of
a great temple. Crewmen move across the deck, dwarfed by
the awesome scale of the steamer.
```

Where the former was stark and cold, this one is grand, opulent, almost overblown in its word choice. And isn't that completely fitting for this ship, for this movie, of its pomp and grandiosity?

Again, the words describe what we see, but also create a tone, a sense of scale and magnitude that goes beyond merely what we are looking at, to a sense of how the characters within that setting must be feeling. Inner life revealed through external means. Clear, common words, elevated and deepened through poetry, through metaphor.

And finally, take a look at one of my favorite setting descriptions. From *The Long Kiss Goodnight*, here's how writer Shane Black describes Sandusky, Ohio, the town in which the bloody adventure is set:

```
Peaceful. Serene. It's the town in the glass bubble, the
one God shakes to watch it snow . . .
```

Clear. Concise. Economic. He's writing for a reader. Giving us the visual facts, but in an interesting way. Then injecting just enough personality and commentary into the narration to set a tone, to make it fun to read without distracting from the story.

Amazing how just a few well chosen words, common and metaphorical, can communicate so much about what we *see*, AND how much a setting can inform our story.

Action Description

When we refer to "action," we aren't simply describing a brawl or shoot-out or car chase, things associated with action movies. We are referring to *any* action on the screen, from the subtle to the epic. If a character is DOING something, it's an action. Subsequently, action description often makes up the *bulk* of what you describe on the page.

At the risk of sounding like a broken record, we only need to describe what is essential to tell the story, to reveal character, and to move the narrative forward. Not every detail. Use an economy of language and choose

the words that are clear, specific, and active, that create a deliberate image in your reader's mind.

And again, it's about finding that middle ground between the commonplace and the exotic, between using clear "vulgar" words and elevated, ornamental expression to create a "vividness in the reading."

The key, as Aristotle suggests, is to SEE the scene play out in your mind's eye. And once envisioned, describe it as you see it, paying particular attention to:

a. behavior that reveals character
b. actions that dramatize your character's quest for their immediate scene goal
c. whatever is required for you to achieve your Writer's Intention in the scene.

Extraneous description that distracts from these primary purposes is almost always unnecessary. So concentrate only on actions that serve your story.

And as with any description, be *precise*. A character should never WALK, when he can PRANCE or AMBLE or STRUT or PACE or SAUNTER. These words take up the same amount of real estate, but communicate so much more vividness.

And while you may find yourself with a lot of action to describe, you must never let it get too blocky, too prosy.

When I look at a page of screenplay that looks like a page from a novel, with a *lot* of text and very little empty space, my immediate thought is that this is going to be a chore to read. Screenplays are *not* novels. They aren't made up of lengthy prose passages.

So find ways to break up action description. In general, no paragraph should ever be much more than four lines long. Anything longer than that is unfriendly and daunting. And worse, a reader will likely skim through it, missing important detail.

There are some clear rules to breaking up action description. For instance, every time you describe a *new* action, it gets a new paragraph. Whenever you describe a different character within the action, it gets a new paragraph. And when you describe a different area within the same general locale, it gets a new paragraph.

What you are doing every time you hit a HARD RETURN is creating the impression of a film CUT. So in movie parlance, a paragraph is the equivalent of a SHOT.

For instance, if you were describing the action of a bar fight in a western, you might describe the Sheriff punching a ne'er do well through the window. Hard return. Now you describe the piano player ducking as a bottle soars inches from his head. Hard return. Now you describe a barmaid up on the balcony drop-kicking some miscreant over the railing and onto a table below.

That was one fight, broken up into three paragraphs to differentiate either separate locales, characters, or actions. The alternative, cramming that whole

description into one paragraph would not only be a chore to read, but more importantly, would bury important info in the middle.

Another vital element of good action description is it should take about as long to *read* as it takes to play out on screen.

I mentioned earlier that a page of a screenplay equals one minute of screen time. So if you are describing a car chase or love scene, or simply someone crossing the street, think about how long you expect it to play out on screen. Then make sure to describe it for that length of time.

That will afford you the opportunity to reveal character through their specific actions during such sequences, instead of wasting the opportunity with "An exciting chase ensues" or a simple "They make love."

Finally, keeping in mind that the READ should approximate the experience of the VIEWING, allow your action to have some personality, some embellishment, not just be a journalistic recitation of facts.

There's opportunity to be entertaining in the way you describe things. To be exciting if the scene calls for it. Or funny. Or sexy. Or mournful. You are, after all, TELLING A STORY, and the storyteller can have a voice.

Just make sure that yours never distracts from the story. As Aristotle says:

> *"The poet should speak as little as possible in his own person, for it is not this that makes him an imitator."*
> *(Poetics, Part XXIV)*

So as with other types of description, strike a balance between the common and the poetic, neither too vulgar nor too exotic. Remember, the story always comes first, and that means before YOU as well.

Let's look at some examples of action description done well.

From *Some Like It Hot*, here's how Wilder and Diamond describe the critical moment when Joe blows his cover in order to do something selfless for once.

```
Joe appears in the vestibule at the top of the stairs,
looks down.

From his point of view, we see Sugar perched on top of
the piano, bathed in a spotlight. She is a little drunk,
and more than a little blue, and she is singing the
lyrics with heartbreaking conviction.

Joe, watching her from the landing, is deeply moved.

Slowly, he starts down the steps.

On the bandstand, Sugar is winding up the torchy ballad,
when suddenly Joe steps into the spotlight. Without a
word, he takes her in his arms, kisses her.
```

First, notice how the writer just describes the moments that matter, the images, actions, and reactions that move the story forward while revealing character. There is nothing extraneous.

Yet even with an adherence to the relevant facts, he finds room for texture. Words like *perched*, *blue*, *torchy*, the fact that Joe steps into a spotlight,

that he kisses her without a word, all these details add color, tone, mood, take us beyond mere facts without weighing things down.

And look how the description has been broken up. Five paragraphs, five separate actions. We move back and forth from Joe to Sugar, implying the cuts back and forth that we will see on screen.

Notice, too, how the writers break up Joe's slow descent down the steps, isolating that vital character-changing moment. And notice how they've combined into one paragraph the end of Sugar's song and the unexpected kiss, emphasizing the seamless connection between those two actions.

So it's not just the words themselves that paint a picture, but *how* they are laid out on the page that is important, directing our attention appropriately.

Here is an exciting moment from the film, when Joe and Sugar are both racing to the pier for their big date.

```
Sugar is now almost running toward the pier, a look of
great expectation on her face. This is the big night of
her life.

Joe is pedaling desperately to get to the pier before
her, oblivious of the earrings dangling incongruously
from his ear lobes.
```

Nothing extraneous. Just what we need to know to advance plot and character. Clear, precise, economic.

But consider how "the big night of her life" informs our understanding of the *look* on Sugar's face, the pace of her steps. And of course, that tiny detail of Joe's earrings not only encapsulates his own reckless urgency, but also sets up a delicious complication to engage us as we anticipate how that oversight might play out.

It's the small details, like those earrings, that bring our description to life. Characters don't walk or sit or ride a bike. Rather, they pedal desperately, oblivious to their incongruous earrings!

What can we glean from this action description near the end of *Fargo*?

```
After hitting him several times, Shep yanks Carl's belt
out of his dangling pants and strangles him with it. Carl
gurgles. Shep knees Carl repeatedly, then dumps him onto
the floor and starts whipping him with the buckle end of
the belt.
```

The Coen Brothers *could* just tell us that Shep beats up Carl. But recall that it should take as long to read as it should to play out on screen. And remember that *every* moment in your screenplay is an opportunity to reveal character and advance story. So here the fight is choreographed.

Every tiny nuance isn't detailed, that's for the director and actors to work out. But what do the specified actions reveal? While Carl's pants are *dangling* and Shep is *yanking*, *kneeing*, and *whipping*, what are we learning about these characters and their relationship? It's one thing for Shep to punch Carl in the face, it's quite another to completely dominate him with his own belt.

Again, the devil is in the details. So keep it clear, and keep it specific. An action sequence should never be generic, but always utilized to give additional insight into the story, the characters, and their relationships.

And that specificity is critical even when the action *isn't* a brutal fight. What is revealed in this simple action description from *Fargo*?

```
Jerry slams down the phone, which immediately rings. He
angrily snatches it up.
```

We just watched a man hang up a phone and then pick it back up. But we want our words to convey *more* than simple facts, we want specific verbs to reveal the inner life of the character. So *how* he picks it up or puts it down, slamming or snatching, is what matters, more than the mere action itself.

Take a look at this moment in *Star Wars*, shortly after Luke has joined up with Ben on the Millennium Falcon.

```
Ben watches Luke practice the lightsaber with a small
"seeker" robot. Ben suddenly turns away and sits down. He
falters, seems almost faint.
```

And now here's a description near the climactic trench battle toward the end of act three.

```
Vader's wingman panics at the sight of the oncoming
pirate starship and veers radically to one side,
colliding with Vader's TIE fighter in the process. Vader's
wingman crashes into the side wall of the trench and
explodes. Vader's damaged ship spins out of the trench
with a damaged wing.
```

The former is a small, gentle moment. The latter is big and exciting. Yet both are crucial to the development of the story, both are ACTION descriptions, and both benefit from the specificity of the description. So Ben *falters* while Vader's wingman *veers radically*. How do these word choices contribute not just to our understanding, but to the FEELING of these visual descriptions?

Think about that question when you read this description from the midpoint of *The Shawshank Redemption*, after Andy locks himself in the Guard Station.

```
Andy is reclined in the chair, transported, arms fluidly
conducting the music. Ecstasy and rapture. Shawshank no
longer exists. It has been banished from the mind of men.
```

Andy is listening to music. That is *all* that is happening.

Yet this simple action means so much, that he's found a way to escape the horrors of his situation, if only temporarily. So we *see* the way he's moving his arms as if he is already in another place.

And to fully communicate the EMOTION of these visuals, Darabont adds that bit of poetry: *Shawshank no longer exists*. It doesn't mean the

prison walls have actually disappeared. It means that the visuals of this scene should *evoke* that result. It infers a physical description, as it gets to the heart of the look on Andy's face, the nature of his movements, how his inner life is manifested in his external actions.

And how does the specificity of the resulting action description reveal the inner lives of the characters?

```
Norton and Hadley break the door in. Andy looks up with
a sublime smile. We hear Wiley POUNDING on the bathroom
door.
```

Norton and Hadley's inner life, their anger and desperation, is revealed by their actions, breaking the door in. But what is Andy doing? Knowing he's about to be beaten and hauled into solitary, does he panic or resist? No, he smiles. Sublimely. It may be a detail about what we SEE, but crucially, it reveals what is going on *within* him. He knows they'll never be able to contain him now. He's already beaten them.

Let's look at one last passage from *Shawshank*, this one laid out a bit differently.

```
Norton drops his cigarette. Crushes it out with the toe
of his shoe. Glances up toward the plate shop roof as—

HIGH ANGLE FROM PLATE SHOP ROOF (SNIPER POV)

—a rifle scope pops up into frame, jumping Tommy's image
into startling magnification, framed in the crosshairs.

THE SNIPER

rapid-fires a carbine—BLAM!BLAM!BLAM!BLAM!—his face lit up
by the muzzle flashes. Captain Hadley.

TOMMY

gets chewed to pieces by the gunfire. He smacks the ground
in a twitching, thrashing heap. Eyes wide and staring.
Dead. Surprise still stamped on his face. Silence now.
Norton turns, strolls into darkness.
```

Okay, a lot to digest there. Of course we can see and appreciate the clarity, the economy, and the specificity. But also notice the sentence fragments, the use of sound effects, how some sentences begin in one paragraph only to continue in the next.

All these choices are adding up to one thing. They make the *read* as exciting, as breathless, as revealing, as we hope the action will be when played out on screen.

Yes, you can *do* that. You aren't bound to simply giving complete and grammatically correct paragraphs. Doing so here would slow down the read, impede the progression of the action.

So instead, we isolate the focus of our attention in individual lines, THE SNIPER, TOMMY, to create the impression of quickly jumping back and

forth between them, echoing the rapid-fire excitement of the muzzle blasts themselves.

The sound effects heighten the frenzy. And the breaking of the sentences, the double dashes that keep us fluidly connected from one locale to the next, add even more to that excitement, that breathlessness. As do the fragments. Dead. Captain Hadley.

You aren't bound by the rules of grammar. You are only bound to clarity. And to creating an experience in the reading that approximates the experience of the viewing.

But you don't need to manipulate format to build excitement. Check out how this action description from David Lynch's *Blue Velvet*, strictly adhering to traditional grammar rules, also accomplishes it.

```
Unable to hear the warning horn, Jeffrey nonchalantly
leaves the bathroom as the tank is still filling.

SUDDENLY, he hears something. A key going in the door.
He bolts toward the closet. He flies inside it and is
swinging the door shut as the front door opens.

Just as suddenly, the toilet tank gets full and the water
shuts off - SILENCE, except for Dorothy Vallens at the
front door.
```

It's all about word choice *and* about how the action is broken up, that creates the mood, the tone, and the meaning.

And finally, before we leave this section, let's look at a subtler moment of action description, this one from *Titanic*.

```
TIGHT ON JACK as his eyes come up to look at her over the
top edge of his sketchpad. We have seen this image of him
before, in her memory. It is an image she will carry the
rest of her life.

Despite his nervousness, he draws with sure strokes, and
what emerges is the best thing he has ever done. Her pose
is languid, her hands beautiful, and her eyes radiate her
energy.
```

No punches or explosions. Just a boy painting a girl.

If you've seen the movie, you know how critical this moment is to the story, to the development of the central relationship. Look at *how* Jack paints. Look at *how* she poses. And look at how Cameron reveals the magnitude of this quiet moment. He is only telling us what we *see*, yet with his choice of words, he is revealing so much more.

And that's description.

Nothing extraneous. Only what's necessary to advance the story and our understanding of character.

We want words that reveal what is observed, yet which are chosen to provoke feeling.

Hmmm. Do those qualities sound familiar? They sure should.

Mimesis and *catharsis*.

So as with that ubiquitous *nautilus*, whose overall shape finds reflection in each of its parts, the overarching principles necessary for an effective story, for an effective beat, and for an effective scene, are applicable down to the absolute smallest unit of your screenplay—for an effective WORD.

Just remember Aristotle's admonition.

Clarity and poetry. Simplicity and ornamentation.

Whether describing character, setting, or action, something exciting, sublime, or mundane, finding that balance is not only how we tell the story effectively, but also how we make the READING of it a pleasure.

But description, as they say, is only half the story. Time to tackle the other half, oftentimes the most prominent part of a screenplay, the DIALOGUE.

THIRTY

Dialogue

What You Say Is What You Get

"Under Thought is included every effect which has to be produced by speech, the subdivisions being: proof and refutation; the excitation of feelings, such as pity, fear, anger, and the like; the suggestion of importance or its opposite."

(Poetics, Part XXVI)

We've already discussed dialogue to some extent when we discussed character because, as we've seen, it's nearly impossible to isolate one element of drama without bringing in others since, when done well, they all work in concert.

But here we'll come at dialogue from a slightly different angle.

Admittedly, Aristotle doesn't say a lot about it. In fact, he kind of shoehorns it into the end of his treatise. But what little he does say is pure gold for screenwriters, even if it seems a bit elusive at first read.

So let's walk through his observations of what he refers to as SPEECH and arrive at that gold at the end of the proverbial rainbow.

First, as the quote above indicates, when discussing *thought*, Aristotle enumerates what he considers the various EFFECTS of speech.

In other words, regardless of whether it's to put forth an argument, to evoke or reveal an emotion, or simply to provide information, a character always speaks in order to accomplish something.

And speech comes in a variety of flavors, what he calls the MODES OF UTTERANCE, depending on which of those effects is desired. These include:

> *"A command, a prayer, a statement, a threat, a question, an answer, and so forth."*
> (Poetics, Part XXVI)

But Aristotle is quick to dismiss this path of inquiry, saying these different modes of speech are more about "delivery" than about the "poet's art."

What matters is not so much *how* a speech is delivered, that's the actor's purview. What's vital is the simple truth that when a character speaks, he does so for a purpose, to *get* something in response.

So far so good?

Aristotle then goes on to make a point about NONVERBAL ACTIONS and their relationship to speech. He says:

> *"The dramatic incidents must be treated from the same points of view as the dramatic speeches. The only difference is that the incidents should speak for themselves without verbal exposition . . . for what were the business of a speaker, if the Thought were revealed quite apart from what he says."*
> (Poetics, Part XVI)

In other words, what a character DOES can produce the same effects as what he SAYS. And in keeping with his assertion that nothing in a story should be unnecessary, Aristotle stresses that the *thought* that gets REVEALED through behavior need not also be communicated through speech, and vice versa. It would be redundant.

What is crucial here is the equivalency that Aristotle makes between speech and behavior, between what a character says and what he does.

Both can produce the same enumerated effects, be they proof, refutation, emphasis, or evocation of emotion.

But even more importantly, they both reveal the *thought* that motivates them.

And if you were paying attention during our chapter on CHARACTER, you'll recall that everything a character DOES has consistency when it is motivated by the intersection of their *moral disposition* and *thought*, who they are and how they judge a particular situation.

So if words and deeds are indeed equivalent in all ways, except one is spoken and the other isn't, then we know what Aristotle believes motivates speech as well.

Say it with me: the character's IMMEDIATE GOAL, the same GOAL we've discussed as the driving force propelling any good scene.

That is why Aristotle specifically defines *thought* as:

> *"the faculty of saying what is possible and pertinent in given circumstances."*
> (Poetics, Part V)

Possible and pertinent. For Aristotle, a character's words reveal *thought* because those words are always in service of what the character WANTS at that particular moment.

So what does this mean for screenwriters?

Simply put, dialogue is spoken by a character in order to accomplish their Scene Goal.

Read that previous sentence again. Commit it to memory. It may be the most important one in this chapter. Dialogue is spoken by a character in order to accomplish their Scene Goal.

But there is more to it than that. That is merely the *function* of dialogue. We need to distinguish what makes *good* dialogue.

For that, we must examine what Aristotle means by speech REVEALING thought, as opposed to merely EXPRESSING it.

For Aristotle, there's a huge difference between a character *saying* what they want and a character speaking to *get* what they want.

And *that* is the difference between good and bad dialogue.

It's the difference between a character saying, "I like you, I wish you were my girlfriend," and "Hey, I got an extra ticket to the concert, wanna go?" The first example is a simple recitation of an emotional fact, someone saying precisely what they are feeling. The second example *implies* that feeling without actually spelling it out.

What circumstances are involved with the first utterance? A character clearly likes another, but has probably blown any chance of getting her. And the second? A character *also* clearly likes another, and is actually *trying* to accomplish his goal of winning her affections.

And for Aristotle, when a character uses speech to achieve an effect, whether it's to prove, refute, convince, evoke, or anything else they may want in the immediate circumstances, their words reveal the underlying *thought* that motivates that goal without them having to prosaically state it.

Does it come as any surprise that Aristotle would prefer this type of speech, that a character should speak clearly, but not *too* clearly, REVEAL what he wants without actually STATING it? It shouldn't. It is after all the same admonition he gave us when speaking about language in general, and description specifically.

Language that is *too clear* is vulgar.

So the same rule applies to dialogue. We want speech that reveals *thought* WITHOUT overtly articulating it.

With that in mind, we can put Aristotle's words into the parlance of a modern screenwriter.

When he talks of "every effect that must be produced by speech," he is talking about the character's IMMEDIATE GOAL, what that character hopes to achieve through their dialogue.

And when he talks of the "thought revealed" by that dialogue, he is talking about what we call SUBTEXT.

Subtext is simply what is implicit in a character's dialogue, separate from the dialogue itself. It is the window into the character's INNER LIFE, the *reasoning* that motivates the speech.

And it is critical to good dialogue.

Subtext means there's a difference between what a character *says*, the actual words they use, and what they *mean*. And what allows for that distinction is when a character speaks to get what they want and *not* to express their thoughts.

And that leads us to **Aristotle's Guiding Precept #18:**

IN GOOD DIALOGUE, CHARACTERS SPEAK SOLELY TO ACHIEVE THEIR IMMEDIATE SCENE GOAL, AND THAT SELDOM REQUIRES THEM TO SAY WHAT THEY THINK, MEAN, OR FEEL.

Don't misunderstand, it is *important* to know what is going on in a character's head. That is critical to understanding character and where they are in their journey at any particular moment. But we discover their thoughts *not* from the words they use, but from our understanding of the reasoning behind *why* they are using them.

If there is no difference between what a character says and what they mean, simply the articulation of precisely what they think or feel, we call that dialogue ON THE NOSE. OTN dialogue sounds flat, fake, and hollow, and we avoid it like a Theban plague.

The goal is dialogue with subtext. And *that* is accomplished when dialogue is spoken entirely to achieve the character's immediate goal, not to give us information. After all, they don't even know we exist.

But enough theory, let's look at some flesh and blood examples.

In *Some Like It Hot*, after Joe and Jerry have arrived safely in Florida as Josephine and Daphne, Jerry tells Joe he's had enough of being a gal and wants out.

> JERRY
> You promised—the minute we hit Florida, we were going to beat it.

> JOE
> How can we? We're broke.

> JERRY
> We can get a job with another band. A male band.

> JOE
> Listen, stupid—right now Spats Colombo and his chums are looking for us in every male band in the country.

> JERRY
> But this is so humiliating.

> JOE
> So you got pinched in the elevator. So what? Would you rather be picking lead out of your navel?

> JERRY
> All right, all right!
> (rips off his hat and wig, tosses them on the bed)
> But how long can we keep this up?

```
            JOE
What's the beef? We're sitting pretty. We get room
and board—we get paid every week—there's the palm
trees and the flying fish—
```

What's happening here? A simple argument. Jerry wants to leave, Joe doesn't.

We call this dynamic "two dogs, one bone" when characters have scene goals that are mutually exclusive of each other. Only one can succeed, so we get conflict.

Joe's immediate scene goal is *to convince Jerry to stay*. Why? Because he likes palm trees or flying fish? Because he still fears mob retaliation?

No, we know from the context of the story that Joe wants to stay because he wants Sugar. Desperately. And the only way he has a chance with her is if he remains at the hotel and makes use of what he's learned about her "dream man."

But if Joe were to speak the truth, On the Nose, and simply state what he's thinking, "Please let's stay so I can selfishly get it on with Sugar," the result would be Jerry simply saying NO, end of discussion. Joe wouldn't get what he wants.

So he doesn't articulate his true thoughts or reasoning, but REVEALS them through the subtext as he speaks solely to achieve his goal through the tactic of playing on his partner's fears and insecurities.

Similarly, in *The Shawshank Redemption*, when Warden Norton learns that Tommy might have evidence that could exonerate Andy, he brings Tommy to the yard and says:

> Tommy, I need to make sure that Andy never gets out of here, because if he does, he'll probably blab about the money-laundering I've been involved with. So if you are trying to help him get out, tell me now so I can stop you.

Does he say that? Of course not, that dialogue would be completely On the Nose, devoid of any subtext. That IS the subtext. So the actual dialogue is:

```
            NORTON
The right decision. Sometimes it's hard to figure
out what that is. You understand?
    (Tommy nods)
Think hard, Tommy. If I'm gonna move on this, there
can't be the least little shred of doubt. I have to
know if what you told Dufresne was the truth.

            TOMMY
Yes sir. Absolutely.

            NORTON
Would you be willing to swear before a judge
and jury . . . having placed your hand on the
```

```
Good Book and taken an oath before Almighty God
Himself?

          TOMMY
Just gimme that chance.

          NORTON
That's what I thought.
```

In the scene, Norton wants to know what danger Tommy's info poses for his own well-being. So his immediate goal is *to find out how loyal Tommy is to Andy.*

But if he told the truth of his intentions, spoke his subtext, Tommy would undoubtedly lie to save his friend and Norton wouldn't achieve his goal.

Thus the tactic he uses is *to earn Tommy's trust.* That is the intended effect of his speech. He must convince Tommy that he too is on Andy's side, the opposite of the truth. His approach becomes *to question Tommy's loyalty*, to create a situation where Tommy feels compelled *to convince Norton of his desire to do the right thing.* That then becomes Tommy's goal.

And as a result, Norton gets just what he wants.

Similarly, Vito Corleone could tell his godson Johnny Fontaine, "Don't worry, I'll have Tom kill Woltz's favorite horse, put the decapitated head in his bed, and he'll get the message that he must do what I want, and you'll get the part in the movie."

OR he could say, "I'll make him an offer he can't refuse." After all, Vito's goal in the scene is *to put Johnny's mind at ease.* That's the intended effect of the speech, not to freak him out by revealing the truth of his anti-equine plans.

For another example of what might be revealed by a character's words, beyond the words themselves, look at this exchange at the midpoint of *Star Wars*:

```
          HAN
I'm not going anywhere.

          LUKE
They're going to execute her. Look, a few minutes
ago you said you didn't want to just wait here to
be captured. Now all you want to do is stay.

          HAN
Marching into the detention area is not what I had
in mind.

          LUKE
But they're going to kill her!

          HAN
Better her than me . . .

          LUKE
She's rich.
```

```
                    HAN
          Rich?

                    LUKE
          Yes. Rich, powerful! Listen, if you were to rescue
          her, the reward would be . . .

                    HAN
          What?

                    LUKE
          Well, more wealth than you can imagine.

                    HAN
          I don't know, I can imagine quite a bit!

                    LUKE
          You'll get it!

                    HAN
          I better!
```

What is Luke's immediate goal in this exchange? He wants *to get Han on board his plan to rescue the princess*. At first, he tries the tactic of appealing to Han's sense of decency. *They are going to kill her!* Unfortunately, at this stage of the story, Han lacks that particular sense.

So Luke tries another tactic to achieve the same goal, to appeal to Han's greed. *She's rich!* And bingo, he manages to pique the pilot's interest and ultimately get Han on board.

Luke speaks solely to accomplish his immediate goal, not to provide us information. Yet by doing so, we ARE provided information, valuable insight into *who* Luke is at this moment, someone capable of reading others, of making a plan, of taking charge, of becoming a leader.

It's not the words themselves, but how they are utilized in pursuit of a goal that reveals Luke's character, his *moral disposition* and *thought*.

Just like the scene from *Fargo* that we discussed earlier. Marge could have said to her deputy: "I'm sorry I corrected your police work and emasculated you. I wish I could clear the air and make you feel better." Awesome dialogue, right? Instead she tells the vanity license plate joke, plays her goal instead of speaking the subtext, and reveals her character in the process.

Similarly, in *Tootsie*, when Michael wants to sleep with Julie, he could speak completely On the Nose and tell her, "You know . . . I could lay a big line on you, but the simple truth is—I find you very attractive . . . and I'd really like to go to bed with you."

But again, he'd just be speaking his subtext. Would that accomplish his goal? Of course not. So what he actually says is . . . wait, that IS what he actually says.

And she hurls her drink in his face, as well she should.

That's what you'll find over and over in good scene after good scene. Characters speak to achieve their immediate goal, a goal that is seldom, if ever, served by saying precisely what they mean, think, or feel.

And the result is that, in good dialogue, there is a difference between what a character says and what they mean.

What they SAY are the words they use. What they MEAN is the *thought* that motivates the speech, what is revealed between the lines. And it is that subtext, what they want and how they go about getting it, that gives us insight into *who* they are at this point in their journey toward their Change of Fortune.

And that, my friends, is Aristotle's gold at the end of the proverbial rainbow, the key to writing good dialogue.

But that's not all there is to say on the subject.

THIRTY-ONE
Dialogue Continued
Still More Left to Say

"Character and thought are merely obscured by a diction that is over brilliant."

(Poetics, Part XIV)

We've discussed Aristotle's biggest insights when it comes to good dialogue, that it's always in the service of a character's immediate goal and that it therefore has subtext.

But there remain a few more important points to make:

1. I always bristle when I hear a student say he has a great line of dialogue, but he just doesn't know which character to give it to. Guess what? That is *not* a great line of dialogue. Dialogue only works when it is precisely what a specific character would say in a specific situation to achieve a specific goal.

 So create the scene's circumstances first, *then* figure out what a character would believably say in them, according to what is possible and pertinent. Never work the other way around, coming up with a bit of dialogue and then trying to find a scene to justify it.

2. *How* a character speaks is unique to each character. In fact, a character's individual VOICE is one of the key ways to reveal their *inner life*. It gives an indication of where they come from, their occupation, ethnic background, economic class, level of education, etc. It can even give insight into the character's psychology, revealing how they think, what they value, and how they see the world.

 So use your characters' backstories to make decisions about specific speech patterns, dialects, slang, argot, and idiom. You want every character in your screenplay to speak consistently and uniquely, and as the goal is *mimesis*, AUTHENTICALLY.

3. Keeping in mind that film is a visual medium and that what we *see* communicates far more than what we *hear*, when crafting dialogue, just as in description, be economical. LESS IS MORE.

 In most good screenplays, it's rare to find a speech that stretches more than a few lines. Monologues are primarily theatrical devices and can weigh a scene down, or worse, remind the audience that they are just watching a movie. So if you are going to have a lengthy speech, make darn sure it's warranted, that the character's goal *requires* a story be told.

 And always bear in mind Aristotle's admonition on diction, that when choosing words we must strike a balance between the common and the ornamental. That applies to dialogue as well as description. We don't want speech to be too clear—that's where subtext comes in—but we also don't want to be too obscure. Nor do we want it to be overwrought with affect or embellishment, unless of course, such verbiage is specific to the character's voice.

4. As discussed earlier, avoid dialogue that simply states FACTS, whether about emotion or about expositional information. It always reads as On the Nose, as dialogue for the audience's benefit, not the character's, since it has no subtext.

 So a character would never simply state: "I'm mad at you." They'd say: "Did you get the dry cleaning? No, of course you didn't." And the *subtext* is "I'm mad at you."

 Similarly, they'd never say: "I was bored to death in Professor Price's class." They'd say, dripping with sarcasm: "Yeah, Price's class. What a party."

 But what if you desperately *need* a character to express a fact? What if the Writer's Intention of a particular scene is to reveal some bit of information or backstory that can only be expressed through dialogue?

 Ah, well that's where Aristotle's Guiding Precept #17 comes in.

 When you need to reveal *exposition*, which is just a fancy word for info the audience needs in order to understand the story, you must DISGUISE it by making it a consequence of the character's pursuit of their immediate goal.

 For example, you might have a scene where you want to reveal that Ben and Sarah had a father who left them when they were very little.

 You could have Ben say: "Sarah, when we were young, dad left us."

 And yes, that bit of dialogue would *suck*. It's completely On the Nose, just a recitation of an expositional fact with no subtext. It may be a TRUTH, but it falls flat since there is no reason for Ben to say it, given that his sister clearly already knows that fact, no reason other than to give US the info. And as I've said, characters don't know we exist.

 So while the line might accomplish the Writer's Intention, it doesn't work unless it is said to accomplish the Scene Protagonist's immediate goal.

 What circumstance would create a goal for Ben that would lead him to say this line AND accomplish our own goal for the scene?

Well, maybe Sarah said something to Ben's girlfriend in a previous scene, something that revealed a secret he wanted kept hidden. That might motivate Ben to want to hurt his sister in this scene. *To hurt* is a goal, a good, motivated goal in the context of the circumstances.

So now Ben might say: "Sarah, you know YOU were the reason that dad left all those years ago."

Bingo. What just happened? Ben tried to hurt Sarah. To accomplish that, he said something that would achieve that EFFECT. *To hurt*. And in the process, he revealed a bit of expository information.

That's how you disguise exposition, with CONFLICT, by making it not for *our* benefit, but for the *character's*, in pursuit of their goal.

5. And one final thought when it comes to dialogue. As with description, never get in the way of it. You should be invisible.

By that I mean, don't use dialogue to advance your own personal agenda, philosophies, or worldviews. We'll see right through that. Dialogue is neither a polemic, nor a soapbox for the writer. Similarly, it is not a canvas to reveal how witty or clever you are with a turn of phrase. The key is to not draw attention to yourself at all.

So let the characters speak for themselves, as themselves, to get what they want. We want dialogue to sound real and to advance the story and our understanding of character. We don't want it to make us stop and think about how clever you are. Because if we do, you aren't.

So to sum up:

Characters have immediate goals, the result of their *moral disposition* and their *reasoning* when faced with particular circumstances. And they speak in clear, simple speeches, with distinct but consistent voices, to achieve those goals.

And while they never prosaically state what they think, mean, or feel, they reveal that inner life through subtext, not by what is said, but by what is meant, by the *thought* motivating the speech.

And that is dialogue.

Now before we put everything together, what we've learned about scenes, description, and dialogue, we have to discuss one final element of the modern screenplay, one about which Aristotle has virtually nothing to say. Formatting.

Formatting

Ah, the Lovely White Space

"To attain the proper vividness in reading, the poet must place the speech 2.5 inches from the parchment's left, align transitions right, and double space after headings, creating the most pleasurable arrangement of elements. Alternately, as Homer bade, download Final Draft."*

(*Poetics, Part XVII*)

Okay, you got me. Aristotle doesn't really have anything to say about screenplay formatting. At least not explicitly.

Still, several of the principles we've been discussing are wholly relevant when deciding how to physically arrange our words on the page.

First, is the principle of CLARITY. As we've seen, Aristotle believes the reading of a script should be pleasurable, not a chore or struggle. And that can't be accomplished if the story isn't presented in a manner that is easily and effortlessly grasped.

So when laying out your scenes on the page, you should always be guided by what makes the information you are trying to convey the most accessible to your reader.

Second, is Aristotle's precept that the experience of reading the script should approximate the experience of seeing it play out on the screen, provoking the same feelings, thoughts, and emotions.

That too depends not just on the words chosen, but also on how they are laid out on the page. Think back to our discussion of action description and the example of Tommy's death in *The Shawshank Redemption*, how the *manner* in which it was presented was intended to create the same breathless excitement, terror, and surprise that the viewer would experience.

But while *clarity* and *correlation of experience* may be the primary goals when making formatting choices, there exist actual rules for laying out a screenplay page that must be adhered to if you want your effort to look like a professional screenplay.

Many of the rules that have developed over the years were first introduced for practical production reasons, such as to provide key info to a production manager or set and sound designers, to alert line producers to location and scheduling requirements, to provide casting or call information, or simply to make sure each page equals one minute of screen time.

But regardless of the rationale for the rules, if you want your work to be taken seriously, abide by them—as long as you waste as few precious seconds and brain cells thinking about them as possible.

Most writers I know use formatting software when writing their screenplay. Unfortunately, software won't actually write your story for you. At least not yet. But it can help you to lay it out properly without having to memorize margins, spacing, tabs, and caps.

Still, whether typing into a template or working with one of the many screenplay apps available, you should at least be aware of what those conventions are so that you can utilize them to facilitate the read, fulfilling Aristotle's admonition that it be a pleasurable experience that approximates the viewer's.

So let's look at them on a sample page from Robert Towne's classic screenplay for *Chinatown*:

```
A FULL SCREEN PHOTOGRAPH

grainy but unmistakably a man and woman making love.
Photograph shakes. SOUND of a man MOANING in anguish.
The photograph is dropped, REVEALING ANOTHER, MORE
compromising one. Then another, and another. More moans.

                    CURLY'S VOICE (3)
                 (crying out) (4)
              Oh, no. (5)

INT. GITTES' OFFICE - DAY (1)

CURLY drops the photos on Gittes' desk. Curly towers over
GITTES and sweats heavily through his workman's clothes,
his breathing progressively more labored. A drop plunks
on Gittes' shiny desk top. (2)

Gittes notes it. A fan whiffs overhead. Gittes glances
up at it. He looks cool and brisk in a white linen suit
despite the heat. Never taking his eyes off Curly, he
lights a cigarette using a lighter with a "nail" on his
desk.

Curly, with another anguished sob, turns and rams his fist
into the wall, kicking the wastebasket as he does. He
starts to sob again, slides along the wall where his fist
has left a noticeable dent and its impact has sent the
signed photos of several movie stars askew.

Curly slides on into the blinds and sinks to his knees.
He is weeping heavily now, and is in such pain that he
actually bites into the blinds.

Gittes doesn't move from his chair.
```

```
                    GITTES
          All right, enough is enough—
          you can't eat the Venetian
          blinds, Curly. I just had
          'em installed on Wednesday.
                              CUT TO: (6)
```

It looks like a professional screenplay page, doesn't it? That's because Towne is adhering to the conventions of a professional screenplay format. Let's break them down.

On the page are SIX different screenwriting elements: SLUGLINES, ACTION, CHARACTER NAMES, DIALOGUE, PARENTHETICALS, and TRANSITIONS.

Each of these elements is always in 12-point COURIER.

And here's how they break down:

(1) Sluglines

Also known as the SCENE HEADING, a SLUGLINE begins every new scene. It tells us when and where the scene is set and looks something like this:

INT. CLASSROOM—DAY

The first part of the slug tells the reader whether the scene is an interior or exterior location, giving the crew some indication of how it will be lit, if weather will be an issue, and all the other factors that come into play when you are shooting indoors versus outdoors.

The second part gives the specific locale, indicating which set is being utilized, whether on a soundstage or on location.

The third part reveals the time of day. The possible choices are usually only day or night. Again, this gives an indication of lighting requirements, but also gives vital info to the line producer who must schedule ahead of time what must be shot and when.

Remember, you'll need a new SLUGLINE every time you start a new scene, every time you shift the time or place. It's always in ALL CAPS and is spaced all the way to the left margin. It also has a space above and below it.

(2) Action

Sometimes referred to as DESCRIPTION. This is the element wherein you describe what is actually transpiring on the screen, who is present and what they are doing. As we've discussed, it comes in three flavors: setting, character, and action description.

It follows standard rules of capitalization, is single spaced, and is always written in the present tense. It too goes all the way to the left margin.

(3) Character Name

This element appears above dialogue and tells us which character is speaking. It is always in ALL CAPS and is usually tabbed to 3.7 inches.

(4) Dialogue

These are lines that the character speaks. Dialogue is single-spaced and follows standard rules of capitalization. It is tabbed on the left at 2.5 inches and to the right at 2.5 inches.

(5) Parenthetical

This element comes between the CHARACTER NAME and the DIALOGUE. It is primarily used to describe a simple action a character may be performing while speaking, who they are speaking to, or *how* they are speaking if it wouldn't otherwise be clear in context.

As the name of the element implies, parentheticals are written in parentheses. They also appear on their own lines (not within the dialogue lines). They start at a half inch to the left of the CHARACTER NAME tab mark and they only go for 1.5 inches before wrapping around to the following line.

PARENTHETICALS should be used sparingly, and only for clarity. You don't need to do the actor's job for them by telling them how to speak the line (angrily, lovingly cheerfully, etc.), UNLESS the meaning of the line is the opposite of what is stated, as when it's intended to be sarcastic or ironic. That is why some writers refer to PARENTHETICALS as *wrylys* (since they indicate when a line is supposed to be spoken wryly, duh).

(6) Transitions

These include things like CUT TO: or DISSOLVE TO:. They aren't used that frequently anymore since a cut is always implied by a new slugline without having to use up valuable page real estate. But when you really want to emphasize a juxtaposition or shift between scenes, you can use them.

They are in ALL CAPS, formatted to the right of the page, and followed by a colon.

And those are the biggies when it comes to standard formatting rules. Here are some additional things to know:

Page margins are LEFT: 1.5 inches, RIGHT: 1 inch, TOP: 1 inch, BOTTOM: 1 inch.

PAGE NUMBERS go in the upper right-hand corner.

The first time a character's name appears in description, it appears in ALL CAPS.

Sound effects within description are written in ALL CAPS.

Important props or isolated actions to which you want to draw particular attention can also be written in ALL CAPS (as long as you don't overdo it).

NEVER USE CAMERA DIRECTION in a writer's draft. That's incorporated into the SHOOTING SCRIPT, written many drafts down the road and usually with the collaboration of a director or cinematographer. So leave out CLOSE UP, PULL OUT, TILT, DOLLY, etc. You can IMPLY these directions simply by what you choose to describe. For instance:

```
A long yellow ribbon of asphalt winds through the Nevada
desert. Angela's back slams into the car seat as she
shifts from first to fifth gear.
```

In the preceding action description, we clearly started with a bird's eye view of a highway, then quickly cut to a CLOSEUP of Angela in the car. The reader can follow the intended choreography without the distraction of camera direction.

Don't use SCENE NUMBERS. Those are also for the shooting script.

And lastly, always remember that WHITE SPACE is your friend.

Again, it is impossible to overstate the fact that a screenplay is meant to be READ. Sure, it is also the blueprint for a production and hopefully will be used for that purpose one day. But until then, it must pass through the various gatekeepers who will be *reading* it.

We've already discussed how you can use language and your actual word choice to keep that read interesting, finding the happy medium between the journalistic facts of the story and distracting embellishment. And to that we've added the opportunity to lay out those words in meaningful ways, breaking up lines, chopping up syntax, using sound effects, manipulating or adhering strictly to the rules of format, to keep the read dynamic.

But a simple technique to keep the read as friendly, enjoyable, and entertaining as possible, one that is far more mundane but no less significant than any we've discussed, is to allow for plenty of *blank real estate* on the page.

That's what we mean by WHITE SPACE—the absence of text.

For that reason, try to keep blocks of description and lines of dialogue under four lines. Break up lengthier description with dialogue, and larger blocks of dialogue with description, since every time you change elements, you create more white space.

And the more white space, the easier the read. And the easier the read, the better the chance that it *will* be.

In the end, as far as formatting goes, only four rules ultimately matter: That your page looks professional, that it communicates your intent clearly,

that it approximates the experience of watching the film, and that it is a pleasure to peruse.

If you adhere to those rules, a reader can forgive variance in any of the others.

So do that.

THIRTY-THREE

Pages

Putting It All Together (Part 3)

"The poet should endeavor to combine all poetic elements; or failing that, the greatest number and those the most important."
(*Poetics, Part XVIII*)

Now that we've discussed all the various components required to translate a story beat into words on a page, the description, dialogue, and formatting, let's look at an actual scene to see how all these elements come together.

Here's the opening scene of an early draft of *Spider-Man*, written by one of my all-time favorite screenwriters, David Koepp. And even though it changed quite a bit before the final Shooting Script, it provides an excellent example of Aristotle's precepts.

```
EXT. A BACK ALLEY—DAY

The screen is filled by the face of PETER PARKER, a
seventeen year old boy. High school must not be any fun
for Peter, he's one hundred percent nerd—skinny, zitty,
glasses. His face is just frozen there, a cringing
expression on it, which strikes us odd until we realize
the image is freeze framed.

                    PETER (V.O.)
          Look, I'm going to warn you right
          up front. If somebody told you
          this was a happy story, if
          somebody said I was just your
          average, ordinary seventeen year
          old, not a care in the world . . .

The image un-freezes. A FIST, at the end of a right hook,
comes into frame and punches poor Peter. His head snaps
back and bounces forward, his eyes roll.
```

> PETER (V.O.) (cont'd)
> . . . somebody lied.

The image freezes again, Peter's glasses dangling from one ear.

> PETER (V.O.) (cont'd)
> That's me. Peter Parker. A.K.A.
> Spider-Man, but not yet. Gotta go
> through some ritual humiliation
> first. All right, I didn't want
> you to see me like this, but we
> might as well get it over with.

The image unfreezes again, another fist comes into frame, this one a left cross. It CRUNCHES into Peter's nose and he crumples to the pavement in this alley in the city.

THREE HIGH SCHOOL PUNKS commence pounding the crap out of him. FLASH THOMPSON is the leader, he's 17, good-looking, body of a twenty-eight year old.

> FLASH
> You do NOT talk to her! How many
> times I gotta tell you that? Do you
> listen when I talk? Hey! I asked
> you a question! Do you LISTEN when
> I'm talking to you?!

> PETER
> Huh? Sorry, I wasn't listening.

This enrages Flash; he punches Peter in the ribs. Peter groans in pain.

> FLASH
> Next time you're gonna pay, puny
> Parker, you are gonna pay.

Peter spits out some blood.

> PETER
> Will a credit card be okay?

The other two Punks laugh, they find Peter kind of amusing. This upsets Flash even more, he picks up a garbage can and is about to bring it down on Peter's head when a voice from behind stops him.

> M.J.
> What kind of man—

They turn. A girl stands in the entrance to the alley—MARY JANE WATSON, seventeen, painfully sexy already, with a knowledge and sadness in her eyes way beyond her years.

> M.J. (cont'd)
> —picks on a helpless little dweeb?

 PETER
 Look, I know you mean that in a
 good way . . .

Flash raises the trash can again.

 M.J.
 Leave him alone, Flash.

Frustrated, Flash upends the trashcan, dumping its
contents on Peter's head and tossing it aside. He and the
other Punks head for the mouth of the alley, leaving Peter
behind, covered in garbage, humiliated. M.J. lingers, for
a moment it's just the two of them in the alley.

 PETER
 Thanks, M.J.

She squints at him. Have we met? He gets up and follows
her out of the alley.

 PETER (cont'd)
 Next door . . .

 M.J.
 Huh?

 PETER
 That's what I was trying to say on
 the bus, I live right next door to
 you. And I'm in your biology class.

As the scene ends, Peter and M.J. walk around a corner and we discover
they are part of a high school field trip. They continue their conversation as
they approach a Columbia University building.

 PETER
 (to M.J.)
 This class. Our class.
 (no recognition)
 I'm Peter.

 M.J.
 (I've never seen you before
 in my life)
 Oh yeah! Well, you better get away
 from me. Flash has a real temper,
 and I might not be there to save
 your butt next time.

 PETER
 I was doing fine.

She reaches out, wipes a bit of blood from his lower lip.
Slowly. She smiles.

```
                          M.J.
                 Sure you were, Tiger.
```

She disappears into the crowd. Peter sighs, and sits at
the edge of a fountain, starts cleaning himself off. He
watches her walk away. She owns his heart. Ours too.

We go with M.J. as she heads into the building. She
passes a Town Car with tinted windows that's parked at
the curb. She stares, sighs to herself, a heartsick look
on her face. Whoever's inside, he owns her heart.

Nice Opening Hook, huh? It's an exclamation point *and* a question mark, and certainly compelling us to turn the page to see what comes next. Let's examine the various scene elements we've discussed so far, starting with first principles, as Aristotle would say.

So what is the WRITER'S INTENTION of the scene?

It's to introduce us to the protagonist, Peter Parker, and to a lesser extent to set up the love triangle that is at the romantic heart of the story.

Where is it set? Who is present? What does the setting *look* like?

Well, we're in an alley. With Flash, M.J., Peter, and some various punks. There's a trashcan. Maybe some rats scurrying around. Certainly some garbage. A putrid puddle running into a sewer grate.

Wait, you say. Was any of that described? Sure, it's right there in the scene heading. EXT. ALLEY—DAY. That slug communicates a lot, though most is left for us to fill in.

Now, a tougher question. Whose scene is it?

Okay, I lied. Not tough at all. It's Peter's scene of course. He's the Scene Protagonist. But what does he want?

He wants *M.J. to recognize him. That* is his clear, specific, immediate goal.

And what are the obstacles keeping him from accomplishing it?

Chiefly, despite being in his class and living next door to him, M.J. has absolutely no clue who Peter is. That's a problem. Another is that Flash clearly told Peter in a previous off-screen scene that he MUST NOT talk to her. Then there's Flash's fist. Not to mention Peter's own awkwardness and geeky ineptitude. These are the sources of conflict, both internal and external, that stand in Peter's way.

So what tactics does Peter employ to overcome these obstacles?

Primarily, he keeps doggedly reminding M.J. who he is, hoping to jog her memory, but with little success. Additionally, he makes jokes to try to disarm Flash, which unfortunately only serves to enrage him further.

But even if Peter is unsuccessful, through these tactics, we learn vital things about him as a character.

We learn he's nerdy. He's physically weak. He has a good sense of humor, though it doesn't always serve him well. He has the hots for M.J. He's pretty much invisible to those he cares about, and a source of abuse for those he doesn't.

And of course, he doesn't come out and *say* any of these facts. Nor does anyone say them *about* him. We glean them partly from how he's physically described, but mostly from his behavior, what he says and does in pursuit of a goal.

So just as we want, the Writer's Intention, introducing us to Peter in a Representative Behavior, is accomplished through the conflict of the Scene Protagonist pursuing his immediate goal, getting M.J. to recognize him, despite the obstacles standing in his way.

And what of the description and dialogue?

Well, there's a good variety of each, and yes, a lot of friendly white space in between. But do they follow Aristotle's dictates?

"High school must not be any fun for Peter." "Painfully sexy already." "Body of a twenty-eight year old." "It CRUNCHES into Peter's nose." "She owns his heart. Ours too."

Examples like this paint a very clear, vibrant picture of what we are looking at, with words that are economic and precise, but also entertaining to read. Revealing more than simply the visual facts, yet never distracting.

The dialogue too is clear and economic, and always in the service of a character's goal, whether it's *to threaten, to remind, to amuse, to console,* or whatever else may be the desired effect. The words are NEVER simple pronouncements of what is going on in a character's head, yet they still reveal *thought.*

"I was doing fine," says Peter. *Was* he doing fine? No, not for a second. But his goal at that moment is to impress M.J., not tell her how powerless he feels.

And what of her response? "Sure you were, Tiger." Does she really think he was doing fine? Of course not. But her goal at that moment is to make him feel better, a goal that wouldn't be accomplished if she spoke the truth: Liar, you were getting your butt kicked.

So how do we know what is actually going on in her head, the subtext between the lines?

First, by the context of the circumstances. She did after all just witness his pummeling along with us. Second, by her clear goal to make him feel better, a goal that reveals her sympathetic disposition and her reasoning that he requires reassurance. And, third, by her physical behavior. While speaking dialogue intended to accomplish a goal, what does she do? She "wipes a bit of blood from his lower lip."

Actions speak louder than words.

And characters only speak to achieve an effect, to accomplish their immediate goal, not to say what they mean, think, or feel.

So this scene does a good job of illustrating the elements we've been discussing. It accomplishes the Writer's Intention, it advances story and character, it engages us with conflict, we came in as late as possible and left at the earliest possible moment, and it was a fun, easy read.

Now you go do that.

ASSIGNMENT #12: OPENING HOOK

Write the first scene of YOUR screenplay, utilizing proper screenplay format and our discussion of dialogue and description. Remember, the goal of your first page is to get the reader to TURN the page. The goal of the second page, is to get them to turn that one, and on and on.

Your Opening Hook should give us insight into the character or their world, and whether a question mark or an exclamation point, hook us into the story.

THIRTY-FOUR

First Draft

And You're Finally Done

"These then are the rules the poet should observe."
(Poetics, Part XV)

As I've previously bemoaned, students are constantly asking me, "On what page should the Inciting Incident happen?" The Point of No Return? The Beat of Achievement? Big Gloom? Etc.

To them I answer, "If you want a formula, take up calculus." While that's usually not what they want to hear, that we can't simply plug our beats into a successful template, it doesn't mean there aren't observable patterns that we can learn from.

If you look at the screenplays for the movies I've listed on my Recommended Movie List (see Appendix), a nice cross section of movies that have or will stand the test of time, you will see these patterns.

For instance, your average screenplay these days, whether for artistic or economic reasons, tends to be around 100–120 pages.

Most screenplay festivals and competitions insist that a feature length entry be at least eighty-five pages long. That's also the length that the UCLA MFA screenwriting program insists upon for students' final submissions. Anything shorter is really a short. Plus, I always tell my students that if their script is turning epic, I'll read the first 120 pages. Life's too short to spend it reading a script, however good it might be, and I'm sure most producers feel the same.

Still, the only rule about page count is that your screenplay has to be as long as your story requires. So in terms of Aristotle's *proper magnitude*, if you stick to only what is essential, your screenplay will be the proper length. And if you find yours falling within that 100–120 page range, just know you are in good company.

Similarly, if you find that your inciting incident falls somewhere between pages ten and twenty, that your first act ends somewhere between twenty-five

and thirty, and that your second act break falls around eighty-five to ninety-five, then once again, your story simply comports with many more making their way to the silver screen these days.

However, these page numbers can't be forced, not without seeming so. Like I said, there's no template, your story needs to be told the way it needs to be told.

To that, my students usually snort derisively and then go ahead and force their stories to conform anyway. And when they do, the strain never fails to show.

Let the story itself guide you. As long as you abide by the precepts we've been identifying, your story will dictate when and where the specific moments must happen naturally. Trust it.

And now that you've outlined your story, determined every beat, started the process of transforming those beats into scenes of dialogue and description, into actual screenplay pages, the next part of the process should be obvious.

Write the rest of your screenplay.

But as you do, let me offer some practical advice.

Admittedly, Aristotle says a lot about how to craft a screenplay, but precious little about the actual experience. So let me add my humble two cents.

One of the hardest challenges of writing a screenplay draft is simply putting your derriere in a chair.

To that I say, scheduling and deadlines are your two best friends.

Writing is one of those enterprises that you can *always* be doing, since the vast majority of writing is actually *thinking*. And you can always be thinking, right?

As a result, if you are serious about writing, you can rest assured you will feel incredibly guilty much of the day for *not* writing. And if you've ever written anything before, you know full well the attractive and deadly allure of procrastination.

So it's important to give yourself permission *not* to write. In fact, I find this "negative time" one of the most useful ways to ensure productivity. Simply put, for the majority of hours in the day, I am not *allowed* to write or even think about it. In those hours, I sleep, eat, watch TV, do the laundry, interact with other human beings. That makes my actual writing hours all the more productive, especially toward the end of those hours, when I know my time is almost up.

And as for the actual writing time, I find it crucial to set aside some time to write EVERY DAY. Your creativity is a muscle and it needs to be exercised or it will atrophy. It doesn't matter if you actually accomplish new pages each time you sit down, but it is important that you set time aside in which, as unproductive as you may be, you are not allowed to do anything *but* write.

And it needn't even be a screenplay. It could be a short story, a comic book, a speech, a character sketch. As long as you are being creative, and not mindlessly minesweeping or web surfing, you are flexing those writing muscles.

It is also important to set concrete writing goals for yourself. Start by determining how many pages of your screenplay you want to accomplish in

a given week. At UCLA, where students are expected to write a new draft every ten-week quarter, we advise that they write a minimum of ten to fifteen pages a week. So deciding how many days a week you can set aside to write, it's easy to figure out how many pages you will need to write per day in order to meet that goal.

Yeah, I know, I promised no math.

I usually start my writing time by going back over and rewriting what I did the day before. This is a great way to get back into the *groove* of the story, its voice and tone, as well as a way to get a running start into the new material.

It's also a great way to get a leg up on the rewriting process (more on that in the next chapter). The truth is that every pass you make through a scene will improve it. So go back to those previous pages, remove everything that is unnecessary in terms of action, description, and dialogue. Increase the conflict, raise the stakes. Come in later, leave earlier. Sharpen and focus everything that remains.

Then with that running start, write your new pages for the day.

When and where I write is important too. It may vary from project to project, but I find that if I situate myself in a similar spot, in terms of my writing environment, it makes it easier to slip back into the same creative space.

So do some experimenting. Figure out if you work best at night, in the morning, during banker's hours. If you prefer working at a desk at home or at your local Starbucks. If you do best typing into a laptop or scribbling freehand on a legal pad.

Also, do you require silence or noise? I know some writers who need the company of a TV running in the next room, but for others any sound is distracting. Years ago, the producers of a script I was writing sent me a CD of the film's proposed soundtrack, and I found it such a gateway into the spirit of the screenplay that I've taken to writing while listening to an appropriate score for each subsequent project.

Then once you've found the environment that works best for you, try to recreate it each time you sit down to write. You'll be amazed at how habituating your creative surroundings helps you get back into the psychological space of your story. And given how difficult it is to get your butt in the seat, anything helps.

And one final word of advice before you begin, perhaps the most crucial of all: Give yourself permission to SUCK.

No joke. As we will see in the next chapter, your first draft is just the first step in a much longer process. You will have plenty of opportunity to shape your screenplay into the critical darling and box office behemoth it deserves to be in subsequent drafts. But you need something to rewrite. So your goal while writing this first draft is quite simply *to get to the end.*

And that is easier said than done.

A reality as true today as it must have been in Aristotle's time is that most people who fancy themselves writers, aren't.

That's because, for all their lofty ambition, they've never gotten to the end of that first draft. Either they've buckled under the workload, become

enamored of some sexy *new* idea that's caused them to jump ship, *or* they've labored under the misconception that a scene must be perfect before they can proceed to the next, getting stuck on an endless treadmill of constant revisions, edits, and second guessing that prevents any forward progress.

As my esteemed UCLA colleague Linda Vorhees says, "Perfection is the enemy of completion!" And for a first draft, it is all about completion, not about how pretty or polished the result is. There's a reason first drafts go by another name in this business: the Puke Draft.

I know writers who put a Post-It note on their laptop while writing a first draft that simply states "First Drafts Suck," and I make my students whole-heartedly accept this universal truth before proceeding.

So keep writing forward. Don't agonize over every word, trying to get everything just right. It won't be. And all the struggle spent perfecting that opening will most likely turn out to have been a complete waste of time when you discover you actually needed to begin somewhere else entirely.

Because however cumbersome, overwritten, on the nose, or just plain ghastly the first draft my seem, you cannot truly know what your story *is*, what it *wants* to be, what it *needs* to be, until you get to the *end* of it.

So let's do it. Remove Solitaire from your laptop, along with Facebook, and, well, everything that isn't your screenwriting software. Stick a Post-It on your laptop that says "First Drafts Suck," set your Beat Sheet on the desk beside you, put on your headphones, shut out the real world, transport yourself into your invented one—

—and write.

ASSIGNMENT #13: YOUR ROUGH DRAFT

Write the rest of your screenplay, all the way to FADE OUT.

SECTION V
A RESOLUTION

(Wherein we wrap it all up with a bright red bow)

Rewriting

Ha! You Thought You Were Done

"Every kind of error should, if possible, be avoided."
(Poetics, Part XXV)

Wow.

If you've made it this far *and* kept up with the assignments, you've just done something phenomenal, something extraordinary, something truly admirable—completed the first draft of a screenplay.

That is a HUGE accomplishment, one that very few people, even those who purport to be screenwriters, ever actually accomplish.

So congrats on getting to the end. You are a screenwriter. Aristotle and I are proud of you.

But before you go overboard with the celebration (and you *should* go overboard with the celebration), keep in mind that you still have a ways to go before you reach the finish line. But you can *never* get there if you don't first accomplish this impressive first step.

When you finish a script, you should feel euphoric, a sense of accomplishment on par with scaling the Himalayas. Because it is a BIG DEAL. If nothing else, you have proven that this story can be written and that *you* could write it. And that is huge.

But that joy is invariably followed by severe depression. Because after pouring all your sweat, your tears, your blood into those pages, what exactly do you have to show for it? If you're like most, a hundred or so pages of crap. The crap of our Golden Buddha. And the cracks in our gold spray paint can't help but show.

But have no fear. You've got more spray paint. An endless supply. And every coating will bring this misshapen ball of initial choices, the good, the bad, and the breath-takingly ugly, closer and closer to the Platonic ideal you originally envisioned.

It's impossible to put too fine a point on it, but there is only ONE purpose of a first draft. It is not to have something to sell or get an agent with, not something to enter into a contest, to win awards, accolades, and multi-picture deals.

No, the *sole* purpose of a first draft is to have something to REWRITE.

You are just at the beginning of a much larger process, and hopefully, knowing that will help ease the sense that what you currently have may not be fit to wipe your two-year-old's nose.

So how do you go about starting a rewrite?

Well, the first thing you do is go and reward yourself. In the future, that reward will hopefully be a fat check from a grateful producer. But while you are waiting for that day, it can be an ice cream cone, an afternoon at the movies. Anything at all. Finishing a first draft is a huge accomplishment, and you need to treat it as such.

The second thing you need to do is to put your script in a drawer and COMPLETELY FORGET ABOUT IT.

Huh?

Yeah, you heard me correctly, put that sucker away and erase it from your memory.

Students often balk at this advice, but it is an absolutely *critical* step of the rewriting process.

You cannot rewrite a script while you are still in the same mindset you were in when you wrote the first draft. You will unavoidably make the same mistakes, overlook the same flaws, and be married to the same choices.

Ever wonder why it's so much easier to give someone else notes on their work than to turn a critical eye inward on your own? It's because you feel no ownership of someone else's choices, no loyalty or connection whatsoever to what they've done or why. You can be completely objective.

At its heart, rewriting is all about "killing your darlings," as Faulkner says, and that is only possible if you can read, digest, and dismantle your script just as objectively as if it were someone else's. When you don't have a CLUE why you made the choices you initially made, you can much more easily change, improve, or outright discard them.

And that can *only* happen if you put some distance between the initial draft and your first rewrite, if you allow yourself to *become* someone other than who you were when you wrote it.

Now some writers advise that you put a minimum of three months between a first draft and a second in order to be able to pick apart your work from a fresh vantage point. Others say less, others say more.

But I find any duration completely arbitrary.

My advice is that between a first and second draft, you need to write the first draft of something else entirely.

It's the equivalent of being served a sweet sorbet between courses of a fancy meal. But instead of cleansing your palate, you are cleansing your imagination of all the choices and their rationales from your previous draft. Having to deal with a whole new set of issues and problems, of characters and plotpoints, will create the necessary distance from that first draft that an arbitrary amount of time cannot.

A secondary benefit of writing the first draft of a new script between drafts of another is that you begin to build up a repertoire of material. This is important from a career perspective since when you finally do complete a script and are ready to launch it into the world, you want to make sure you have others behind it.

That's because if it gets optioned or sold (knock on wood), producers will want to see what else you have. And if you're savvy, you'll have something more to show them to capitalize on that heat, instead of having devoted all your time and energy to just that ONE effort.

Still a third benefit of working on another script between drafts is that you can give your writing muscles a workout. If you wrote a comedy, write a drama next. If you wrote a sci-fi, tackle a western. This isn't just about cleansing your creative palate, but about taking the opportunity to figure out what KIND of script you enjoy writing most and what kind of script you write the BEST.

Trust me, when you do launch your career, an agent or manager is going to want to brand you, to put you in a box, so that they know what kind of assignments to send you out on and producers will know what kind of jobs to consider you for. The reality is, they're seldom looking for a *good* writer, but a good *romantic comedy* writer. A good *literary-adaptation* writer. *Period epic* writer. *70s-horror-remake* writer.

So if you're smart, don't let your reps put you in that box. Brand YOURSELF. That will make you attractive to prospective agents, that you have the confidence of knowing who you are. And it will allow you, at least in the early part of your career, to concentrate on what you do best and enjoy the most.

But now we're really jumping ahead. Have I made my point? Write something new between drafts.

So assuming you take that advice, you've put your first draft in a drawer and just completed the first draft of another script. Now what?

Take your script out of that drawer and read it.

Don't make notes. Don't make changes. And don't jump off a cliff. Just enjoy the experience of reading it through. Pretend to be the READER you'll eventually be sending it to, just turning the pages and absorbing it.

It will probably be painful.

After so much time away, you hopefully won't have a clear memory of the writing experience. So things you thought would *suck* may now seem halfway decent, and things you thought were awesome may now nauseate you. But regardless of how good or bad any of it is, it can *all* be better. And that's the attitude you must adopt.

As Somerset Maugham said, "Only a mediocre writer is at his best."

You're not a mediocre writer—as evidenced by the fact that you are holding this book—so there is no way you can be satisfied with what you've done. The honest truth is, even if you become a successful writer, you will *never* be satisfied with what you've done. Embrace that fact.

And now that you've read it through, take a walk around the block and think about what you just experienced. Was it a pleasurable read? Did you want to turn the pages, to see what would happen next? Was there engaging conflict? Were the characters real and memorable? Did they change as

a result of their pursuit of a dramatizable objective? Was it the story you'd originally wanted to tell? Is it one you'd pay money to see?

The answers to these questions should be a definitive "meh," and a resounding "not quite yet, but could be." So now we start the process of turning *potential* into *actuality*.

And that begins with giving yourself notes.

Be thorough, and be severe. Remember, the key is to read it objectively, as if it were someone else's work, someone who wants *help*, not validation. Your goal is to give "them" notes to maximize the potential of their story, to take it to a higher level, never to settle for things the way they are.

And to do that, you'll read it through several times, each with specific things in mind.

First do a Story Read.

As you read, concentrate on the big picture concerns of the story. Is it clear? Does the action *rise*? Is there cause and effect between events? Are the structural moments, the key reversals and revelations, as big as they can be? Are they in the right places? Is everything motivated? Believable? Interesting? Entertaining? Is anything tangential or unnecessary?

As you do this read, jot notes in the margins. Mark that sucker up with thoughts, comments, reactions, and especially IDEAS. Cross things out, scribble things in.

Then take a deep breath. Relax. And take the rest of the day off.

Next, do a Dialogue Read.

Read the speeches OUT LOUD to get a better sense of them. Are the voices consistent? Distinct? What is On the Nose? Does everything have subtext? What can be trimmed or cut? Is there a logical flow to conversations? Does the dialogue sound real? Is exposition disguised by conflict? Are speeches always in service of the characters' scene goals?

Again, mark that sucker up. Scribble in new thoughts. Strike everything out that isn't necessary. Trim and add subtext to everything that is.

Then take a breath. Relax. Take the rest of the day off.

Next, you'll do a Description Read.

Is everything clear? Is anything inessential? What can be cut? Trimmed? Do you describe things we can't see on screen? Is it economical? Do the words strike that proper balance of the common and poetic? Are you revealing story and character through external means? Is it enjoyable to read, with just enough personality without being distracting?

Cross things out. Jot down better ideas, better words. Less words. And you know the drill, breathe, relax, take the rest of the day off.

Then do a Character Read.

Track each individual character from the beginning to the end. Are they real? Are they consistent? Are their actions always motivated? Are those motivations clear? Are they fresh and interesting? Will actors want to play them? Do they have depth? Contradictions? Do they change? Is that change a function of their struggle in pursuit of their goal?

Go through each character's journey individually. Think of details to make them more surprising, more memorable, more authentic. Cross out moments

that are redundant, that don't reveal additional layers. Jot down notes to clarify internal life through external behavior, to track a more gradual but more profound change. Elevate even the minor characters to make them more interesting.

Now go take a long nap. You've earned it. Dream happy thoughts of red carpet premieres.

By this point, your script should look a mess, full of notes and comments scribbled in the margins, things crossed out, arrows pointing backwards and forwards. This is as it should be.

You've dissected your Puke Draft, and from that foundation, begun the process of reassembly, seeing the possibilities within it that you missed the first pass through, possibilities you could only discover having *had* the experience of going through it that first time.

Now the next step is to give that script to someone else to read, for an even fresher objective perspective. I recommend you give it to SEVERAL people you trust to give you helpful notes. You don't want readers who will just tell you it's good. It's not good; you know that. And no matter how good it might be, you know it can be better.

So find some writers, people who can tell you what's confusing, who can suggest things you didn't think of, who will tell you what's working and what's not.

Give the script to them at the same time to read over a weekend. And then have them give you their notes together, in a group. Hopefully, they will candidly tell you their reactions and offer specific suggestions for new possibilities or for improving choices you've already made.

Remember, this is *not* a social occasion, but a productive work session. So while the desire to serve wine and chitchat might be strong, avoid it, at least until *after* they've helped you out.

The reason you want to hear from a group is that it gives them a chance to *discuss* issues. It's not uncommon for an individual reader to feel a problem they can't quite put their finger on. But with a chance to air that issue, clarity and multiple solutions may result. Plus, if you hear the same concern repeated, you know you need to do something about it.

Now, let me share some advice on the fine art of note-receiving, for it is a skill you'll need to cultivate as much as any in the writing process.

The number one thing to keep in mind is that it is not your job to do ANY-THING that anyone suggests. But it *is* your job, if you're smart, to create an environment in which note-givers want to help you.

To that end, don't do anything that puts up a wall between you and them. You don't need to challenge them, or debate them, or *defend* or *explain* anything you did. Doing so creates the impression that you don't find their responses valid, and that will only hinder their candor and helpfulness.

This holds true in *any* situation in which you receive notes, which, as I've said, is quite frequent in the writing process. You'll get notes from peers, from agents, from directors, from actors, etc. And in each situation, it is to your benefit to be an active and eager LISTENER.

Sure, you may ask questions to *clarify* certain feedback if it's unclear. But keep in mind that it doesn't matter what you intended or if a reader missed

something you're certain is in there. All that matters is *their* response, the fact that they *didn't* get it, since you won't be on hand to explain everything to everyone every time you send the script out.

To put it simply, just shut up and listen.

Remember, you can throw each and every note into the trash—when the meeting is over and you are out of the room. But *in* the room, do nothing but ENCOURAGE honest feedback, hoping that somehow, somewhere, within all those responses will be some gem of a thought or idea or suggestion that either works better than your own choice or, more importantly, inspires your own creativity toward an even better solution.

So nod your head. Smile. Occasionally say, "what an interesting idea, I'll definitely consider that." The subtext for that line might indeed be "what a stupid idea, I already considered and rejected it, you missed the point, you're an idiot." But to whose benefit would it be to *say* that?

And while they speak, write down EVERY NOTE they give you, the ones you know you'll discard, the ones that seem promising, the ones that make you want to scream and run out of the room. Don't dismiss any suggestion out of hand. But by the same token, don't blindly accept any either.

The truth is, even if you wholeheartedly agree with a note, you should never do anything that anyone else suggests. It is *your* story after all. Instead, the task when receiving notes is to try to identify the PROBLEM that someone's suggestion is intended to fix. Then come up with a better solution of your own that is more fitting to the story you want to tell, to your characters, and to your intent, all of which you know better than anyone.

Have I made my point? Then let's move on.

So after all this, you now have a lot of notes. Notes given to you by objective readers who hopefully know what makes a good script, and notes you've given yourself since *you* know what makes a good script.

Take all of those notes, the good, the bad, and the ugly—

—and start the whole darn process ALL OVER AGAIN.

Start with a new logline. Expand that into new Anchor Points. Transform those into a new two-page synopsis and from that, create new Stepping Stones. From those create a new Beat Sheet.

And from that, write your brand new second draft.

Wait, wait, wait, hold the phone, you say! Can't I just go into my original first draft document and simply make the changes that I think need making?

In a word, *uh-uh*.

That isn't a rewrite. That's an edit. A polish. A revision. That step will certainly come in time. But we are not there yet. Far from it.

A second draft is a *page one* rewrite.

That may sound daunting, like you're re-upping for all the same struggle, pain, and toil you went through the first time. But starting the process over again is *not* the same as starting from scratch.

Far from it.

Having learned all there is to learn from stumbling through the story the first time, you are now much better equipped to write it as it *should* be, as it

wants to be, as it *needs* to be. And so, far from being a drudgery, the second time around is pure joy. Or at least a step closer to it.

EVERYTHING about that first draft experience, from writing it to reading it, will inform the new choices you make in the second draft. As a result, the second draft cannot help but be exponentially better. You are no longer creating something from nothing. Instead, you are now maximizing the potential of your story, every aspect of it, every page, line, and word, with all the wisdom gleaned from the initial go-round.

Your new plot, as laid out in your second draft Beat Sheet, will most likely be very different from your original one. It will certainly be better.

Maybe one or two beats remain the same, like the story-defining beat that ends the first act. But everything else will be discarded, replaced, or improved now that your struggle through the first draft, with all its discoveries, dead ends, wrong turns, and *aha moments*, has shown you what your story really wants to be and what is the best way to tell it.

So now write *that* script.

And then, after you've gone through the entire process again and completed that second draft . . .

. . . you'll do it all again.

And again.

Most screenplays take up to ten drafts before they are worthy of being sent out, of being read by people who matter (and who will only read it once, so make sure they are reading the best it can possibly be). Each pass through will make it better. And each pass through, you'll change less and less.

In the first rewrite, you're making the big structural and story changes. The next time through, more confident that your big moments are where they should be and the general shape is sound, you'll be concentrating more on individual scenes, improving, trimming, discarding.

By the third draft, it's all about character, honing each journey. On the fourth, your attention is on dialogue fixes, improving description. And in later drafts, it's just about tightening and focusing, then punctuation and spelling, and ultimately, how your choices are best formatted on the page.

Are you feeling some déjà vu all over again? You should. Remember what Aristotle said about the writing process:

> *"First sketch its general outline, and then fill in the episodes and amplify in detail."*
> *(Poetics, Part XVII)*

Sure, that crucial advice applies to the initial crafting of your screenplay. But it also informs the rewrite process, as essential a step as any other we've discussed.

Which brings us to **Aristotle's Guiding Precept #19**:

SCREENPLAYS ARE NOT WRITTEN; THEY ARE REWRITTEN.

Your first draft lays the initial groundwork. Your first rewrite tackles the big picture issues and concerns. Your subsequent drafts deal with increasingly smaller and smaller issues, scenes, characters, dialogue, description, word choice, and layout. From the big to the small, from the general shape to the individual episodes, to the smallest detail.

So when is it done?

Well, as we're fond of saying at UCLA, a screenplay is never really finished, it's just abandoned. There are *always* things you can improve or change. But at some point, you'll realize the changes you're contemplating are just cosmetic, a different word choice here or there. They aren't necessarily making things better, just slightly different.

Then it is probably time to stop messing with it, set it down, and send it out.

And guess what. After it goes to an agent, or producer, or director, they'll have notes for you as well. And the whole process begins anew.

Whew.

And *that* my friends is why it is so vital that the idea you start with be something *personal*. You'll be living with this story, this script, for years, from initial draft, through rewrites, through development, through production. And you'll need to be just as passionate about it toward the end of the process as you were at the outset, when you first scribbled out that logline.

Which brings us full circle, all the way back to our initial discussion of STORY, the most important element of a screenplay.

Your story must be predicated on a truth about YOURSELF and your experience. That truth, and your need to communicate it, will pull you through all the years and all the iterations of your story since it will remain the core of every draft, regardless of the specifics that change.

As long as you start the whole process with an idea that *matters* to you, that you have a personal stake in, you'll have the passion required to go the distance.

And that takes us, finally, to the last remaining element from Aristotle's list of elements necessary to make a good drama work.

THIRTY-SIX

Theme

What's It All About, Ari?

"Thought is found whenever a statement is proved to be or not to be, or a general truth enunciated."

(*Poetics, Part V*)

In our first chapter on STORY, we discussed Aristotle's list of the elements that make up a drama, and we said that in modern screenwriting terms, they become: story, character, theme, dialogue, and action.

We've discussed them all now—save one.

And it's fitting that we've saved THEME for the end, since it, too, only gets revealed at a story's resolution.

Aristotle refers to what we think of as a story's theme whenever he discusses *thought* and *moral disposition*. For as we've noted, he maintains these distinct qualities are possessed not only by the individual characters, but also by the story as a whole.

And just as they provide the motivation for a character's actions, so, too, do *thought* and *moral disposition* provide the motivation for the story itself—its theme.

But wait a second. It was one thing to argue that fictional characters have these qualities. But how can a story?

Well, for Aristotle, the story's *thoughts*, also often translated as *ideas*, are simply the aggregate of all those revealed by the many characters' words and actions, and whether they are "proved to be or not to be."

And how do we know if a particular *thought* or *idea* is endorsed or supported by the story? How do we know if it reveals what Aristotle terms a *General Truth*?

Simple.

Recall that it is the *thoughts* of the individual characters that lead to their actions, which, in turn, move the story forward, and which ultimately determine success or failure.

So it is that outcome, success or failure, which determines the validity of the *thoughts* that led the character to that resolution.

And then it is that resolution, whether or not those *ideas* were proven sound, that ultimately reveals the story's *moral disposition*.

In other words, how we answer our dramatic question, whether or not the hero achieves their objective, and what they gain or lose as a result of their Change of Fortune, determines the *moral character* of the story—or put more plainly, the *moral* of the story.

Therefore, the various *thoughts* and *ideas* revealed by the characters, either overtly in their dialogue or implied by their behavior, not only are moving the story forward, but are also debating some larger question, a THEMATIC question.

It may be "Does love conquer all?" or "Does love stink?" "Are we all in this together?" or "Do we have to look out for number one?" "Do nice guys finish last?" or "Do you sometimes gotta break the rules?" "Is a man the sum of his achievements?" "Can you ever go home again?" "Does God exist?" *Who are we? Why are we here? What is our place in the universe?*

Different characters may represent different responses to these questions, and by *how* they ultimately fair, we can ascertain the story's answer, the GENERAL TRUTH that is revealed.

So another way to think of a story's unity and wholeness is that in Act One a thematic question gets posed, in Act Two it gets debated through the words and deeds of the characters, and finally, in Act Three, it gets answered by the resolution.

Think of the many speeches in *Oedipus Rex*. On the one hand, the characters are saying what they need to say, what is possible and pertinent in the given circumstance to get what they want. But on the other, their words and actions reveal them to be wrestling with larger issues that go beyond the immediate moment.

What is fate? What is destiny? Is our own end predetermined or can our actions shape a different path? These are big questions, universal questions that are argued, discussed, and examined through the characters' dialogue and deeds as Oedipus tries to achieve his ultimate objective.

And when he's blind, broken, overcome with grief, and staggering alone into the wilderness at the story's resolution, the writer's answer comes through loud and clear. Can we escape our fate? Not a snowball's chance in Hades.

So for Aristotle, *thought* both drives the plot by motivating the actions of individual characters AND explores larger questions that transcend those characters. The *moral dimension* of the story, simply put, is the answer to those questions.

Together, these elements provide the THEME. And that provides us **Aristotle's Guiding Precept #20:**

A GOOD STORY REVEALS A UNIVERSAL TRUTH, ONE EXPLORED THROUGH THE WORDS AND ACTIONS OF THE CHARACTERS AND DETERMINED BY THE OUTCOME OF THE HERO'S PURSUIT.

In other words, we may have begun our whole writing process with a personal truth about ourselves. But like the heroic protagonist himself, who must ultimately sacrifice his personal objective for some greater good, we must end up with a result that reveals a larger truth, one with resonance beyond our own experiences.

And yes, I just compared the hero's path to that of the writer. But we'll come back to that correlation in our concluding chapter.

In the meantime, enough with the theory already.

As with everything else, Aristotle goes beyond simply identifying this general PRECEPT to describing its application in practical terms. Right?

Nope.

Sure, he speaks explicitly and often in *Poetics* about every other element, their qualities and characteristics, the best choices to make, and how to go about constructing them. But beyond describing how the story itself has *thought* and a *moral character*, the former leading to the latter, he doesn't say anything practical at all about how to craft a story's theme.

And that's simply because—you don't. To paraphrase a classic t-shirt, THEME HAPPENS.

If you try to impose a theme, or God forbid, build your story from it, you will most likely construct a soap box, not a story. And we go to the movies to have an emotional experience, not to eat spinach.

You'll often only discover your theme after completing a first draft in which you've concentrated solely on plot, structure, characters, dialogue, and description. If you get those right, *and* you've started from a story based on a personal truth, you can trust the rest will be there.

It's also not uncommon that you'll be TOLD your story's universal truth by someone else who reads that draft. Nothing wrong with that. It only means the story's *moral dimension* arose organically, rooted in your own subconscious *thoughts* and *ideas*, yet with clear resonance for others.

Then, once aware of that deeper theme that has emerged, you can explore it more consciously in subsequent drafts, making sure it is posed, that it gets debated or challenged, and that ultimately, the resolution of the plot and the character's Change of Fortune answer it to your satisfaction.

So if you've been keeping score, we now have three separate but interconnected threads binding our story: the DRAMATIC thread based upon the hero's quest for their objective, the CHARACTER thread based upon their Change of Fortune, and the THEMATIC thread based upon the General Truth revealed at the resolution.

A good story has these three currents running through it in parallel, giving it its proper wholeness, unity, and magnitude.

As an example, let's look at Michael Arndt's *Little Miss Sunshine*.

The DRAMATIC THREAD, the "head" story, is about a family trying to get to a beauty pageant. The dramatic question posed at the set-up is, "Will they get there in time?" The answer at the resolution: yes.

The CHARACTER THREAD, the "heart" story, revolves around the family patriarch. That question posed in the set-up is "Will Richard heal his relationship with Olive by becoming the caring, supportive father he needs to be?" The answer at the resolution: yes.

The THEMATIC THREAD, the "gut" story, concerns themes of success and failure, specifically the assertion that Richard makes at the beginning, "If you don't win, you're a loser." The thematic question is simply whether that assertion is true or false.

And throughout the story, it is challenged as Richard himself is challenged. Until finally, at the end, as father and daughter dance exuberantly in front of a bewildered crowd, we get the answer: *hell no*. Success isn't judged by winning a contest, but by finding rewarding connections with those you love. That is the film's General Truth, the moral to the story that gives it, thematically, a wholeness and unity.

And that brings us back to our original discussion of *thought*.

I said quite emphatically in our chapter on DIALOGUE that characters never simply state what they think, mean, or feel. Instead, thought gets *revealed* through what they say and do in pursuit of their goals.

Well, the same can be said of a STORY'S *thoughts*. They, too, are *revealed*, not articulated, but intimated by the events of the story.

So when we see Richard and Olive dancing on that stage, acting like winners despite what the pageant judges have decreed, we *experience* the moral of the story, the resolution of the thematic question that has been debated throughout, without having to be *told* it.

As always, it's all about STORY. That's the vehicle for the *ideas*, not the other way around. Your audience wants to *feel*, not be enlightened by your awesome philosophy of life.

So don't write a story about HOW WE MUST PUT FAITH IN A HIGHER POWER IF WE ARE TO ACHIEVE OUR FULL POTENTIAL. Write a story about a young moisture farmer who sets out to deliver some blueprints and ends up saving the rebellion from an evil galactic empire because he trusts in the Force.

Don't write a story about HOW LOVE TRANSCENDS GENDER IDENTITY or HONESTY IS THE BEST POLICY. Write a story about two out of work musicians who witness a mob hit and must disguise themselves as women in order to survive, with hilarious romantic complications.

When we *do* learn something profound, that's the icing. But the story is the cake.

For like the best dialogue that reveals *thought* through the subtext, THEME is the subtext that gets revealed through the story.

Conclusion

Bringing It All Back Home

"Poetry implies either a happy gift of nature or a strain of madness. In the one case, a man can take the mold of any character; in the other, he is lifted out of his proper self."

(*Poetics*, *Part XVII*)

Okay, so what have we learned?

A whole bunch, hopefully. But here are some highlights.

Storytelling, the art of telling lies skillfully, has been around since the dawn of man, distinguishing humans from all the other creatures on Earth and connecting us as a species.

Its basic form and content transcend geographic and cultural boundaries, and have remained relatively unchanged throughout history.

And while screenwriting, the most contemporary and perhaps ubiquitous form of storytelling, may be relatively new, its guiding principles adhere to the same patterns we can observe in all the narrative mediums that preceded it.

We began our discussion with Aristotle's deconstruction of the successful tragic plays of his time and his observations and conclusions of what makes a good dramatic narrative and why.

We learned that a good drama is an imitation of an action that is whole, unified, complete, and of a certain magnitude. It has a beginning, middle, and end that track the Change of Fortune of a protagonist as he pursues a clear, specific dramatizable objective.

It requires *mimesis*, the representation of a universal experience, utilizes *reversals* and *recognitions*, is structured around causally connected events that follow the laws of probability and necessity from first cause to the conclusion, and ultimately produces an emotional experience, a *catharsis*.

We observed these same truths in movies we watched and screenplays we analyzed.

And along the way, we utilized all these principles in our own work, starting with a logline, expanding it into Anchor Points, to synopsis, to Stepping Stones, to Beat Sheet, and finally to pages and a completed first draft.

So now we have a screenplay, one that follows the classical principles of storytelling that Aristotle first documented in his *Poetics* and which remain as relevant today as they did in his time.

Now let's bring it all back full circle.

I asked the same question at the top of this book that Aristotle himself poses at the beginning of his. *What is the function of storytelling?* Is it just an entertainment? A chance to escape our lives, if only temporarily? Or is there perhaps some higher purpose?

Since this book *about* storytelling is itself TELLING a story, it's only proper that it ends with some kind of resolution of that dramatic question.

So I hope that since you've absorbed Aristotle's Guiding Precepts, digested my own take on his invaluable teachings, and experienced the process of crafting your own screenplay according to those principles, that you will have reached similar conclusions of your own.

Storytelling, and screenwriting specifically, certainly CAN provide an entertainment, a chance to take a break from our routine, our problems and concerns, for a couple hours at the mall or on the sofa each weekend.

But that is certainly *not* all there is to it.

The mere fact that there exist so many observable patterns in the *way* we tell stories, and that these patterns transcend medium, history, culture, and geography, indicates there must be something more going on here, some kind of evolutionary function built into our DNA that *requires* us, as a species, to tell stories.

For the truth is, watching movies, like any kind of storytelling experience, is actually *not* a way to escape our lives at all.

It is a way to *deal* with them—to confront and cope with our problems and concerns, but from a safer, more objective physical and emotional distance.

And just as vital is the communal aspect of the experience.

When we see a character or watch an event that resonates with us, that makes us *care*, as the best characters and stories do, it is because we are aware that "that is *me*" up on the screen. And that association provides the comfort of knowing that our experience is not isolated.

For the questions, hopes, dreams, worries, and fears that get addressed, explored, and debated in the best stories are the same fundamental questions, hopes, dreams, worries, and fears that are shared by every human being on the planet. *They* are ultimately what connect us as a species.

So if we don't get actual solutions, at least we take consolation in getting to participate in the pursuit of them together, whether in an actual theatre or part of a virtual one in our living rooms. And it is that shared journey, that collective search for answers, which not only comforts and connects us, but also affords us "the liveliest pleasure."

That's because Nature has bestowed upon us a *joy in learning*. And as Aristotle observes, we best learn through watching and participating, observing and feeling. That duality is what good storytelling provides—*mimesis* and

catharsis, the chance to have an emotional experience, and by it, to learn something of our shared selves.

And of course, it's through *learning* that we grow, develop, and have the opportunity for our *own* Change of Fortune—as individuals, as a community, and as a species.

That is the biological imperative and evolutionary function of storytelling.

And so *that* is why we tell them.

Which brings me to my final observation.

Even if we now have a better understanding of storytelling's function and the elements required to fulfill that function, what we've really been discussing all this time is why stories are necessary from an *audience's* perspective, why we want and need to *experience* them.

The reader of the script or the watcher of the film, like the caveman sitting by the fire hearing the tale of that morning's Great Saber-Toothed Tiger Hunt, is satisfying a desire to learn about his place in the universe through that shared emotional experience.

So the question remains: Why do we TELL stories? Not why must we experience them, but why does the *teller* of a tale feel compelled to share it? What need is being fulfilled for him or her? For *you*, who's made the investment of reading the wisdom contained in this book?

In other words, even if we now have a better sense of what makes a good screenplay, we need to ask what makes a good screenwriter.

Aristotle gives us an answer when discussing how a successful screenwriter writes a scene. Remember, he says:

> *"The poet should place the scene, as far as possible, before his eyes . . . as if he were a spectator of the action."*
> (Poetics, Part XVII)

And then he quickly follows that advice with:

> *"Those who are actually experiencing the emotions are the most convincing; someone who is distressed or angry acts out distress and irritation more authentically."*
> (Poetics, Part XXVII)

So while we've seen how an audience both observes and feels the world of a good story well told, we've also acknowledged that Aristotle insists a writer must do the same. He must SEE the action play out in his mind's eye, and simultaneously EXPERIENCE the emotion of it.

And as the quote that opens this chapter indicates, for Aristotle, the ability to do both effectively implies either *talent* or a *strain of madness*. And if you've ever met a successful screenwriter, you know that it's more than a bit of both.

Remember when I joked about needing to silence the voices in my head? That may have been said to elicit a laugh, but like the best lies, it was based upon a truth.

To be successful, you don't need to be a drunk or a social outcast, however romanticized those things may be. You just need two things: to have *something* to say, and to have an almost *desperate* need to say it.

The reason to write a screenplay is *not* to make a buck. You often won't. It is *not* to become famous. There are far easier ways to do that. No, it is simply because you don't have a choice in the matter. You have a story to tell, something that you care about, that consumes you, that you *know* will have resonance with every soul who sits in that theatre, and you can't go one day longer without sharing it with them.

For you can learn what makes a good story, and you can even develop the skills to tell them well. And after reading this book, hopefully you're well on your way to cultivating the talent required for success.

But as for the requisite strain of madness—for that we have to circle all the way back to our initial discussion of *catharsis*.

As I said at the top of this book, Aristotle uses that term without much, if any, explanation. We've taken it to mean a purging of emotion, an opportunity to *feel*, in a way that is safe and that allows us to learn about ourselves.

But while that discussion was from the perspective of an audience, the same applies to the artist. The reasons why we like to watch movie stories are not different from the reasons we need to TELL them—to learn about ourselves, to have an emotional experience, to make connections with other people with whom we're sharing this amazing and terrifying journey.

For just as an audience derives pleasure from the emotional experience of watching a movie, a successful screenwriter must get pleasure from the emotional experience of telling one. In other words, communicating your story to others must itself be *cathartic*.

I suppose that's what I unconsciously meant by needing to quiet the voices in my head, and what prompted my fellow students in the room to nod in agreement. We are crazy because we *need* to tell our stories regardless of how difficult and painful it might be—because it is even more difficult and painful, not to mention deafening, *not* to.

That need for release, or *purging*, is what makes a writer willing to enter into a terrifying world of the unknown, to face seemingly insurmountable obstacles, with only their commitment to their objective to pull them through, until finally they emerge, bruised and battered, but having learned something vital about themselves in the process.

And that's why I can equate the path of the hero with that of the writer, for as you can see, they are one and the same.

It's been said there are only two types of gunslingers, the quick and the dead. Well, there are only two types of screenwriters, those who succeed and those who throw in the towel.

So I hope you utilize the advice and precepts of this book, from Aristotle and a humble disciple. But most importantly, being the stalwart, determined, and resourceful hero of your own story, when faced with the obstacles of naysayers, rejection, procrastination, and overwhelming self-doubt, I hope you never give up.

And if you truly have something to say and a need to say it, whether to explore your own place in the universe, to connect with others on the journey, or simply because you require the *catharsis* of creative expression to make it through your day, you won't give up.

Because you *can't*.

And that brings us to **Aristotle's Guiding Precept #21**:

> **TO BE A SUCCESSFUL SCREENWRITER, YOU MUST HAVE TALENT, A SCREW LOOSE, AND MOST IMPORTANTLY, SOMETHING TO SAY.**

So if you *are* one of those lucky and miserable wretches with a gift of nature and a strain of madness, then good luck and Godspeed to you. Write for the joy of it, for that's the only fuel that will keep you going.

So go and do that.

FADE OUT
THE END

ASSIGNMENT #14: REWRITING AND BEYOND

1. Rewrite your screenplay until it's "done." Sell it and/or get it made. Then follow all these steps again with another idea. Repeat as often as desired.

 All the while, write every day. Don't be discouraged and don't give up. Remember, only a mediocre writer is ever satisfied. Don't be mediocre.
2. When you accept any award or kudos, thank Aristotle.

APPENDICES

Aristotle's Guiding Precepts

1. TO TELL A GOOD STORY EFFECTIVELY, WE MUST a) SHOW OUR AUDIENCE SOMETHING UNIVERSAL OF THEMSELVES AND THEIR WORLD REFLECTED BACK TO THEM, AND b) THROUGH THAT IDENTIFICATION, GIVE THEM AN EMOTIONAL EXPERIENCE.

2. THE MOST IMPORTANT ELEMENT OF A SCREENPLAY IS THE STORY.

3. IN A GOOD STORY, *TRUTH* IS MORE IMPORTANT THAN *FACTS*.

4. A GOOD STORY IS INFUSED FROM START TO FINISH WITH CONFLICT.

5. A GOOD STORY HAS CLOSURE, WITH A CLEAR BEGINNING, MIDDLE, AND END.

6. A GOOD STORY HAS A UNITY OF ACTION, ONE DEFINED BY A HERO'S OBJECTIVE.

7. IN A WELL-CONSTRUCTED PLOT, EVERY EVENT IS CAUSED OR AFFECTED BY WHAT PRECEDES IT AND CAUSES OR AFFECTS WHAT FOLLOWS, ACCORDING TO THE LAWS OF NECESSITY AND PROBABILITY.

8. A SOUND PLOT IS BUILT UPON MOTIVATED MOMENTS OF REVERSAL AND RECOGNITION.

9. THROUGH PURSUING AN OBJECTIVE, THE HERO IN A SOUND PLOT UNDERGOES A TRANSFORMATION.

10. IN THE BEST PLOTS, HEROES EITHER OVERCOME THEIR FATAL FLAW OR THEIR FATAL FLAW OVERCOMES THEM.

11. THE PROPER WAY TO CONSTRUCT A PLOT IS TO GO FROM THE GENERAL TO THE SPECIFIC, STARTING FROM THE BIGGEST MOMENTS OF REVERSAL AND RECOGNITION AND THEN FILLING IN THE EVENTS THAT CONNECT THEM.

12. CHARACTER IS ALWAYS IN SERVICE OF STORY, SO ALL CHOICES MADE ABOUT CHARACTER SHOULD BE MADE TO FACILITATE IT.

13. WHILE SERVING THE NEEDS OF THE STORY, A CHARACTER AND THEIR ACTIONS MUST ALWAYS REMAIN BELIEVABLE.

14. A CHARACTER IS BELIEVABLE AND SERVES THE STORY WHEN THEIR ACTIONS ARE ALWAYS MOTIVATED BY AN IMMEDIATE GOAL.

15. A SOUND PLOT IS MADE UP OF CAUSALLY CONNECTED EVENTS THAT CHANGE THE CIRCUMSTANCES OF THE STORY AND OUR UNDERSTANDING OF THE CHARACTERS.

16. A SCREENPLAY SHOULD BE EQUALLY AFFECTING TO READ AS TO WATCH ON SCREEN.

17. WHEN WRITING DESCRIPTION, BE FOCUSED, PRECISE, AND CLEAR, BUT NEVER BORING.

18. IN GOOD DIALOGUE, CHARACTERS SPEAK SOLELY TO ACHIEVE THEIR IMMEDIATE SCENE GOAL, AND THAT SELDOM REQUIRES THEM TO STATE WHAT THEY THINK, MEAN, OR FEEL.

19. SCREENPLAYS ARE NOT WRITTEN; THEY ARE REWRITTEN.

20. A GOOD STORY REVEALS A UNIVERSAL TRUTH, ONE EXPLORED THROUGH THE WORDS AND ACTIONS OF THE CHARACTERS AND DETERMINED BY THE OUTCOME OF THE HERO'S PURSUIT.

21. TO BE A SUCCESSFUL SCREENWRITER, YOU MUST HAVE TALENT, A SCREW LOOSE, AND MOST IMPORTANTLY, SOMETHING TO SAY.

Assignments

ASSIGNMENT #1: LIES AND THE PERSONAL TRUTH

1. Write down FOUR interesting, unique FACTS about yourself. ONE of them must be a complete and total lie, but a good lie, one that would be hard to detect from the truths.
2. Then write a short one-page story about a fictional character that incorporates both that lie and one of your true facts. Think about the differences between facts and lies, and how both can be used in service of the truth.

ASSIGNMENT #2: PREMISE

Write TEN Loglines. Five from movies you've seen. Five from ideas you make up yourself. The trick is to be specific without too much detail. Give a sense of a dramatic question; of a beginning, middle, and end; and of whose story it is, what they want, and what's keeping them from getting it.

ASSIGNMENT #3: A CHANGE IN FORTUNE

For each of the Loglines from the previous assignment, identify:

a. the hero's dramatizable objective
b. the hero's primary flaw
c. how the hero changed (or what they learned) as a result of the pursuit of their dramatizable objective

ASSIGNMENT #4: ANCHOR POINTS

1. Take two of your loglines from produced movies from the last assignment and write the six Anchor Points that determine the big picture of the story, its beginning, middle, and end.

 EQUILIBRIUM
 INCITING INCIDENT
 POINT OF NO RETURN
 BIG GLOOM
 CLIMAX
 NEW EQUILIBRIUM

Now—

2. Do the same with your OWN STORY.

ASSIGNMENT #5: CHARACTER TRAITS AND BACKSTORY

1. Fill in the following 5 Ps Character Worksheet for your hero.
2. Write a one-page Backstory for your hero, paying particular attention to any traumas, successes, regrets, and relationships that account for your hero's MORAL DISPOSITION at the start of your screenplay. Specifically, what events in their early life account for their flaw and their objective, their need and their want?

5 Ps Character Worksheet

PHYSICAL PRESENCE
Age:
Gender:
Race:
Nationality:
Height:
Weight:
Appearance/Demeanor:
Wardrobe:
Physical strengths:
Physical weaknesses:
Tics/Mannerisms:
Distinguishing features:
Other important physical attributes:

PERSONA
Religion:
Job:

Political affiliation:
Education:
Marital status:
Economic class/Income:
Hobbies:
Clubs/Memberships:
Talents/Skills:
Other important social interactions:

PSYCHE
Intelligence:
Fears/Phobias:
Ambitions:
Obsessions:
Disappointments:
Frustrations:
Pet peeves:
Secret delights:
Mental abilities:
Other important psychological traits:

PERSONALITY

Out of the countless number of personality traits, list the five to ten most defining ones for your character. For example: ambitious/unmotivated, caring/insensitive, cheerful/moody, courageous/timid, courteous/rude, decisive/hesitant, enthusiastic/dispassionate, faithful/untrustworthy, focused/scattered, friendly/cold, generous/stingy, hard-working/lazy, honest/deceitful, humble/arrogant, optimistic/cynical, realistic/idealistic, self-reliant/needy, selfless/selfish, trusting/suspicious

PRIMARY MOTIVATING FACTORS
Dramatizable Objective (want):
Primary Flaw (need):

ASSIGNMENT #6: TWO-PAGE SYNOPSIS

Write out your story in prose, in just two pages, double-spaced, tracking your hero's journey, the pursuit of their objective, and their transformation.

Think of it as a short story in three parts, the Set-up, Complications, and Resolution, in which you incorporate all the elements we've discussed so far—character, plot, and structure—particularly with regard to how those elements are shaped by your hero's primary flaw and dramatizable objective.

Make sure you're answering the questions:

How does it begin? What are the important facts of the world at equilibrium? Who is the main character? What happens to disrupt that equilibrium and start the story into motion? How does the hero respond? When can't the hero go back to the beginning? What does he now want and set out to achieve? What are some of the big complications, reversals, and recognitions along his journey to accomplishing it? What happens to leave him farthest from it, with all hope lost? What re-inspires his goal? What is he finally able to do that he couldn't before? How does it end? How has he changed?

Note: You can describe a lot in two pages, double-spaced. But if you can relate *everything* that happens, you don't have enough story for a feature-length film. So you must make choices about what to leave out. By doing so, you are deciding what is absolutely essential to leave in, the important events *required* to describe the big picture of your story. And it's that big picture, told with an *economy of language* that makes an effective synopsis.

ASSIGNMENT #7: FIRST ACT BEATS

Watch the first acts of two of the movies in the Recommended Movie List (see Appendix), noting the various events that make up the Set-Up. Can you identify the major Stepping Stone beats? Do the same patterns emerge?

ASSIGNMENT #8: SECOND ACT BEATS

Watch the second acts of the two movies from the previous assignment, noting the various events that make up the Complications. Can you identify the major Stepping Stone beats? Do the same patterns emerge?

ASSIGNMENT #9: THIRD ACT BEATS

You guessed it, watch the third acts of the two movies from the previous assignments, noting the various events that make up the Resolution. Can you identify the major Stepping Stone beats? Do the same patterns emerge?

ASSIGNMENT #10: STEPPING STONES

Now that you've identified these moments in movies that you've watched, it's time to further refine your OWN story by making these critical choices for your own screenplay. So use the following guide (and the provided samples) to identify the major Stepping Stone beats of your original story.

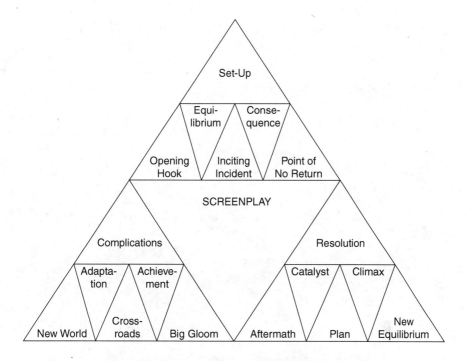

ASSIGNMENT #11: BEAT SHEETS

1. The best way to get a handle on Beat Sheets is to see them in action. So watch a movie from the Recommended Movie List (see Appendix) and write a Beat Sheet from it, according to the following format:

 Number each beat.
 Give each beat a TITLE (this can sum up the principle function of the beat, as in ELLIOT MEETS E.T., or it can be a *slugline* that describes its primary location, as in EXT. BACKYARD—NIGHT).
 Follow the title with two or three sentences that describe the events of the beat in more detail.
 Identify each structural beat (inciting incident, act breaks, climax, etc.).
 Put each new character's name in ALL CAPS when first mentioned.
 Follow the examples as guides.

2. Now write the Beat Sheet for YOUR STORY.

ASSIGNMENT #12: OPENING HOOK

Write the first scene of YOUR screenplay, utilizing proper screenplay format and our discussion of dialogue and description. Remember, the goal of your first page is to get the reader to TURN the page. The goal of the second, is to get them to turn that one, and on and on.

Your Opening Hook should give us insight into the character or their world, and whether a question mark or an exclamation point, hook us into the story.

ASSIGNMENT #13: YOUR ROUGH DRAFT

Write the rest of your screenplay, all the way to FADE OUT.

ASSIGNMENT #14: REWRITING AND BEYOND

1. Rewrite your screenplay until it's "done." Sell it and/or get it made. Then follow all these steps again with another idea. Repeat as often as desired.

 All the while, write every day. Don't be discouraged and don't give up. Remember, only a mediocre writer is ever satisfied. Don't be mediocre.
2. When you accept any award or kudos, thank Aristotle.

Recommended Reading

Some of these books are alluded to or directly referenced in mine, but all of them make up a screenwriter's essential library, whether you are just learning the craft or you're a seasoned professional.

Ackerman, Hal	*Write Screenplays That Sell*
Aristotle	*Poetics*
Bradbury, Ray	*Zen in the Art of Writing*
Campbell, Joseph	*The Hero with a Thousand Faces*
Chitlik, Paul	*Rewrite*
Egri, Lajos	*The Art of Dramatic Writing*
Field, Syd	*Screenplay*
Goldman, William	*Adventures in the Screen Trade*
Hunter, Lew	*Screenwriting 434*
King, Stephen	*On Writing*
McKee, Robert	*Story*
Price, Brian	*Classical Storytelling and Contemporary Screenwriting*
Suber, Howard	*The Power of Film* and *Letters to Young Filmmakers*
Vogler, Christopher	*The Writer's Journey*
Walter, Richard	*Screenwriting* and *The Whole Picture*

And any screenplay you can get your hands on! Produced, unproduced, first drafts, shooting scripts, it's all good. Reading HOW to write a screenplay is valuable, but seeing what a successful finished product actually looks like is priceless.

Recommended Movies

Many of these movies are referenced in this book, and all are essential viewing for anyone interested in a career making them. I usually announce in my first class that students need to watch them all by the second. I'm always surprised by how few of them realize I'm joking.

Airplane!

Alien

An American Werewolf in London

Annie Hall

Beverly Hills Cop

The Bicycle Thief

Big

Blue Velvet

Casablanca

Chinatown

Citizen Kane

A Clockwork Orange

Close Encounters of the Third Kind

The Conversation

Cool Hand Luke

Dawn of the Dead

The Deer Hunter

Die Hard

Dirty Harry

Dr. Strangelove

Dog Day Afternoon

Double Indemnity

Duck Soup

E.T.

Fargo

Flirting with Disaster

The Fugitive

The Godfather

The Goldrush

The Graduate

Harold and Maude

House of Games

The Hustler

The In-Laws

Jaws

L.A. Confidential

The Lego Movie

Liar, Liar

Little Miss Sunshine

The Maltese Falcon

Midnight Run

Miller's Crossing

Modern Times

Network

North by Northwest

An Officer and a Gentleman

The Player

The Producers

Psycho

Raiders of the Lost Ark

Raising Arizona

Rear Window

Risky Business

The Road Warrior

Rocky

Romancing the Stone

Sea of Love

The Searchers

Seven

The Shawshank Redemption

Singin' in the Rain

Some Like It Hot

Splash

Star Wars

The Sting

Strangers on a Train

Sunset Boulevard

Sweet Smell of Success

Taxi Driver

The Terminator

This Is Spinal Tap

Tootsie

The Usual Suspects

The Verdict

Vertigo

Wings of Desire

Witness

Working Girl

Attributions

This book utilizes excerpts or summaries from the following amazing screenplays (if you're smart, you'll buy them and read them in their entirety):

Big
Written by Gary Ross and Anne Spielberg

Blue Velvet
Screenplay by David Lynch

Chinatown
Written by Robert Towne

E.T. the Extra Terrestrial
Written by Melissa Mathison

Fargo
Written by Joel Coen and Ethan Coen

The Fugitive
Screenplay by Jeb Stuart and David Twohy; story by David Twohy; based on characters created by Roy Huggins

The Graduate
Screenplay by Calder Willingham and Buck Henry; based on the novel by Charles Webb

Harold and Maude
Written by Colin Higgins

Liar, Liar
Written by Paul Guay and Stephen Mazur

The Long Kiss Goodnight
Written by Shane Black

Psycho
Screenplay by Joseph Stefano; based on the novel by Robert Bloch

236

Raiders of the Lost Ark
Screenplay by Lawrence Kasdan; story by George Lucas

Seven
Screenplay by Andrew Kevin Walker

The Shawshank Redemption
Screenplay by Frank Darabont; based on the short story "Rita Hayworth and the Shawshank Redemption" by Stephen King

Silence of the Lambs
Screenplay by Ted Tally; based on the novel by Thomas Harris

Sleepless in Seattle
Screenplay by Jeff Arch, Nora Ephron, and David S. Ward; story by Jeff Arch

The Social Network
Screenplay by Aaron Sorkin; based on the book *The Accidental Billionaires* by Ben Mezrich

Some Like It Hot
Screenplay by Billy Wilder and I.A.L. Diamond; based on *Fanfare of Love*, a German film written by Robert Thoeren and M. Logan

Spider-Man
Screenplay by David Koepp; based on the Marvel comic book by Stan Lee and Steve Ditko

Star Wars
Written by George Lucas

Titanic
Written by James Cameron

Tootsie
Screenplay by Larry Gelbart and Murray Schisgal; story by Don McGuire and Larry Gelbart

The Verdict
Screenplay by David Mamet; based on the novel by Barry Reed

Vertigo
Screenplay by Alec Coppel and Samuel Taylor; based on the novel by Pierre Boileau and Thomas Narcejac

Witness
Screenplay by Earl W. Wallace and William Kelley; story by William Kelley, Pamela Wallace, and Earl W. Wallace

Working Girl
Screenplay by Kevin Wade

About the Author

Brian Price is a proud member of the UCLA Screenwriting faculty, teaching in the MFA, undergraduate, and professional programs. He has also taught screenwriting at Yale University, Johns Hopkins, UCSB, and the Brooks Institute, among other places. As a writer, he has worked with major studios, television networks, and independent producers around the world. And as a teacher, he is especially proud whenever his students' work appears on the silver screen, occasionally even getting nominated for Emmys and Golden Globe Awards (for which, of course, he takes full credit). He currently resides in Maryland with his wife Celia and two boys, Maddox and Levi, the best teachers he's ever had.

Index

Italic page references indicate figures.